≪─ Praise for *United States of Americana* ─≫

"A fantastically thorough handbook, *United States of Americana* documents and connects the many thriving communities that are finding value in the unique possibilities of the past. Reighley proves that old is the new new and that fringe interests will blend into the future, making the mash-up of the now." —Faythe Levine, author of *Handmade Nation: The Rise of DIY, Art, Craft, and Design*

"I love it! Kurt conveys the irresistible charm of the roots movement, showing that a taste for the details of the past can blend playfully with the amenities of the present. Independent circus and neo-burlesque are just a couple of the cultural movements he brings to life."
 —Jo Weldon, author of *The Burlesque Handbook*

"Encompassing, engaging, and definitive, *United States of Americana* finds the through-line that connects such seemingly disparate fashions— gin-joints and heritage chickens, banjo playing and bootmaking—to reveal the yearning for simpler times at their heart. Reighley shows us the Americana movement from the inside, not just as a conservative reaction to modern times, but as a progressive response to a popular culture that's increasingly unsustainable. Perfect bedside reading for anyone seeking to inch their way toward a more enriched and rewarding lifestyle."
 —John Roderick, from the Long Winters

"Reighley's book is your magical wardrobe into the Narnia of Americana. If it isn't in here, it isn't part of the heritage. Always fun, fully informed, astutely researched, and extremely generous in scope, *United States of Americana* is the lexicon of a laudable way of life."
 —Wesley Stace (aka John Wesley Harding), author of *Misfortune*

"*United States of Americana* reminds us of many things we need reminding of, inspiring us to reflect on our nation's heritage of values, the virtues of workmanship, and the pride in achievement. One doesn't have to look far to see just how many of us are now longing for something that sounds, tastes, feels, or looks like something from our past—a past where some of our fondest memories are tied directly to the craft of our forbearers. Is the closing of countless mom-and-pop shops finally getting under our skin, and is the outsourcing of America finally taking its toll? This book will hopefully show the reader that while our hands have perhaps softened they are not just for eating, typing, and tying our shoes."

—Chris Bray, cofounder of Billykirk, Inc.

"*United States of Americana* is *Foxfire* magazine for the *Hipster Handbook* audience." —Lance Ledbetter, founder of Dust-to-Digital

"Americana: hard to pin down, but you know it when you see it, and Kurt B. Reighley certainly knows it. With *United States of Americana*, the author sets the table with a heaping portion. Capturing that 'old weird America' with a decidedly twenty-first-century spin, Reighley guides his audience through the intricacies of cocktails and canning parties, where to pick up a good pair of boots, and why modern sounds in country and Western music are essential listening. A field guide, if you will."

—Justin Gage, founder of Aquarium Drunkard

© Steven Miller

✶ ✶ About the Author ✶ ✶

KURT B. REIGHLEY is a Seattle-based writer, DJ, and entertainer. He is the author of *Marilyn Manson* and *Looking for the Perfect Beat: The Art and Culture of the DJ;* he has written for *Rolling Stone*, *Details*, *The Stranger*, and *The Advocate*, and was a contributing editor to *No Depression*. His work appears on MSN.com, and he can be heard weekly on KEXP 90.3 FM Seattle (www.kexp.org).

United States

★ of ★

AMERICANA

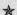

Kurt B. Reighley

Illustrations by
Aaron Bagley

United States

of

AMERICANA

★ ★ ★

BACKYARD CHICKENS,

Burlesque Beauties,

HANDMADE BiTTERS:

A Field Guide to the

New American Roots Movement

HARPER

NEW YORK • LONDON • TORONTO • SYDNEY

For Mark

HARPER

UNITED STATES OF AMERICANA. Copyright © 2010 by Kurt B. Reighley. Illustrations copyright © 2010 by Aaron Bagley. All rights reserved. Printed in the United States of America. No part of this book may be used or reproduced in any manner whatsoever without written permission except in the case of brief quotations embodied in critical articles and reviews. For information address HarperCollins Publishers, 10 East 53rd Street, New York, NY 10022.

HarperCollins books may be purchased for educational, business, or sales promotional use. For information please write: Special Markets Department, HarperCollins Publishers, 10 East 53rd Street, New York, NY 10022.

FIRST EDITION

Designed by Betty Lew

Library of Congress Cataloging-in-Publication Data
 Reighly, Kurt B.
 United States of Americana : backyard chickens, burlesque beauties, and handmade bitters : a field guide to the new American roots movement / Kurt B. Reighly ; illustrations by Aaron Bagley.— 1st Harper pbk.
 p. cm.
 Summary: "A vivid survey of how and why young urban Americans are finding inspiration in Americana and the cultural traditions of an earlier time in many areas of contemporary life"—Provided by publisher.
 Includes bibliographical references.
 ISBN 978-0-06-194649-3
 1. Americana—Social aspects. 2. United States—Social life and customs.
3. United States—Social life and customs—1971–4. Young adults—United States—Social life and customs. 5. Material culture—United States. 6. Popular culture—United States. 7. City and town life—United States. I. Title.
E161.R45 2010
973—dc22
 2010015318

10 11 12 13 14 OV/WCF 10 9 8 7 6 5 4 3 2 1

Contents

✷ **1** ✷

The
REMAKING
of AMERICANS

Philosophy
and
History

In 1997, satirical newspaper the *Onion* ran a story under the headline "U.S. Dept. of Retro Warns: 'We May Be Running Out of Past.'" According to fictitious experts, as pop culture trends came back into vogue with shorter intervals between, the past was in danger of achieving parity with the present. A decade later, those predictions—ridiculous or not—seem to have come true. In 2008, as the nation slogged through another terrible recession and record unemployment, how much comfort could citizens find in revisiting trends and fashions from the 1970s and '80s?

No wonder some began reaching back even further, to simpler times they'd never known firsthand. In a quest to find something of substance in an accelerated world, these modern pioneers are latching on to handcrafts, well-made shoes, gospel and bluegrass music—things that have waxed and waned in popularity, but have endured through eras of prosperity and hardship alike. They've opted to invest in one hand-tailored garment, or a hunting jacket made to the same specifications for over a century—a piece of clothing they might hand down to their children—rather than buy a new American Apparel hoodie every six months. They've stopped paying exorbitant gourmet prices for sun-dried or roasted tomatoes, and started learning to can their own, fresh from a local, sustainable source, maybe their own yard or a nearby farmer's market. They've started noting the arrival of each week's ripe and ready new crops the way clothes hounds anticipate Fashion Week. Musicians are declining to spend their time hunched over yet another

computer, and are forming old-time string bands instead, and then posting the results on their MySpace page. (Ironically, all this looking back has been accelerated by the Internet.)

A generation or two ago, our parents interacted with their neighbors and community members in a much more intimate way. They relied on local craftsmen to repair shoes, tailor trousers, or suggest the best cut of meat for dinner. To Generation X, that mentality can seem downright weird. Who repairs shoes? When sneakers wear out, you just throw them away . . . right? But as big-box stores and cheap goods have driven the valuable, highly skilled services of cobblers, tailors, and butchers to the brink of extinction, the romance of a blacksmith or old-fashioned barbershop is exerting tremendous, practical appeal to Generation D.I.Y.

Today, in almost any city, you can find a watering hole or boutique that looks suspiciously like it was cobbled together from sets of old Westerns or Sherlock Holmes serials. Burnished wood and taxidermy busts adorn the walls. Jukeboxes pump out Hank Williams and Bill Monroe sides. Patrons who only recently came of drinking age order small-batch, local whiskey and pre-Prohibition cocktails. (To quote a popular bourbon ad, "Lewis & Clark Didn't Load the Canoe with Mojitos.") And that server with the smart mouth? On weekends she's a trapeze artist, or a burlesque queen. Probably both.

Whether the subject is beat-up work boots, sequin-encrusted brassieres, or cigar box banjos, more and more folks share similar sentiments. In music, the umbrella term *Americana* encompasses a variety of contemporary artists who use time-tested sounds, such as delta blues or classic country, as a jumping-off point to something new. That impulse isn't limited to songwriters and bands. Its sphere expands every day, throughout fashion, grooming, food, and entertainment. Plenty of people would rather bolster their sense of identity, and become better acquainted with neighbors and friends, by exploring essential favorites from every corner of America's past. They are going back to their roots, in pursuit of goods that will endure and the know-how to maintain them, to the sustenance of tastes and sounds that delighted their grandparents and great-grandparents.

The Real Thing

As a growing number of discerning young Americans opt out of gambling on fads and fashion, the currency of "authenticity"—and the connotations of history and experience that word carries—rises in value. Companies like Red Wing and Pendleton Woolen Mills have survived two world wars and the Great Depression, which speaks volumes about the quality and reliability of their products. There's also some magical thinking afoot here: we want to believe not only that Carhartt knows what it's doing after 120 years of manufacturing work clothes, but also that by wearing their product we connect with some of that accrued wisdom and experience.

"People want to have real, genuine, authentic things," says Christina Vernon of Wolverine, who've made boots since 1883. Thanks to the protracted recession and mounting concerns about conservation, she predicts that demand will only increase. "The throwaway society is going to go away—or be greatly diminished."

On the other hand, there are plenty of savvy, younger entrepreneurs who attach the idea of authenticity to their wares too. They point to attention to classic details and time-honored methods as proof of their commitment to doing things right. These relative newcomers sense the public is dizzy from a million sales pitches honed in marketing meetings and focus groups; instead they emphasize transparency in their operations, with tags like "classic American workmanship."

Since World War II, the production of essential goods—food, clothing, machinery—has moved off Main Street, to an industrial park somewhere on the outskirts of town, then possibly to China or El Salvador. As that detachment grows greater, and the processes by which the things we buy are manufactured and reach our shelves become more opaque, many people are responding with heightened curiosity.

These pioneers understand that buying a product, being a consumer, is only the final step in a long journey. They want to choose their own adventure from the beginning. If they appreciate the sauerkraut and pickled green tomatoes of San Francisco's Bubbies, they may sign up to learn pickling

and preserving at a Canning Across America workshop. They want to get closer to the processes so they not only know exactly what they're getting, but also have a deeper sense of where their money goes and the practices it subsidizes once it's spent.

Small American craft businesses have had to pull back the curtain and expose the inner workings of their operations, and that's good. They can't reduce costs the way vendors who use cheaper overseas labor can, so they emphasize offering value—not bargains. "They can't compete with China or India or the Dominican Republic today," observes Kevin Shorey of Quoddy, Inc., a Maine footwear maker. "So they have to say, 'Here's what we're making—and it is better than what they're making.' And that has really raised the bar for American-made products."

America's heritage is teeming with invention and ingenuity that are still alive today. If you were one of those kids subjected to one too many field trips to Colonial Williamsburg or Plymouth Rock, you might be surprised at how fascinating the labors of butchers and soap makers can be (especially once you lose the tricornered hats and breeches).

In order to appreciate some of America's greatest traditions, occasionally we have to set aside preconceived notions and stereotypes. Just because the passing pickup drivers who harassed you as an adolescent nonconformist were blaring Lynyrd Skynyrd shouldn't discourage curious music lovers from investigating the Drive-By Truckers; as a legion of alt-country fans have learned, American roots music can resonate as powerfully as punk rock. A woman who knits can still be CEO of a Fortune 500 company. Heck, one of the biggest resources for information on home canning is not a division of some corporate agribusiness giant, but part of the U.S. Department of Agriculture (USDA).*

Take a look at the vendors on the American List, one of the most popular features on A Continuous Lean, the men's style blog helmed by New

* If the feds let folks know that our tax dollars help spread the gospel of how to put up your own beets and tomatoes, to feed your family responsibly, people might face April 15 a lot more cheerfully.

York apparel publicist Michael Williams. Or visit the Winn Perry boutique in Portland, Oregon, and browse through owner Jordan Sayler's carefully chosen stock of Alden shoes, vintage Pendleton shirts, and Billykirk leather satchels. These are young, urban dudes, aggressively promoting goods made in the U.S.A. (even as Tea Party patriots in middle America fork over their dollars to Walmart, a company whose determination to deliver the lowest possible prices favors goods manufactured overseas).

Naomi Gross, a professor at New York's Fashion Institute of Technology, points toward two reasons "Made in America" are three very sexy words these days: the severe economic downturn of the last few years, and concerns over global warming. If goods are manufactured in America, they come with a smaller carbon footprint than ones that are made in China or South America, then shipped or flown here. Plus a label that says "Made in America" carries the promise that there are still good jobs to be had in the United States of America.

⌐∙] STEAMPUNK [∙¬

Everything old is new again . . . "You mean like steampunk?" No, definitely not.

Steampunk refers to a subculture of literature, music, and other pursuits with an emphasis on anachronistic technology, especially from the Victorian era—lots of locomotives and clock gears and goggles. It's all very H. G. Wells.

Some cynics dismiss steampunk as just Goth for kids inclined to prefer brass and wool tweed over chrome and black fishnets. They should get over themselves. Steampunk might not be a groundbreaking movement, but it is an interesting subculture. *The League of Extraordinary Gentlemen* is a fun (if confusing) film, and the first couple

of records by the "Ladies' Cello Society" Rasputina hold up better than their tattered Victorian getups might suggest. And who doesn't appreciate a gent in a bowler hat?

Certainly steampunk incorporates and modifies ideas from olden days, and it gleefully ransacks the past, but it does so in the name of fantasy, of fiction and role-playing. It's a subculture more focused on pretending to romp around an alternate future than improving day-to-day existence. Entertaining? Thought-provoking? Yes, but right now it lacks the essential pragmatism found in the topics that follow.

Knowledge Is Power

Many Americans feel something vital is missing from their lives. Perhaps that unnamed thing is vague and existential: a sense of accomplishment; an assurance that life as they know it won't end before their kids graduate. Or it could be very specific: strawberry jam just like Aunt Katie used to make every summer; embroidery patterns that don't look like Dust Bowl–era relics.

Now Column A seems pretty daunting. We look to world leaders and religion to address craziness on that scale. But Column B? All of us can tackle problems like that. It may require visits to the library, delving into online discussion groups, even sourcing raw materials from vendors who haven't been busy since the abacus was the new iPhone, but you can do it. Ask small business pros like Slow Jams' Shakirah Simley or embroidery maven Jenny Hart from Sublime Stitching. The day you figure out exactly how to balance new flavors in a jar or duplicate those perfect French knot stitches, the existential dilemmas seem easier to cope with.

Taavo Somer and Sam Buffa are two of the New York dudes behind Freemans Sporting Club, the fashionably old-fashioned Lower East Side boutique and barbershop. They know knowledge is power. "You don't want to be the helpless one in any scenario. The clothing harkens back to the thir-

The DIRIGIBLE

What Is It? Ludicrously huge balloons filled with lighter-than-air helium or hydrogen, with gondolas attached, and propelled by small motors. Considered the zenith of luxury transatlantic travel in the 1930s.

Practicality: Great mileage, indifferent to turbulence, virtually noiseless. Low altitudes afforded passengers excellent views of countryside below. Moderate speeds (75–80 mph max). The first transatlantic crossing by dirigible, from Scotland to Long Island in July 1919, lasted four days, twelve hours, and twelve minutes. (The return flight was much quicker—just seventy-five hours—thanks to strong tailwinds.)

Availability: Sudden nosedive in popularity following 1937 *Hindenburg* disaster. But seems like an idea worth revisiting. Surely they've worked out the kinks by now.

SUBLIME OR RIDICULOUS? *Compared to being shoehorned into 27-B with a screaming infant in the row behind, and an insufferable Sandra Bullock comedy for in-flight entertainment? Are you kidding? Bring back the airships!*

ties, forties, and fifties, when men knew how to do things," Somer told the *New York Times* in 2007. "It's nice to know how to start a fire, how to shoot a gun," said Buffa in *New York* magazine the same year.

The convenience culture of the twentieth century has left many of us feeling more helpless than our ancestors. Not just in the face of huge entities like Wall Street or the government but on a day-to-day level too. But you don't need to make a field trip to a firing range to feel better equipped to soldier through life—putting up plums can work too.

"It's amazing how far removed people are from actually being able to manufacture, or fix, or even understand the things they use," says Seattle vintage clothing dealer Cybele Phillips. "It's pretty terrifying, actually. Were something catastrophic to happen, we'd all be in pretty bad shape."

Jaron Lanier, the American computer scientist who pioneered virtual reality, once wrote that "information is alienated experience." There are still types of information—for example, the emotions and physical sensations that may accompany slaughtering a chicken—that can only be obtained through an unmediated experience. Once upon a time, much of this was common knowledge. Ask at the next big family reunion—odds are a grandparent or great-aunt is all too familiar with how to make headcheese or tack on a new shoe heel.

In this digital age, the Internet and other media bombard us with new information, but not experience. When we actually engage directly with our world—raising, tending, killing, butchering, and cooking a chicken in our own home, instead of simply picking up a package of fryer parts at Safeway—our experience feels profoundly different. It feels real, authentic, and information alchemizes into something more like wisdom.

When we step away from our computers and mobile phones, iPods and HDTV, we can relish experiences in real time more fully. Yes, the stimulus of the world grows more complex (and potentially overwhelming) every day, yet everything around us, living or inanimate, has evolved over time to fill a specific niche. Presented with the choice between the novelty of something new but untested, and an older alternative that not only fits its niche well, but has worked hard to maintain that place of pride, it's no wonder many

people are increasingly drawn to the latter. We crave certainty in an uncertain world.

Appreciating how and why we make small choices is a value-add in itself. "It's very spiritual for me," says filmmaker Faythe Levine. "That kind of conscious living just makes you aware of the things you have around your life . . . and who we are as we walk through our daily lives. That mindfulness is really exciting."

Don't Trash Your Laptop

When it comes to information dissemination, the Internet whips the pants off smoke signals and carrier pigeons. It's just a poor substitute for getting your hands dirty. "It's silly to give up your Mac just because you want to have vegetables growing in your yard," says New Mexico musician Rennie Sparks. You can have your zucchini and blog about it too.

The members of this new American roots movement get out from behind their laptops, especially once they've connected with like-minded individuals, near or far. The burlesque blowout Tease-O-Rama, first held in New Orleans in 2001, sprang from a Yahoo groups list of the same name, launched a year earlier. Before *No Depression*, the now-defunct alt-country magazine, the online community at NoDepression.com, or the No Depression Festival, there was an AOL discussion group devoted to the same music.

Take Your Time

You can peruse a lot of information quickly on the Internet. Want to know more about cable-knit sweaters or old-time string bands? With a few keystrokes, your monitor can be teeming with diagrams and instructions, tutorial videos from YouTube, heated cross-continental arguments, and themed playlists of MP3 files.

But if you actually want to learn to plunk out "Turkey in the Straw" on the banjo, that requires more time. Patience and practice, and hands-on

experience. A break from the eight hours a day the average American over age eighteen spent in front of various flashing screens in 2008–2009.* It can be a welcome respite from the nonstop, rapid-fire multitasking of our daily lives, an opportunity to get lost in a moment.

Getting away from a glowing monitor was the reason Marty Krogh of Art & Sole Comfort Footwear in Portland, Oregon, left his lucrative career in graphic design for the world of shoe repair. "It's good to be able to work with your hands," he says. "So much is computerized now. I didn't get to interact with people. I wasn't outside. Everything is virtual. The tangible is really nice."

Back to the Land and Back

In 1975, jazz legend Peggy Lee recorded a song called "Longings for a Simpler Time." While it wasn't a Top 40 hit, the sentiment of its title tapped into a zeitgeist familiar to many Americans, then and now: a desire to return to a mythic Golden Age—even if that never really existed.

Back in the 1960s and '70s, those "longings" were manifested nationally by a movement called Back to the Land. This was a response by some urban dwellers to the era's ills: the energy crisis, water and air pollution, rampant consumerism, and the political abuses of Watergate. City folk eager for a simpler life relocated to rural areas, where they hoped to cultivate their own food, build their own homes, find natural power sources—in short, to live "off the grid" (just so long as their copy of the latest *Whole Earth Catalog* showed up safely in the mailbox).

You don't need an engineering degree to draw a straight line between many of the subjects addressed by the new American roots movement and Back to the Land. Some of the key players even grew up in families shaped by Back to the Land ideals.† Those impulses are coming back today: a

* This study, "Video Consumer Mapping," was conducted by Ball State University's Center for Media Design and Sequent Partners for the Nielsen-funded Council for Research Excellence.

† Robin Pecknold of the band Fleet Foxes recalls his parents living for a year in a teepee.

desire to reconnect with nature; to preserve our dwindling resources by pursuing a sustainable way of life; to work with neighbors and community members toward common goals.

Besides the expense involved, building your own stone house and digging a root cellar is tiresome labor.* In the twenty-first century we're seeing more young people in cities and suburbs who are improving their quality of life by relearning skills their grandparents took for granted, while still retaining their trendy zip codes. They may not have a smokehouse, but they cure prosciutto in their kitchen. This isn't about going Back to the Land; it's importing the best of the land back into daily activity.

Slow Foods

Another precursor to this shift in American consciousness was the rise in the late 1980s of the slow-foods movement, which rejected the wholly industrialized approach to food preparation and consumption, emphasizing instead eating locally, seasonally, sustainably, and as a community. Picking your own strawberries involves understanding how strawberries grow, in relation to seasons and weather, soil conditions, in a way that simply buying a prepackaged pint doesn't. This prompts us to examine our own place in the overall ecosystem, which in turn leads to a greater sense of connection and interdependence. This is why slow-foods buffs prefer to think of themselves as "coproducers," not consumers. They are acutely aware of having a small but powerful part in the larger food system, with their own set of responsibilities.

Fast Music

Punk rock was also a point of entry for some into a new American roots lifestyle. Operating outside the mainstream music business, punk rock relies

Eric Demby, founder of Brooklyn Flea, lived in a commune in Maine until he was four; he remembers farm animals and a garden, but no running water.

* Just reading the chapter on how to construct your own buildings from Scott and Helen Nearing's 1954 Back to the Land classic *Living the Good Life* is exhausting.

on a D.I.Y.* sensibility that, as we'll see in chapters that follow, subsequently crops up in the handmade crafts movement and the reinvention of circuses and burlesque.

And though you'd have never guessed it watching the Sex Pistols wrangling with urban cowboys during their ill-advised jaunt through the southern United States way back in 1978,† over the years punk rock has also opened the door to American roots music, and older traditions in general, for many a disgruntled youth as maturity sets in. That was certainly the case for Nan Warshaw and Rob Miller, who would found seminal alt-country label Bloodshot Records in 1994.

"Both Nan and I connected some of the lack of artifice we found coming out of the punk scene with some of the three-chords-and-the-truth aspect of country music, and how it's really stripped down," says Miller. As he got older, his desire to smash the state hadn't deteriorated—but his level of raw energy had, at least a little bit. How to reconcile the two? "I remember standing on the street one day, and a bus went by with a designer flannel ad for the Gap." It was 1992, the year Nirvana's *Nevermind* topped the *Billboard* album charts. "This is what my underground gestalt has turned into; just another marketing ploy." He still craved the honesty and attitude of punk as an antidote to the mainstream pop culture being crammed down the nation's throats. "And then you start hearing things like Johnny Cash and Hank Williams, and you think, 'Wait a minute. There is this other music that was completely devoid of artifice . . . even if it was created fifty years ago.' "

Crossroads

The more conscious we are of the minutiae and intertwined systems of the world in which we live, the more rich and real life seems, and, consequently,

* "Do It Yourself."
† One of the Pistols' many misadventures featured in Julien Temple's excellent documentary *The Filth and the Fury* (2000).

the more rewarding our experiences feel. We can also contextualize what we have learned in more and varied ways. This accounts for the ripple effect so pervasive throughout the *United States of Americana*—why accomplished burlesque entertainer Peekaboo Pointe of the World Famous Pontani Sisters enrolled in a hog butchering workshop, and rock band the Decemberists recruited Sublime Stitching to make embroidery kits to sell as tour merchandise.

For the last decade, Kevin and Kristen Shorey have brought Quoddy Trail Moccasins to the annual Common Ground Country Fair, hosted by the Maine Organic Farmers and Gardeners Association. If someone feels strongly that purchasing and preserving local peaches in season is better for the planet than buying commercially canned ones, then they're more likely to invest in hand-sewn shoes too.

"When you are conscious of how things are made, because you're doing it yourself, you're that much more connected to the people who make the things that you consume, or the people that you consume them with," observes Callie Janoff, founder of the Church of Craft, an international organization that promotes creativity and making as a spiritual practice. "That fosters a sort of connectivity that is really important to people, right now in particular. It's an attractive way to be in community."

Leaving Frontierland

When the original Disneyland opened in summer 1955, one of its biggest draws was Frontierland. In marked contrast to other sections of the theme park, Frontierland was short on thrills and attractions—popular early "rides" were a stage coach and pack mules—but long on natural surroundings, and evocation of a simpler time.* "Here we experience the story of our country's past," proclaimed Uncle Walt. "The colorful drama of frontier America in the exciting days of the covered wagon and the stage coach, the

* Frontierland's main drag was home to a store that carried rugged American clothing brands like Pendleton, Levi's, Stetson, and Justin Boots, and even sold fabric by the yard.

advent of the railroad and the romantic riverboat. Frontierland is a tribute to the faith, courage and ingenuity of the pioneers who blazed the trails across America."

Part of Frontierland's draw was tied to Disney's successful branding of American folk hero Davy Crockett, but it also appealed to park visitors on a more primal level. Life had grown bigger and scarier in the wake of the Great Depression and World War II. Modern conveniences led to modern headaches, from traffic congestion to the mysteries of boxed cake mixes. Nikita Khrushchev and Dwight Eisenhower were ushering in a new era of the Cold War. The easiest way to get away from it all? Step back in time, if only for an afternoon.

The new American roots movement transcends mere nostalgia. Nostalgia is a desire to return to the past, accompanied by a generous side of sentimentality. Nostalgia is *The Big Chill* soundtrack on an iPod, a stack of thrilling 45s that once made a generation clap, sing, and dance, now boiled down to a bunch of ones and zeros. Dwelling in yesteryear never comes to a good end. Put *Sunset Boulevard* in your Netflix queue if you need a reminder.

The different parts of this movement embrace traditions, but are not necessarily consumed by nostalgia. Think of it this way: What do you do when you lose something important, like your house keys? You retrace your steps. You scrutinize the past to solve a problem in the present. That's not indulging in nostalgia. That's common sense.

There is a lot of history tucked into the pages that follow. Yet no matter how vigorously they may have studied how things were done in the past, the pioneers of the *United States of Americana* aren't trying to wrench back the hands of time and freeze it there. Yes, there are young bucks running around Brooklyn dressed like lumberjacks, and dandies rolling through town on high-wheel bicycles, in the twenty-first century. But they still carry cell phones in their coveralls—and those ringtones lifted from scratchy 78s were created with digital technology. Welcome to the United States of Americana.

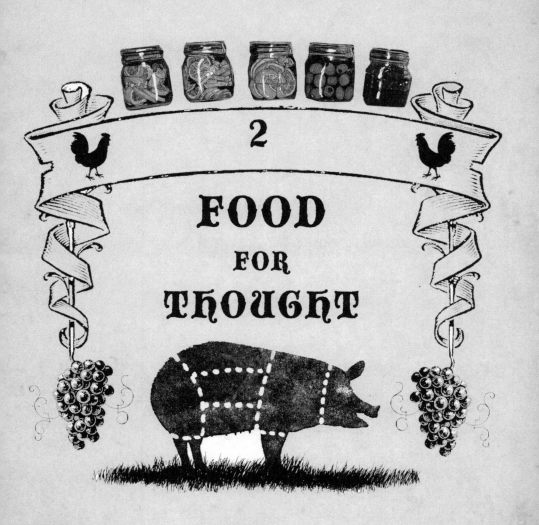

2

FOOD
FOR
THOUGHT

New
Old-Fashioned
Eating

In the twenty-first century a colorful package isn't enough to sway some grocery shoppers—they want to know exactly what is, and isn't, inside every product on the shelves, and how those ingredients got there. Did they come from the next county or another continent (or a chemical laboratory)? Could the consumer make the same item in their own kitchen? Could they improve upon it?

The way many Americans approach their diet is evolving—or returning to a more traditional approach. We want to feel a closer connection to the people, places, and processes that yield our daily bread. In 2007, the *New Oxford American Dictionary* announced that its Word of the Year was *locavore*, meaning a person dedicated to only eating locally grown foods. The last twenty years have seen a boom in Community Supported Agriculture (CSA), a practice where customers purchase annual shares in a nearby farm and once a week receive a parcel of fresh, regional, seasonal produce (and sometimes other goods) from that farmer—kind of like a subscription to local produce.

Other folks are removing the middleman too. Jackson Landers, an insurance broker in Charlottesville, Virginia, teaches a course called Deer Hunting for Locavores. In Brooklyn, Michael Hurwitz and Ian Marvy of the nonprofit Added Value have transformed an old asphalt playing field into the Red Hook Community Farm, employing low-income youth from the surrounding neighborhood to help raise more than three dozen differ-

ent crops over the year. Individuals are turning their windowsills into herb gardens, and converting backyards to grow tomatoes, corn, bell peppers . . . even livestock and poultry.

Nobody Here but Us Chickens

Adam Hasson is a sweet, soft-spoken guy who works in real estate. He doesn't look like he could hurt a fly. But he knows how to "harvest" a chicken, from firsthand experience. As he surveys his flock, a colorful menagerie that includes a silver-laced Wyandotte, one Buff Orpington, an Araucana, and three others, he makes no bones about their fate once they stop laying after a few years. Adam is fond of his chickens. "I enjoy watching them, they're very entertaining." They have names (Opal, Barracuda), but they are part of his food chain, not pets.

Hasson is part of the multitude of Americans tending chickens in their backyard.

Though he felt a little odd doing it at first, once he began mentioning it to other people he realized the undertaking was neither as antiquated nor as faddish as he thought. "Almost everyone is just one generation—two, at the very most—away from raising chickens," he says. "And yet it seems to be totally new."

Tending chickens is relatively simple. The challenge is keeping them safe. Hasson admits there are a thousand and one grisly ways for chickens to meet their demise. "I have raccoons in my yard almost every night. It's actually pretty miraculous they [the chickens] are all still alive."

As is the case for many of his peers, Hasson's motivation for entering the world of backyard chickens was simple: fresh eggs. Compared to supermarket eggs, the firmness and bright orange color of the yolks is astonishing. Buying them at his local farmers market was competitive, and customers were lining up even before the market opened for a shot at the egg vendors.

How many people can say with certainty they know the source of their food, or its well-being? Just because the cartons at your grocer are labeled "cage free" or "free range" doesn't mean the contents came from birds liv-

ing idyllic lives. Even chickens that don't spend their lives behind bars are often kept in cramped quarters, and want for easy access to fresh dirt and the sun's warming rays.

"People like the fact their eggs are coming from chickens that were treated well, fed well, and lived a good life," observes Rob Ludlow, who runs the popular online community Backyard Chickens and is coauthor of *Raising Chickens for Dummies*. Some of those folks—including some vegetarians—keep the birds as pets, while others raise them for meat, or harvest them after they slow down egg production.

"My Pet Makes Me Breakfast," reads a popular Backyard Chickens T-shirt, but that's only one selling point. They also keep yards free of weeds and bugs without dangerous chemicals, and their nitrogen-rich manure makes great fertilizer (although it has to be composted first).

Although Adam's hens don't seem especially eager to be stroked or held—of the six, only Opal, is willing to be picked up without a struggle—Ludlow insists that the birds make good, inexpensive pets, displaying a surprising amount of personality. Docile breeds like Australorp, Rhode Island Red, and Plymouth Rock are even suitable around children.

Raising poultry at home is a manageable step toward sustainable living, even in tight quarters. Apartment dwellers have been known to build coops on roofs and fire escapes. If you are worried about space, experts recommend that, per chicken, owners allow four square feet in a coop and ten square feet in an outdoor run.[*] Chickens kept too close together will resort to pecking and fighting. That postage stamp you call a

[*] Because chickens are social animals, it's best to have a minimum of two birds. For a better idea of how to accommodate chickens, visit www.BackyardChickens.com and click on the Coop Designs tab; there are photos and building instructions for more than three hundred varieties.

backyard might not be big enough for a full-fledged vegetable garden, let alone grazing cattle, but it can accommodate a few hens. It's a way to enjoy an agrarian experience without getting all *Green Acres* about the whole enterprise.

Don't expect a massive reduction in your grocery bill, either. "There's a misconception that if you raise your own chickens, you'll be able to get your own meat and eggs cheaper." At best, if you're already buying free-range, organic eggs, you might break even. Depending on sex and breed, each baby chick will set you back between one and five dollars apiece, while pullets range between fifteen and twenty-five. Buying from agribusiness mass producers is actually easier on the wallet.

How generous your chickens turn out to be depends on several factors, including breed, age, and season. Some types are raised specifically for meat, others to lay eggs, and dual-purpose chickens do a little of both. Hens start laying at the age of four to five months and are most generous in their first year. A healthy chicken bred to lay eggs may turn out one a day at peak productivity. Chickens live between eight to ten years on average, and lay less frequently as they grow older. During the winter months, when daylight hours are shorter, hens produce fewer eggs.

Before you send off for a batch of hatchlings, order feed, and start building a coop, do a little homework. The legality of keeping chickens varies across the nation. Visit city or county government Web pages and plug in search terms like "poultry" or "livestock." If that doesn't work, call city hall and speak to zoning and health authorities. At this point, even the densest metropolises have fielded a few inquiries about chickens and should know what is or isn't permissible.*

You should canvass folks who live nearby first too. On the recommendation of a friend who already had chickens, Laura Smith surveyed all her neighbors before unleashing a flock in her South Carolina yard. Sharing

* If you don't like the answer you get, seek a second opinion. If the answer is still no, begin investigating why that is—and what would be required to change the law, at least enough to permit keeping a few hens. Children as young as eleven years old have succeeded in getting local chicken ordinances changed.

fresh eggs is a way to curry favor too. You may even make converts. "Many of our friends are impressed with us having chickens and dream of the same," says Smith. If local ordinances restrict the number of chickens per household where you live, perhaps an adjacent neighbor will consider joint ownership of a modest flock.

While you might romanticize the notion of being awoken by a crowing cock, rather than a glowing clock, your neighbors probably don't. Keeping roosters as part of a backyard flock is a civic nuisance at best and, depending on local ordinances, often illegal. But depending on where you purchase your newborn chicks,* or if you elect to hatch them in an incubator, odds are fifty-fifty you'll wind up with boys. So what's an urban chicken owner to do when they find themselves saddled down with unwanted males?

Post a notice on Craigslist, suggests Ludlow (who wound up with four cockerels out of five chicks in his first flock). "Depending on where their heart is, some people will say 'pets only' and hope somebody with a field out in Illinois will take a bunch of roosters and integrate them with their flock." Others simply opt for Don't Ask, Don't Tell. Or learn to "harvest." (After all, they are made of meat.)

Pickles and Preserves

Huge vats of boiling water. Unusual metal imple-
ments. The threat of deadly poison hanging in the
air. Welcome to the world of home canning.

Of all the domestic arts that have fallen
from favor over time, the decline of home
canning is one of the least mysterious. It
might sound quaint to hear your grand-
mother reminisce about "putting up"

* Hatcheries and feed stores generally only sell pullets and will refund or exchange cockerels (males under a year old). Straight-run—that is, "unsexed"—chicks are much cheaper, but you take your chances.

Hard Tack

What Is It? An extremely thick cracker, made from flour, water, and occasionally salt. Favored by seafarers, soldiers, pioneers, and explorers; pairs well with long journeys and no fresh food. Also known as sea biscuit, pilot bread, sheet iron.

Practicality: Virtually indestructible, so long as it stays dry.

Availability: Sailor Boy brand pilot bread, manufactured by Interbake Foods, is a popular snack in Alaska.

SUBLIME OR RIDICULOUS? *You'll never go back to Saltines.*

peaches, but what she'll also tell you is that home canning entails plenty of hard work.

Imagine spending a sweltering summer day in a steam-filled kitchen hovering over a variety of hot pots. Cutting and chopping and seasoning, working in tandem with neighbors and family, well aware that you'll have to repay their kindness and repeat this grueling cycle in someone else's home

a few days later. It's enough to make anyone reach for a can of supermarket tomatoes, or a stiff drink. "How generations of women managed to can together without killing each other, I'll never know," quips Jill Lightner, editor of *Edible Seattle* magazine. Perhaps this was because their well-being, or at least the state of their pantry during the winter months, depended on it.

As old-fashioned as it may seem, canning is actually a relatively new development in the long history of food preservation, and like so many innovations, it came about as a by-product of war. "An army marches on its stomach," said Napoleon Bonaparte, but in the late eighteenth century, French soldiers couldn't always rely on their field rations. Drying and smoking enabled meats and produce to keep longer, but the food was still vulnerable to spoilage. Nor did it taste as good as fresh fare, which had consequences for morale. In 1795, Napoleon issued this challenge: to the individual who could devise a better way to preserve food for long periods of time and across great distances, he would pay the princely sum of twelve thousand francs (roughly thirty thousand dollars today).

Enter Nicolas Appert, the father of canning. The French confectioner showed an abundance of one quality essential to canning: patience. He spent fourteen years experimenting and refining a process of putting prepared meats and produce into glass jars, sealing them with cork, wax, and wire, and bathing them in hot water for prolonged periods. When he'd perfected the technique, Appert sent jars of partridge, vegetables, and gravy to Napoleon's army, and in 1809 claimed his prize money . . . which he promptly reinvested in the world's first commercial cannery: the House of Appert. He also published *L'art de Conserver, pendant plusieurs années, toutes les substances animales et végétales* ("the art of preserving animal and vegetable substances for many years"), the original D.I.Y. canning manual.

Related innovations soon followed, including the tin can, which wasn't nearly as fragile as a glass jar. By 1819, canning had arrived on American shores, but it didn't gain popularity until another military campaign. During the Civil War canned food proved an invaluable resource for soldiers on the move.

Homemakers weren't equipped with the necessary machinery to literally

can food at home, but they could reproduce the original process, using jars made of glass, an element Appert had chosen because of its nonreactive qualities. In this manner, the fruits of the harvest could be enjoyed year-round. Beginning in the 1860s, hundreds of patents were issued for new or modified jars, seals, and lids. It was only around the 1940s, when commercial freezers became widely available as an alternative means of preservation, that home canning fell out of favor. Moreover, as women joined the workforce and spent less time in the home, they sought new ways to feed the family with ease. Commercially canned foods, boxed cake mixes, and other time-saving conveniences were a welcome addition to the family pantry.

But lo and behold, in 2008, sales of home canning supplies were up 30 percent, according to the folks at Ball Brand Fresh Preserving Products. As celebrity chefs, Food Network stars, and bloggers continue to tout the virtues of shopping locally and organically, home canning has gained momentum.* A 2009 survey conducted by number-one food Web site Allrecipes.com revealed that 55 percent of home cooks planned to can that year, most in larger amounts than in years previous. Moreover, almost half those surveyed were under forty years old. And nearly 50 percent lived in suburban areas, not rural towns.

The reason may be that many of us are overeducated and underemployed; learning to control our own food sources feels empowering. We are living in an era of scarcity. On a daily basis, the media remind us that basic necessities—clean air and water, efficient energy sources, ethical behavior by government leaders—are in short supply. Home canning celebrates the opposite: abundance. Not just of perishable, seasonal fruits and vegetables but of like-minded community members too.

For some, canning is a family activity. Brothers Bob and Joe McClure of McClure's Pickles learned their craft by gathering in a kitchen every summer with their grandmother, parents, cousins, and family friends. Others

* Hopefully, they'll follow through too. After all those canning demos, a year from now when Martha Stewart or Rachael Ray prepares on the air a recipe requiring tomatoes, they'd better well turn to their own pantry for a jar, rather than opening a can from Whole Foods.

host parties with neighbors, divvying up tasks to distribute the load, from providing jars and produce to supplying refreshments. "I find that when I do it myself, I'm more apt to do a small batch," says Brenda Schmidt, brand manager for Ball and a lifelong canner who learned as a girl in eastern Iowa. "If I have friends over, we're likely to say, 'Hey, we're all here together,' and pitch in, and perhaps partake in a beverage or two along the way. And that makes it more fun."

Canning by your lonesome can feel overwhelming, especially for a beginner. Working in a group ensures more than just a division of labor; it's also a surefire way to connect with others. When you're in a kitchen with other people for several hours, and everyone is responsible for a specific yet crucial part of the task at hand, bonding is inevitable.

In rural areas, there still exist community centers dedicated to this craft. Callaway Cannery, located in the Blue Ridge Mountains of Virginia, is one of many such venues that originally sprang up in the 1940s when mothers were working to keep their families fed while husbands were away at war, and manpower and fresh produce were at a premium. Today, Callaway is still in operation two days a week from July through December. Everyone arrives and leaves with his or her own produce and shares the equipment (including oversize kettles that can hold ninety-six quarts), helping one another to ensure that operations run efficiently.

Canning connects us to the cycle of the seasons, even in the most bustling metropolises. Staying abreast of what's in season also allows the smart home canner to maximize fruits and vegetables at the peak of their flavor, and at the best bargain. Sour cherries only appear at the farmers' market for a few weeks out of the year; turning those little red gems into jam will allow you to savor them for months. Properly canned, fruits will stay safe and flavorful for two to three years.

Making jam or jelly is only one type of preserving, even if it does overshadow others in popularity. A little marmalade goes a long way, says food writer and professional gardener Amy Pennington. "I don't think anyone eats that much toast. You don't need to turn everything into jam." There are other options, such as transforming apples into chutney instead of apple butter.

But even making jam is a step toward independence and a new perspective on the food chain, says Kim O'Donnel, the founder of Canning Across America (CAA). "If you only put up blueberry jam this year, because you love blueberries, you have made progress. You have not only learned a skill, but you have created a supply of something you like, celebrated abundance, and become empowered." The beginner now has the incentive and courage to try something more ambitious, and a better sense of how to prepare. Plus a cupboard full of blueberry jam.

Another factor behind the resurgence is concern about healthy living. When deadly *E. coli* and salmonella bacteria start showing up in unlikely places like spinach, peanut butter, and prepackaged cookie dough, and the best solution the government offers is irradiating groceries,* one can hardly blame the public for taking matters into their own hands. In another Allrecipes.com survey, 83 percent of folks who canned claimed, "It's worth a little extra time to make my own foods to control the ingredients my family eats." Putting up your own grape jelly instead of buying a jar of Welch's ensures it will be free of high-fructose corn syrup and packaged in a container less likely to become landfill. That might not immediately seem cost-effective, but can you put a price tag on peace of mind?

"For the past forty years or so, we just accepted that what was on the shelf was good for us," concurs Bob McClure, who's taught pickling classes at Brooklyn Kitchen. Now, in the Digital Age, consumers have the resources to verify or disprove those assumptions, and to take recourse if they don't like the answers they uncover. Preserving your own food is one way to do that. Where once food technology urged us to get out of the house, now

* Treating foods like red meat, poultry and fish, potatoes, and fresh fruit with gamma rays to extend shelf life and reduce or eliminate pathogens is an accepted practice in Canada and forty other countries, but has been slow to catch on in the United States (even though the Food and Drug Administration approved the process in the 1960s).

it's encouraging us (albeit sometimes inadvertently) to get back in our own kitchens.

But it's not as easy as 1, 2, 3. First, the kitchen must be equipped: mason jars; pots deep enough to submerge jars in boiling water; a fitted rack or grill to keep jars off the bottom of said pot;* metal tongs for lifting items in and out; a wide-mouthed funnel for filling vessels. You can find the requisite tools at fancy-pants kitchen boutiques, but if you want to truly be in the right frame of mind, make an expedition to a well-stocked hardware store instead.

There are a hundred little things to learn as you go; the difference between table salt and pickling salt;† the requisite acidity of vinegar for pickling;‡ how adding pectin to jams or jellies helps them set up firmly; the choreography of ladling hot liquid and sealing jars. However, the biggest obstacle that confronts the home canner is invisible to the naked eye: food poisoning.

Flip to the pages on canning, and *Joy of Cooking* becomes as terrifying as any Stephen King novel. Home canning, if done improperly, is potentially dangerous. Botulism might seem benign when Hollywood stars are injecting the toxin into their faces, but it's hard to shake fears of it while reading boldface warnings like "1 oz. could theoretically kill 100 million people" and "poisoning may be present even if no odor, gas, color change or softness in food texture indicates its presence." Super. You set out to make sweet-and-sour pickles and end up cooking Gherkins of Death.

Hold on a minute, no need to overreact. Pickles and most fruits are high in acidity,§ and botulism can't grow in an acidic environment. The main concern when pickling, or putting up high-acid fruits (apples, pears, peaches, grapefruit, and berries), is spoilage. The truly death-defying part of putting up your own food comes when you start home-canning low-acid fruits (such as figs or watermelon), vegetables, or meats. That requires a

* Contact with the bottom of a pot of boiling water can cause glass jars to crack or shatter.

† Additives, such as iodine, in table salt can turn pickles dark and brine cloudy. Now you know.

‡ To kill bacteria, 5 percent or higher is best. You'll find the number right there on the label.

§ When you pickle something, you're curing it in vinegar, which is acidic.

new piece of gear: a pressure canner. Water-bath canning can only get to temperatures of 212 degrees, which isn't hot enough to wipe out the bacteria lurking in many foods. Pressure canners go to 240 degrees, which knocks out all bacteria, including the dreaded *Clostridium botulinum.* If you choose to investigate canning low-acid fruits or other low-acid foods like meat, poultry, or vegetables, please do more research to ensure your safety.

Embracing pressure canning is the next logical trend as newcomers build confidence. Experts like Ball's Schmidt anticipate continued growth in both processes. People who have successfully mastered water-bath canning graduate to the next level, but at the same time there are going to be numerous individuals with some extra tomatoes and a hankering for salsa who'll see the success their neighbors had water-bath canning last summer, and take the plunge.

Making pickles and high-acid fruit jams are great warm-ups to more ambitious canning projects. This allows the beginner to become familiar with the process and safety requirements, and build confidence. "Putting up is not cooking," stresses O'Donnel. "It's processing. And for this cook, that was a learning curve. I quickly realized I had to really, really pay attention. Like your life depends on it."

There is a happy medium. You can learn to put up food without feeling like you're walking though the valley of the shadow of death. I figured out how to make pickles and not only lived to tell the tale, but cobbled together this crude recipe too. I wouldn't put them up against James Beard or Martha Stewart yet, but they taste great out of the jar and add zing to tuna or egg salad.

Easy Hot-N-Sour Pickles

8 medium cucumbers	Black peppercorns
Pickling salt	Bay leaves
Fresh dill	4 cups white vinegar
Bulb of garlic	4 cups sugar
Red pepper flakes	Pint jars, lids, and bands

1. Wash cucumbers. Cut cucumbers in half, then quarter each half, lengthwise, into four spears. (After cutting up that first cuke into spears, make sure they're short enough to sit in the jars you plan to use, with head space to spare. You may need to do some trimming or cut shorter spears.)

2. Place cucumber spears in a large bowl or tub. Cover with a mixture of 3 tbsp. salt per every 2 cups of water. Set bowl aside for 18 to 24 hours.

3. Drain salt water (brine) off cucumbers.

4. Wash jars, lids, and bands in hot, soapy water (even if they are new). Then immerse in boiling water for five minutes. Pull out with tongs, drain out any water, and let dry on paper towels. In addition to killing germs, this ensures the jars will be warm when you add hot liquid. Putting hot liquid in a cool jar could cause it to crack or shatter.

5. Heat sugar and vinegar over medium heat until sugar has completely dissolved.

6. Into one of the sterilized jars, place the following: one glove of garlic (cut in half); one bay leaf; three peppercorns; a pinch of red pepper flakes; two sprigs of fresh dill; and as many cucumber spears as will fit comfortably. That'll probably be between seven and nine spears.

7. Using a ladle, pour enough of the hot sugar and vinegar mixture into the jar to reach within one inch of the rim. Wipe clean the rim of the jar, or the jars may not seal correctly. Place lid on jar, and screw band securely in place.

8. Repeat steps 6 and 7 until all cucumbers are gone. Ideally you're going to get seven or eight jars out of this recipe. If necessary, heat up more vinegar and sugar in equal parts so you have enough liquid to fill each jar of pickles.

9. If you wish, you can simply place the pickles in the refrigerator and let the flavors develop there. If you'd rather be able to store them without refrigeration, process the sealed jars in a boiling water bath (as outlined in any reputable cookbook or canning guide) for five minutes. This may result in a slightly less crunchy pickle; however, it will also help overcome any fears you harbor about water-bath processing (a skill you'll need to master in order to make anything beyond pickles and some jams).

10. Regardless of whether you cold process or use the water-bath method, let pickles sit for two weeks before opening. Either way, they should keep for about six months. Opened jars should always be kept refrigerated.

Generations of women, and some men, gleaned canning basics from family, friends, or home-economics instructors. Even if your mom never got closer to making pickles than popping the lid off a jar of Vlasic dills, there are many resources today, from afternoon classes hosted at farmers' markets or restaurants, to academic extension programs and the National Center for Home Food Preservation (part of the USDA). It was inevitable someone would connect them all.

Food writer and cook Kim O'Donnel taught herself the basics of canning in 2007 and documented her adventure online for the *Washington Post*. Two years later, she had moved to Seattle but hadn't kept up her canning. Eager to refresh her skills, and inspired by the example set by Yes We Can, a Bay Area collective that hosted monthly community canning seminars, she floated a simple idea on Twitter: What if the Emerald City tried something similar? In minutes O'Donnel found herself deluged with excited replies. Not just from Seattle, but from all over the nation. "My Twitter-verse lit up like a Christmas tree," she recalls. Twenty-first-century technology had breathed new life into a practice that dated back to Napoleon.

Thus Canning Across America was born. The idea: set a specific date to celebrate home canning in Seattle, prime the pump with demonstrations and classes before the big day, and urge folks in other cities to get involved too. O'Donnel and her colleagues roped in cooks, writers, gardeners, and food lovers from across the country.

Inundated with inquiries, Canning Across America quickly graduated from a single e-mail address and rudimentary blog to a bustling Web site. Today their site reflects the core value of abundance, with an embarrassment of links to relevant resources, how-to demonstrations, recipes from restaurant chefs, and a calendar of events all over the nation, from big cities to small towns. The latter is especially important to O'Donnel. "I want Canning Across America to exude inclusiveness." Celebrity chefs, community

punk rock houses, stay-at-home parents who never learned from their own mothers or grandmothers—all are welcome.

Moving forward, O'Donnel hopes CAA will include a mentorship program, where experienced canners will "adopt" neophytes, leading them through the process safely, and foster new groups. "This [is] not some new foodie cult," she concludes. "We want everybody involved." People—and pickles—have the power.

A Food Chain Grows in Brooklyn

What Paris's Montparnasse was for writers and artists between the world wars, Brooklyn has become for purveyors of artisan edibles. In 2009, media including the *New York Times*, Food Network, Martha Stewart, and even a Korean TV travel show all descended on Brooklyn with fervor.

Why Brooklyn? New York may be a huge city, but like the East Village in the late 1970s and early '80s, the borough has a close-knit creative community, which has given rise to a network of restaurants, shops, and vendors. In a densely populated neighborhood such as Williamsburg, similar food lovers cross paths at focal points such as the Brooklyn Kitchen, which stocks kitchenware and hosts a variety of classes, and bump into one another on the sidewalk.

Another breeding ground for this movement has been the Brooklyn Flea, a weekend flea market that began in the Fort Greene section in 2008,

then added a second market—under the Brooklyn Bridge—in 2009.* In addition to vintage clothes, antiques, and architectural salvage, founders Jonathan Butler and Eric Demby wanted to be sure the Brooklyn Flea reflected key cultural movements in the borough: music, crafts, and food. Mixing them all together encourages cross-pollination, both within and across specialties. At Brooklyn Flea, customers can sample wares from vendors like People's Pops (handmade Popsicle-type treats made with fresh, local fruit, in flavors like watermelon basil and strawberry rhubarb and honey) and Pizza Moto (a mobile, wood-fired brick oven pizzeria), and socialize with the artisans behind the food. Vendors probably won't divulge trade secrets, but they are quite adept at answering all manner of questions—from where ingredients are sourced to basic preparation processes—while making change and doling out napkins.

The traditional methods utilized by many of these foodies also reflect the historic character of the borough. "The Flea people love Brooklyn partly because it does have all this history, and that is incorporated into what people are doing now," says Demby, who vets all the dealers at the market. Whether they have decided to make their own mozzarella, roast coffee, or bake granola from scratch, the movers and shakers of this movement feel ties to the past.

Outside of the Flea, the best place to seek Brooklyn-made items is still at neighborhood boutiques like Urban Rustic, Marlow & Daughters, and Blue Apron Foods, but a few companies have expanded beyond the borough with only minimal growing pains. McClure's Pickles, another popular favorite at the Flea, is now carried nationally at Whole Foods and Williams-Sonoma, and Frankie's Extra Virgin Olive Oil (a cold press oil made from organically grown Sicilian olives, courtesy of the folks at Frankies Spuntino restaurant) is available at shops in six states, including Whole Foods throughout New York. Nevertheless, Bob McClure is conscious of only dealing with retailers who appreciate that his operation is a small, family business. Supermarket shoppers aren't accustomed to seeing empty shelves,

* Both are open April through December. From January to March, Brooklyn Flea sets up shop indoors at One Hanson, on the corner of Flatbush Avenue.

yet small-batch producers can only crank out a limited volume of goods. "We want those customers who understand, who might walk in and say, 'They don't have it? Okay. They don't have it . . . and I'll wait for it.'"

Betsy Devine and Rachel Mark, the Boerum Hill cheese makers behind Salvatore Bklyn, invest tremendous energy into meeting demand for their handmade ricotta. "I spend a lot of time making cheese, and packing it, and labeling," admits Devine. "Machines would save a lot of time and effort, but for some weird reason, I find these activities to be Zen-like." Their commitment has earned them a protective layer of goodwill with the dozen New York shops that carry Salvatore Bklyn too. "If there is ever a problem, everyone seems to understand that we are only really two people, and we are doing the best we can. At the end of the day most of our customers value that, and want that more often."

When Rick and Michael Mast of bean-to-bar specialists Mast Brothers Chocolate started their venture, the requisite equipment for small-batch chocolate manufacturing was impossible to find anymore, so they improvised. "We were repurposing rice grinders, juicers, grain mills, anything that could do the job," Rick says. The traditional processes involve grinding the chocolate using stone, so now the brothers use a mechanized version, rolling two large granite wheels over a granite bed. They feel the final product merits the extra effort. "This slowly refines and conches the chocolate, keeping the complexity and unique character of each chocolate intact." Mast Brothers sources its cacao from small family farms and co-ops in Venezuela, Madagascar, the Dominican Republic, and Ecuador, which Rick claims costs ten times as much as purchasing West African commodity cacao.

The Mast Brothers don't sell at Brooklyn Flea, but they do go so far in their community outreach as to open up their Williamsburg factory to regular tours, to spotlight how what they do is very different from Hershey's. "Most people that walk into our shop have never seen a cocoa bean before and have never been taught how chocolate is made. It is an incredible opportunity and privilege that we are able to show the process in such an intimate environment." Their small operation, housed in a factory more than a century old, is designed to encourage a family feeling among the staff, and even that component of the venture is on public display. "We all take time

Butter Churn

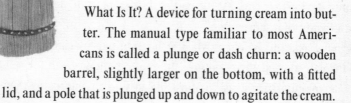

What Is It? A device for turning cream into butter. The manual type familiar to most Americans is called a plunge or dash churn: a wooden barrel, slightly larger on the bottom, with a fitted lid, and a pole that is plunged up and down to agitate the cream.

Practicality: Churning butter by hand remained common practice in the rural Midwest into the early 1940s. The process is simple but laborious and time consuming. Food lore is full of rhymes, songs, and superstitions to "encourage" the butter.

Availability: If you just want to make your own butter by hand, small modern churns, akin to egg beaters fused to mayonnaise jars, are available from specialty vendors.

SUBLIME OR RIDICULOUS? *We have better things to do while sitting on the porch.*

to make lunch together every day, and sit together, talk, and eat at our large communal table up front."

The benefits of choosing the sort of personalized experience that comes with patronizing smaller producers—in Brooklyn or anywhere else—go beyond a mere spike in blood sugar levels. Frequenting a local butcher, baker, or produce stand might not be as immediately convenient as swinging by a big chain grocery store, but interacting with community members who know exactly what they're selling and take pride in it fortifies and enriches us too.

Butchers

If you don't live in a big city, you may never have frequented a genuine, stand-alone butcher shop, but once upon a time they were a Main Street fixture in most towns. Competition from full-service supermarkets changed that, although initially the butchers behind the meat counter at your neighborhood Safeway or A&P fulfilled much the same role, breaking down whole carcasses and slicing cuts to customer order.

Then even supermarket butchers began to fade into the background, and much of their work moved behind closed doors or off-site. Laid out on Styrofoam trays and wrapped in cellophane, meat—now carefully treated with carbon monoxide gas to maintain the rosy-red appearance of freshness longer—was something we bought from refrigerated cases. In meat processing plants, as Eric Schlosser detailed in his eye-opening book *Fast Food Nation*, reducing sides of beef into rib eyes and roasts became an assembly-line task, rather than an individual undertaking by a skilled professional.

Now the pendulum has swung back. "Young Butchers Gain Rock Star Status in the Food World," proclaimed a headline in the Dining section of the *New York Times*. Many, such as San Francisco's Ryan Farr and Brooklyn's Tom Mylan, come from a restaurant background, while others, such as Boston native Adam Tiberio (the butcher for Dickson's Farmstand Meats, at New York's Chelsea Market), started in markets and slaughterhouses. "Part of our job is really to reeducate people," says Mylan. "We're teaching

them how to cook like the eighteenth century, not the twentieth century."

In the past, butchering was a family trade, passed down between generations. Now young aspirants may seek apprenticeships, or even shell out to learn basic skills. Mylan studied the ins and outs of meat hooks and hacksaws from Josh Applestone, one of the owners of Fleisher's Grass-Fed and Organic Meats, in Kingston, New York.* On his Tom the Butcher blog†, Mylan hosts a photo essay from a January 2008 "winter vacation": killing, bleeding out, gutting, and sawing in half a 260-pound pig. Was this blood-spattered hulk the same Brooklyn boy who'd previously specialized in cheese making and managing upscale groceries?

The customer service component of visiting a boutique butcher has not been lost on big business. Several supermarket chains have made a push to bring their cutters out of the back room and reconnect them with shoppers. Southern Family Markets hosted a Beef Training Camp where managers were schooled in how to grill trendy yet economical flat iron (or lifter) steaks. Supermarket chain Kroger began showcasing meat department staff on billboards and in radio and TV spots.

The shift away from mass production and McDonald's, and back toward "Old MacDonald Had a Farm," means taking responsibility for using the whole animal. Pigs are not composed entirely of bacon, nor chickens of skinless, boneless breasts (though certainly there are unfortunate animals, raised on industrial farms, that have been bred to produce more of these favorites). Transforming the rest into something other than hamburger meat or animal feed has inspired something else tasty: nose-to-tail eating.

Oxtail soup, steak and kidney pie, and tripe (cow stomach) are all examples of traditional British cuisine with a nose-to-tail sensibility. In Great Britain, the H. J. Heinz company (the same "57 Varieties" manufacturers of ketchup) has been supplying savory oxtail soup to grocery stores since

* Julie Powell, of *Julie & Julia* fame, also made a pilgrimage to the Hudson Valley to study at Fleisher's. Now they charge ten thousand dollars for a six- to eight-week course in butchery.
† http://tomthebutcher.blogspot.com/.

1930. Perhaps it's no wonder that one of the seminal figures in nose-to-tail eating is also British. English chef Fergus Henderson opened St. John restaurant in London in 1994, with a bill of fare that deliberately emphasized offal and cuts of meat often treated as waste during prosperous eras, and rarely found in white-tablecloth country. Serving duck hearts, pigs ears, and even squirrel raised eyebrows, but it was philosophy that fueled Henderson's cooking. Here was a way of looking back to traditional British dishes but also forward to a more sustainable approach to eating.

Other restaurants embraced the idea too. Purchasing whole animals is cheaper. Tom Mylan—who now oversees Brooklyn butcher shop the Meat Hook—first made his name working at Brooklyn hot spots Diner and Marlow & Sons, two of several eateries owned by Mark Firth and Andrew Tarlow. The team was already committed to sourcing meat from small farms nearby, but in 2007 they began ordering whole carcasses. Representatives from all of Firth and Tarlow's establishments gathered weekly to divvy up all the bits and pieces of whole pigs and cows among four different kitchens.

The challenge of transforming uncommon cuts of meat into appetizing fare involves some sleight of hand—or at least nomenclature.* When Ryan Farr was working as a chef for San Francisco restaurants like Fifth Floor and Orson, he learned the value of what's in a name. No matter how elegantly he seasoned and prepared it, "headcheese" (a jellied meat dish made from calf or pig's head) didn't fly out of the kitchen. The solution? "I'd say I'd worked up a pork rillet."

Butchers and chefs have also taken pains to help diners connect the dots between what lands on their plates and how it began life. In 2006, Tamara Murphy, owner and chef at Seattle's Brasa, invited foodies to join her on a special journey, a scrupulous account of a meal's progress from cradle to table she called Life of a Pig. Beginning in January, she blogged about her regular visits to Whistling Train Farm, the birth and progress of

* As a kid, I remember my cousins once convinced me to order sweetbreads off the menu in a Canadian restaurant. I happily ate several mouthfuls until my sniggering relatives told me I was eating . . . brains!

her piglets, how they were fed and raised . . . and, in the most moving post, their eventual slaughter. The story culminated with a feast that combined familiar pork items (grilled loin, smoked ribs) with tasty uses of fatty skin (cracklings in a salad), and legs and feet (pozole); trimmings and organs were transformed into pâté. Pork even found its way into dessert, in the form of baklava layered with a filling of bacon, nuts, and dried fruit.

Even the most curious epicure might be daunted by a lamb's head, just as the odds and ends sold alongside the familiar bits of a whole or half chicken can intimidate a neophyte. Don't panic; your butcher wants to help. Why discard bones when you could roast them and make soup stock? Toss the roasted bones in a pot, boil them with some carrots, celery, and onion, and strain it off.

Preparation of chicken backs and pigs' trotters (a quaint name for feet) may not figure prominently on the Food Network, but at least the answers are within easy reach. Older cookbooks are full of instructions on how to use offal and less common cuts that are part and parcel of purchasing a whole animal.

"I love to butcher meat," admits Farr. The proprietor of San Francisco's 4505 Meats reiterates this sentiment with a regularity that is disquieting, and pressing him to elaborate doesn't immediately calm the nerves. "I just find taking this whole animal and dissecting it really enjoyable."

Farr, who is self-taught in butchery, takes a Zen approach to figuring out what the meat should be. He is the first to admit that his idea of a pork chop may not match specific USDA guidelines. "Coming at it as a restaurant chef, I looked at the whole animal, and said how can I use all this? And I trained myself." Now he shares his skills with others. His blog is full of illustrated tutorials on how to cut up and prepare various meats, use knives correctly, and other essentials.*

As useful as butcher blogs may be, nothing beats hands-on experience. Like many of his peers, including Mylan and Tiberio, Farr passes along his skills in classes and workshops. Folks who sign up to learn how to cut up a whole pig aren't shy or squeamish, he says. "They're there to get their hands dirty, grab a knife, and start cutting it up." Once the hog is laid out on the

* www.4505meats.com/bestbyfarr/.

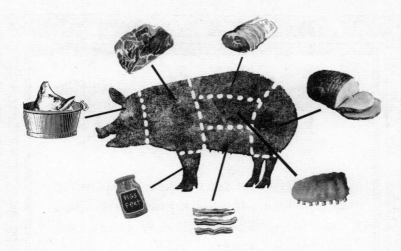

butcher's table and he's made the first cut or two, Farr steps back and guides his pupils. They start by cutting off the head ("it's the perfect icebreaker"), then peel off the face and remove the tongue. Brains get scooped out, to be fried up later for snacking. From there the pig is divided into large sections (primal cuts), and students go off to individual stations to continue breaking down the pieces into smaller cuts. Everyone goes home with a hefty parcel of meat, skin, and bones . . . and plenty of conversation fodder.

Okay. So the modern butcher is definitely pretty cool. But the rock stars of the food world? Well, yeah. Because another big outlet for these men and women are public appearances at bars (like Bloodhound in San Francisco), barbecues, or parties, and just like at a kick-ass gig, sometimes the audience loses control. Watching the meat for their dinner being cut up before their eyes and then cooked over an open fire triggers some primal instinct in civilized city dwellers (especially when augmented with booze), and elbows start flying as folks dive for roast pig or hamburgers.

But do not be confused. If breaking down an animal into individual parts and using every one of them brings a butcher or cook one step closer to appreciating and respecting the living creature that provided this bounty, actually slaughtering it induces even more profound changes. "There's a big difference when the animal is warm and still alive, to when it's cold and in your refrigerator," says Farr. That's coming from a guy who has killed his own bunnies for an Easter supper.

Salt Pork

What Is It? Pork cut from the sides or belly of the pig, and preserved by salting. Unlike bacon, salt pork is not smoked. Along with hardtack, a staple of long sea voyages and Civil War rations.

Practicality: Back in the day, it was revered because it remained edible for a year or longer when stored properly. Also an easy way to add meaty flavor to beans or greens.

Availability: Just ask your butcher. Cheaper than bacon, and still an ingredient in many budget-minded New England dishes, such as baked beans or clam chowder.

SUBLIME OR RIDICULOUS?
Salty, fatty pork. What's not to love?

Forget the flashy aspects, the talk of rock stars and flying knives and blood spatters; by educating diners about their flesh-and-blood food sources, the modern butcher raises our appreciation for life—and making the most of it. Every last scrap. These men and women are butchers, but not barbarians.

3

Time
in a
Bottle

Cocktails
and
Spirits

History in the Mix

There are some misguided fools who actually believe the cocktail was invented during Prohibition. Balderdash! The so-called Noble Experiment damn near drove cocktail culture off the rails. As David Nelson of Seattle bar Tavern Law puts it, "Most drinks made in America during Prohibition were simply bad."

During Prohibition cocktails were also incredibly popular. That's because between 1920 and 1933, when alcohol was illegal in the United States, the general public was reduced to drinking inferior, bootleg hooch, and the best way to mask the taste of rotgut was to shake it up with other ingredients. But mixed drinks had been around since antiquity, and what we would consider "cocktails" today had already been thrilling America for more than a century before passage of the Eighteenth Amendment.

The etymology of the word *cocktail* is tangled up in dozens of myths, with credit going to everyone from Revolutionary War–era innkeeper Betsy Flanagan to an early–nineteenth-century Mexican beauty named X'ochitl. Spectators of eighteenth-century English cockfights quaffed a tonic called "cock-ale," made by infusing ale with a pulverized rooster, raisins, and spices; they also fed this brew to the feathered combatants, to get them riled up. According to another origin story, there was a drinking establishment in an American harbor town that kept a ceramic rooster on the bar, into which unfinished drinks were emptied; rummies could purchase a shot of this potent mix, dispensed through a tap in the bird's tail, at a discount.

Two French words, *Coquetel* (a mixed drink from Bordeaux popular with French officers during the American Revolutionary War) and *coquetier* (tiny egg cups that a popular nineteenth-century New Orleans apothecary served drinks in during his parties), have also been cited as possible roots of *cocktail.*

Whatever the derivation, the earliest documented use of *cocktail* in a form Americans can grasp pops up in 1806 in a political periodical called *Balance and Columbian Repository*, which described it thusly: "Cocktail is a stimulating liquor, composed of spirits of any kind, sugar, water, and bitters. . . ." In 1862, "Professor" Jerry Thomas issued the first bartenders' guide, *How to Mix Drinks, or The Bon Vivant's Companion.*

The terms *cocktail* and *mixed drink* have become synonymous in the twenty-first century, but in the early days of mixology there was a whole family of other mixed drinks. Thomas's *How to Mix Drinks* addresses a half-dozen other types of alcoholic concoctions besides cocktails. Here are some other classic tipples.

PUNCHES: The granddaddy of mixed drinks, punch migrated from India to England via British sailors in the early seventeenth century. A far cry from the sickly sweet ginger ale and sherbet brew served at children's birthday parties, old-school punches were a mixture of spirits, water, sugar, spices or tea, and fruit or juice, served in a large bowl and enjoyed communally.

SOURS: Sours are among the simplest mixed drinks, just booze tempered with lemon or lime juice and sugar or another sweetener. The traditional daiquiri—rum, fresh lime juice, and simple syrup—is one yummy example.

DAISIES: Sweeten a sour with a liqueur or cordial, pour it over crushed ice, and garnish with fruit, and you've got a Daisy, a favorite dating back to the mid-nineteenth century. Think of the daisy as a forerunner of the margarita.

FIZZES: A sour topped off with soda water is a fizz. The gin fizz— gin, lemon juice, sugar, and carbonated water—is the classic, along with variations such as the Ramos gin fizz (which throws cream and egg whites into the glass) and sloe gin fizz.

BUCKS AND MULES: Add a splash of sparkling ginger ale or ginger beer, and a sour becomes a buck (ginger ale) or mule (ginger beer). The Moscow Mule, a potent mix of vodka, ginger beer, and lime juice, popularized vodka in the United States during the 1950s.

COBBLERS: A base spirit (often wine) mixed with sugar and fresh fruit, and served over freshly cracked ice. Cobblers are closely related to daisies but use little or no citrus juice. The popularity of the cobbler in the latter half of the nineteenth century owes much to its use of ice and drinking straws, both novelties at the time.

TODDIES: Hot mixed beverages designed to banish a chill fall into the toddy category. Boiling water is combined with sugar or honey, spices or lemon juice, and then spiked with booze, typically whiskey or sherry.

As tasty as those beverages may sound, by the time Thomas published *How to Mix Drinks*, America was already a nation divided over the issue of alcohol consumption. The temperance movement, an array of religious and social organizations that decried alcohol, particularly hard spirits, as a corrupting influence, had been gaining momentum throughout the nineteenth century. In 1881, Kansas became the first state to outlaw liquor in its state constitution. Temperance leaders found a poster girl in Carrie Nation, a six-foot Kansas hotelier (and the ex-wife of an abusive drinker) who took to descending upon saloons with a hatchet.

In 1920, the Eighteenth Amendment made the manufacture, sale, and transportation of alcohol for consumption illegal. Alas, Prohibition created even more problems than drinking had. Right from the start, Congress failed to allot sufficient resources to enforce the so-called Noble Experiment, with spirits from Canada, Mexico, and the Caribbean being smuggled in and sold at an exorbitant markup. The rest of the demand was met with inferior, homemade liquor: moonshine or bathtub gin. Citizens who wanted

to enjoy a drink "with others" now had to patronize illegal bars known as speakeasies.

From a sociopolitical standpoint, speakeasies had their merits: they opened drinking establishments to women and minorities. However, they also fostered the violent rise of organized crime. (Al Capone controlled ten thousand speakeasies in the Windy City by the end of the 1920s.) Plenty of injuries and deaths were also attributed to homemade or doctored hooch, which could accidentally be tainted with toxins such as lead as a result of ramshackle distillation techniques.

Nor were these gin palaces necessarily palatial, jumping to the sound of hot jazz. Sometimes they were little more than a few rickety tables, propping up grim-faced patrons, and many were simply average. Take this description, from *The Speakeasies of 1932* by Al Hirschfeld and Gordon Kahn: "The room is plain and square, once a loft over a garage. The walls are beaver board. The ventilation leaves much to be desired." And that's a joint they liked!

Prohibition grew increasingly unpopular as the Great Depression rolled on. On December 5, 1933, President Franklin D. Roosevelt signed the Twenty-first Amendment, which effectively ended the failed experiment.* And not a moment too soon: alcohol consumption had actually increased by 11 percent nationwide during Prohibition.

But the fine art of the American cocktail didn't rebound robustly. The damage done by thirteen years of poor-quality spirits shaken up with all manner of mixers was too extensive. "Prohibition was the cocktail lobotomy," says Robert Hess, author of *The Essential Bartender's Guide* and the driving force behind long-running cocktail blog DrinkBoy.† Years of accumulated knowledge and experience had been excised from the national consciousness with the stroke of a pen. Whiskey distilleries closed. Out-of-work bartenders had sought other employment; the best of the lot went abroad, to Europe and Cuba.

* It left the ultimate decision of controlling and legalizing the sale and purchase of alcohol to the states, resulting in a patchwork of different laws nationwide.

† www.drinkboy.com/.

After alcohol was legalized again, too few Americans understood the delicate balance of quality spirits and other ingredients required to make a premium drink. Originally a martini was made with gin and a generous amount of vermouth (a fortified wine, infused with herbs and spices, and much loved for its ability to reconcile different flavors in a cocktail glass). But public figures such as Ernest Hemingway and Winston Churchill convinced the public that the only way to order a martini—the most popular cocktail in 1934—was with as little vermouth as possible.* W. C. Fields claimed it was best just to let the shadow of an unopened bottle of vermouth fall over the martini glass. Great for laughs, terrible for the liver—and the taste buds. Think about it: all the other traditional base spirits are often consumed as is, simply as a shot or neat or on the rocks, no mixer required, but have you ever known anyone to order a glass of cold gin? Yuck. Yet that's what most folks thought a "dry" or "extra-dry" martini was supposed to be.

The end of Prohibition also saw the rise of vodka in the United States, after production of Smirnoff began in North America in the 1930s. A triumph of modern marketing, the odorless spirit quickly gained traction in the '50s, thanks to its reputation for leaving drinkers "breathless," that is, without a telltale hint of booze to tip off the wife or boss. And because vodka is inherently flavorless, it made a great substitute in cocktails that featured other base spirits that had since fallen from favor. Voilà! The so-called vodka martini.

"Vodka is the training wheels to cocktails," says Hess. Alas, today all manner of vodka-based atrocities are mixed and served under the umbrella name "martini." Does Hershey's syrup really belong in a mixed drink any more than motor oil? And yet there it is, on many bar menus: The Chocolate Martini. The Apple Martini. The Bacon Martini.

The march of the "martinis" infuriates A. J. Rathbun, author of the award-winning drinks anthology *Good Spirits*. "Back in the classic cocktail era, there were so many great names." Who wouldn't want to belly up to the

* Papa purportedly preferred his martinis mixed at a ratio of 15 to 1, while the prime minister merely nodded in the direction of France while pouring straight gin.

bar and order Her Sarong Slipped or Elephants Sometimes Forget? "Even if you just changed the type of bitters or vermouth, you would come up with a new, interesting name, because cocktails were an artistic form." Like any artwork, be it poem, play, or film, each drink deserved a distinctive moniker. Calling any old concoction in a martini glass a martini? Lazy. "It just shows a lack of imagination. And good cocktails are driven by imagination and taste."

The Basics

Walk into a well-stocked drinking establishment and you'll be confronted with dozens, possibly even hundreds, of different bottles on display, but don't be fooled by the numbers. There are only six main liquors used as the basis for almost all mixed drinks.

WHISKEY: A spirit distilled from a mash of fermented grain—rye, barley, corn—and aged in wooden casks, particularly oak. European monks brought distillation to Ireland and Scotland in the eleventh to thirteenth centuries, and had the art of making whiskey (or *uisge beatha*—that's Gaelic for "water of life") cornered until Henry VIII decided to kick the Catholics to the curb circa 1530, and closed the monasteries. In the States, heavy taxation on the spirit prompted the Whiskey Rebellion of 1794, one of the first tests of George Washington's presidency.

GIN: A colorless spirit made of grain alcohol flavored with juniper and other aromatic botanicals (for example, cinnamon, citrus peel, fennel, anise, cardamom). What in heaven's name prompted folks to start infusing their hooch with berries harvested from cypress trees and bushes? The Black Plague. In the fourteenth century, juniper was thought to keep the Grim Reaper at bay, and the Dutch made a fortune cooking up and exporting what they called "genever."

The English were particularly taken with it—during the eighteenth century, the popularity of gin nearly brought the nation to its knees, hence its nickname "Mother's Ruin."

RUM: The origin of rum goes back to Christopher Columbus, who first planted sugarcane on the island of Haiti. Originally known as "kill-devil" (either for its medicinal properties or nasty hangover, depending on whom you ask), rum is distilled from fermented cane spirits, specifically molasses and sugarcane juice, by-products of making granular white sugar. Prior to the Revolutionary War, rum made with molasses from the British Caribbean island was colonial New England's number-one commercial industry; whiskey overtook it in U.S. popularity only following trade restrictions with the British territories in the Caribbean. Military conflict brought rum back into favor too: during World War II, when European liquor was scarce and U.S. efforts were focused on the military, our neighbors in the Caribbean—where, coincidentally, there were fourteen military bases—were happy to fill the void.

BRANDY: The oldest distilled liquor made from wine or fermented fruit juice. The name comes from the Dutch *brandewijn* (burned wine), but the roots of brandy lay in the Moorish invasion of Spain in the eighth century, when the new tenants started distilling local wines to try to make medicine. *Cognac* refers to brandy from a particular region in northern France. Other popular French brandies include calvados (apple) and framboise (raspberry). Because fruit is more expensive to raise than grain, brandy traditionally carries a higher price tag, hence its affiliation with the upper classes.

VODKA: A colorless, neutral spirit composed of just water and alcohol made from potatoes, wheat, barley, rye, or other grain, is the number-one spirit in America today. For centuries prior to conquering the United States, vodka—which is a diminutive of the Russian word *voda* (water)—was the firewater of choice throughout the frozen northern nations of Europe: Russia, Poland, Scandinavia. Although its origins can be traced back to the Middle Ages, vodka's

first recorded mention in Western cocktail culture is a brief recipe in the 1930 edition of *The Savoy Cocktail Book*.*

TEQUILA: Another late addition to American cocktail culture was tequila popularized by the margarita after World War II. Though not even a big deal in its country of origin until after the Mexican Revolution, tequila had been around since the early sixteenth century, when Spanish conquistadors distilled a liquor called mescal from pulque, a milky spirit made from the fermented sap of assorted varieties of agave. *Tequila,* which means "the place of harvesting plants," specifically refers to premium agave spirits (by Mexican law, tequila must be made only with blue agave) distilled in and around the city of Tequila, in western Mexico. (Tequila is a regionally specific type of mescal, sort of like how cognac is a regionally specific French brandy.) Oh, and the worm? It's not really a worm, it's a butterfly caterpillar that dwells in the heart of the agave, and it was a gimmick for promoting other types of mescal, not tequila.

The Bitters Truth

In the 1980s and '90s, individuals like Dale DeGroff, who took a gourmet approach to reviving classic cocktails at the Rainbow Room in New York, and *The Joy of Mixology* author Gary Regan began to leaf through the back pages of bartending history. They discovered a realm of forgotten oddities: falernum, orgeat, calvados, and other syrups and spirits that had all but disappeared from bars. Some were no longer manufactured or existed only in mass-produced incarnations that lacked pizzazz. What most tipplers knew as grenadine, for example, was a far cry from its ancestor, having mutated from a distillation of pomegranate or cherry juice and sugar to high-fructose corn syrup tainted with artificial flavors and colors.

In many cases, though, original recipes for these arcane potions could still be found. Thomas's *How to Mix Drinks* is teeming with basic how-to information, even though the proportions and instructions are often vague.

* If you can call serving a chilled shot a recipe.

Apple Brandy

What Is It? One of the earliest popular spirits in the United States. Not to be confused with calvados, its better-known French cousin, or applejack (aka "Jersey Lightning"), which is blended with neutral spirits (that is, grain alcohol).

Practicality: The cocktail renaissance sparked renewed interest in this forgotten potation. Try it unaccompanied after a good meal, or mixed with grenadine and citrus in a Jack Rose.

Availability: Laird & Company (established 1780) is synonymous with American apple brandy. Small, regional variations, including Clear Creek Eau de Vie de Pomme, made in Oregon, get high marks from critics too.

SUBLIME OR RIDICULOUS? *An ideal choice for those autumn months when it's too chilly for gin or vodka but not quite bourbon season yet.*

Resourceful mixologists rejected the ready-made and started augmenting their bar arsenal with fresh, forgotten components. Today the most popular of all is one that goes back to the earliest definition of cocktails, the one we find in 1806: bitters.

If you took the SAT exams back in the twentieth century, you may recall the curious puzzle "Salt is to food, as bitters are to [blank]."* Even many ardent boozehounds don't know exactly what bitters are made of, or why bartenders swear by them. Heck, their formal name alone, "aromatic bitters," is confusing. Do you smell them or taste them?

"Bitters are the magic ingredient," explains blogger and author Robert "DrinkBoy" Hess. "Technically, anything called a cocktail, by definition, has to have bitters." Up until Prohibition, it was a given that anything you saw that was in the cocktail section of a bartender's guide had to include bitters.

A few dashes of bitters is the key to many enduring cocktail recipes, including a classic martini and the Manhattan. You think the preferred drink of New Orleans is honestly the Hurricane? Get off Bourbon Street, man, and try this beloved standard instead:

The Sazerac

Crushed ice
1 teaspoon Pernod, Herbsaint liqueur, or absinthe
Ice cubes

* What scholar had the bright idea that high school juniors knew how to mix a proper old-fashioned anyway?

1 teaspoon sugar, 1 teaspoon simple syrup, or a sugar cube
1½ ounces rye whiskey
Peychaud's Bitters
1 lemon peel twist

Add the Pernod, Herbsaint, or absinthe to a chilled old-fashioned glass; swirl it around to coat the entire sides and bottom of the glass. Discard the excess. In a cocktail shaker, add four or five small ice cubes, sugar or simple syrup, rye whiskey, and two or three dashes of bitters. Shake gently for about 30 seconds; strain into the prepared old-fashioned glass. Twist lemon peel over the drink and then place in the drink.

Around for centuries, bitters are tonics made from herbs, bark, and other natural ingredients, such as cherry bark, vanilla bean, citrus peel, mint, and quinine, suspended in alcohol or glycerin. Originally they were hailed for their medicinal properties. Remember those guys shilling "miracle elixirs" from the back of wagons in old Westerns? Those are bitters, and they really do work, to a degree. Mix a few drops with soda water to settle an upset stomach.

The secret ingredient that made a lot of bitters so effective was alcohol, sometimes up to 90 percent. That'll steady your nerves for sure! In 1906, the new Pure Food and Drug Act had the gall to demand that these so-called remedies start living up to their claims, and the number of bitters manufacturers dropped off.

After Prohibition, only a handful of commercial bitters existed: the leading brand was Angostura, while intrepid connoisseurs might seek out Peychaud's or Fee Brothers. As cocktails of yore return to modern menus, craft bartenders and small businesses have begun manufacturing new varieties. Modern small-batch bitters makers, though, share more in common with the artisan foods community than the hucksters of pioneer days.

Miles Thomas, maker of Scrappy's Bitters, had been bartending at top-notch Seattle restaurants when, to distinguish his drinks from the competition, he began making his own infusions,* liqueurs, and bitters. It wasn't until he was invited to a bitters exchange in early 2009, where twenty local mixologists got together and swapped their handmade wares, that he decided to sell his bitters commercially. His first week in business, he sold through his entire stock.

Scrappy's basic line includes seven main varieties, including grapefruit, chocolate, celery, and Thomas's signature blend, lavender. He experiments with new flavors, such as cola and *amère* ("a bitter caramel orange"). His root beer bitters have been especially well received. Customers began pulling out their wallets and offering big bills in exchange for tiny, half-empty bottles. Scrappy's Bitters reflects prevalent foodie concepts like locality and being in tune with harvest cycles, too, through seasonal offerings (a limited-edition apricot bitters) and a commitment to using only organic or wild harvest herbs.

Having all those flavors at the fingertips opens a world of possibilities to the bartender, explains Thomas. "If you were a painter, and the bar was your color palette, you'd want as many colors as you can get." Sure, celery might seem like an odd shade to throw into a cocktail shaker—but try putting a dash in your next Bloody Mary or martini, and Thomas's kaleidoscopic attitude toward bartending makes a lot more sense.

Making bitters can be a time-consuming pursuit,† but it isn't necessarily difficult. There are plenty of recipes online.‡ Don't be thrown off by the esoteric-sounding ingredients in older ones. "Oftentimes an ingredient looks like something that doesn't exist anymore, but in reality there's another name

* An infusion is a spirit imbued with other flavors by soaking or steeping additional ingredients—herbs, fruits, nuts—in the base liquor. Ginger vodka is a popular example.
† For several years, Hess has been trying to replicate the formula for Abbott's Bitters, which ceased manufacture some time around World War II. He's even gone so far as to compare his own version with some vintage Abbott's using gas chromatographs.
‡ There are nearly twenty to choose from at www.artofdrink.com (look for the tab marked "Bitters").

for it," says Thomas. Prickly ash berry, for instance, is just a highfalutin alias for Szechuan pepper. Membership in a coven isn't required to find cinchona bark and gentian. A visit to an apothecary or herbalist should suffice.

Putting the "Art" Back in Bartending

The resurgence of interest in classic cocktails dovetails neatly with the general public's increasingly refined culinary sensibility. Like a fine dining experience, a number of variables come into play in that cocktail shaker. Consider the martini. The patron has his or her choice of gin and vermouth, as well as the ratio between the two. With or without bitters? Olive or twist?

Whether you're calling out for a PBR tallboy at a local dive, or ordering another bottle of Australian shiraz, we're conditioned to expect uniformity from beer and wine, but cocktails are supposed to vary, from place to place and even bartender to bartender. "Say you go to a restaurant and see something on the wine list and something on the entrée list, and have that pairing," says DrinkBoy's Robert Hess. A week later, at another restaurant, you might order the same two items. The wine should tickle the exact same taste buds it did before. Otherwise the bottle is off. "But the entrée had better taste different, because the chef is participating in some fashion."

Great mixologists stake their reputations on personality, and an ability to earn customers' trust. A. J. Rathbun compares the relationship between a top-notch bartender and his or her patrons to another old-fashioned bond. "It's the same as the way you'd go to a specific record store, because the clerk knew what music was new and interesting."

No matter how piercing his gaze, the bartender won't be able to stare into your eyes and discern that a Dark & Stormy is just what the doctor ordered. But that doesn't mean you have to order your standard or choose one of the specials on the menu. Even if you don't have an expansive knowledge of cocktail culture, you can communicate what you want, to a degree, even without a specific name. Just keep these guidelines in mind:

What type of base spirit do you want?

The big six are whiskey, gin, rum, brandy, vodka, and tequila. With that one decision, you've narrowed the field significantly.

Which basic tastes do you prefer?

Sweet, sour, and tart are all good cues, although you can certainly get more esoteric and throw out "savory" or "bitter"—as long as you mean it. Citrus, yea or nay? What about bubbles? Also, sometimes articulating what you don't like comes easier than describing what you do. If licorice makes you queasy, say so, and you're less likely to be served a Sazerac.

Don't assume you know the best brand to call for.

So much of the booze biz is marketing—confer with your bartender about which varieties they recommend for your libation, and why.

Consider the surroundings.

Is it the height of summer, or dead of winter? Are you overlooking white sand and crashing blue waves through sunglasses or bundled in your favorite reindeer sweater at a ski lodge? There's certainly no law against ordering something light and fruity, such as a Tom Collins, under the latter circumstances, but will it really hit the spot as pleasingly as a Rusty Nail?

Bartenders and cocktail buffs go to market just like chefs, and often make up drinks off the cuff, inspired by what regional specialties are in season. Hess, who lives in the Pacific Northwest, makes a cocktail called the Tillicum, a pinkish variation on the martini garnished with fresh smoked salmon. That may sound esoteric, but the vast majority of cocktails are invented on a whim. Most weren't intended to stay in vogue for long. A few, however, have proven remarkably long-lived.

MARTINI: Gin, vermouth, and orange bitters, garnished with an olive. The drink's origins are uncertain, but most folks agree it evolved from the Martinez, a concoction of Old Tom Gin (a lightly sweetened variety popular in eighteenth-century England), sweet (that is, Italian) vermouth,

maraschino liqueur or orange curaçao (or both), and orange bitters. Technically a "dry" martini refers to the type of vermouth used (that is, dry or French, not sweet), instead of the amount or lack thereof.

MANHATTAN: Whiskey, dry vermouth, Angostura bitters, and a lemon twist. Mythology claims the drink was introduced by socialite Jennie Jerome—later Lady Randolph Churchill, mother of Sir Winston Churchill—who served it at an 1874 election party she hosted for New York mayor Samuel J. Tilden at the Manhattan Club, hence the name.

OLD-FASHIONED: Rye whiskey or bourbon, simple syrup, and Angostura bitters, garnished with an orange wheel and a cherry. Some say it originated at the Pendennis Club in Louisville, Kentucky, but cocktail expert David Wondrich disputes this, citing evidence of an old-fashioned that predates the Pendennis's opening. The name seems to be a nod to changes in cocktail culture in the latter half of the nineteenth century, when newfangled drinks like the martini and Manhattan (neither of which is sweetened) deviated from the original definition of a cocktail: spirits, water, sugar, and bitters.

SIDECAR: Brandy, Cointreau, and lemon juice. Bars in both London and Paris have claimed the drink, which sprang up at the end of World War I, as their own creation. The best story involves a regular at the Ritz hotel in Paris, who arrived in a motorcycle sidecar and asked the bartender to concoct something to warm him up.

DAIQUIRI: Rum, fresh lime juice, and simple syrup. Daiquiri is also the name of a small mining town on the east coast of Cuba where, during the Spanish-American War of 1898, a mining engineer named Jennings

Cox reportedly mixed up the first batch. It was brought to the mainland by U.S. Navy admiral Lucius Johnson, who made it a favorite in Washington social circles.

BRONX: Gin, dry vermouth, sweet vermouth, and orange juice. Rated the third-most popular cocktail in 1934, the Bronx is an overlooked gem that merits reviving. Like many of the aforementioned, its backstory varies. My favorite alleges that Johnnie Solon, a Waldorf-Astoria bartender, named it after visiting the Bronx Zoo, the implication being that imbibing too many cocktails led patrons to see exotic animals (like pink elephants).

The Bronx

1½ oz. gin
½ oz. sweet vermouth
½ oz. dry vermouth
Juice of one-quarter orange

Pour all ingredients into a cocktail shaker, with ice cubes. Shake well. Strain into chilled cocktail or martini glass.

In addition to all manner of spirits, juices and mixers, syrups, and garnishes, the modern bartender also has at his or her disposal many tools unknown to our ancestors: blenders, vaporizers, blowtorches. All good fun, but blessedly unnecessary in the preparation of classic cocktails; a Hawthorne strainer and a bar spoon usually suffice. The simplicity of a fine cocktail doesn't require backflips. You're making a drink, not staging a circus.

That sort of levelheaded approach is a wise one for stocking a home bar too. If you want to be able to whip up every cocktail imaginable, you'd have to shell out a phenomenal

sum on base spirits and liqueurs, plus juices and other mixers, garnishes . . . the wallet aches just thinking about it. Even the bare basics of a versatile liquor cabinet include bottles of all six base liquors, plus commonplace ingredients such as vermouth and triple sec.

Instead, Hess recommends a more organic approach. Pick two or three cocktails you already know you enjoy. Buy the ingredients for those, and practice making them to your tastes. When guests come over, you can offer them a range of choices, just not everything under the sun. Once you have a few drinks mastered, introduce a few more to your repertoire, and add the new ingredients to your liquor cabinet as well. As the number of bottles increases, investigate other drinks that use the same ingredients. Make quality, not quantity, your byword, and over time you'll be able to serve a wide range of cocktails with confidence in your home.

⇥ A NEW AMERICAN SPIRIT ⇤

With his artisanal spirit Root, the "first truly American liqueur since the pre-Prohibition era," Steve Grasse—owner of the Philadelphia boutique Art in the Age—hopes he can alter the way people think about what they imbibe, and life in general.

Grasse made his first splash in distilling with Hendrick's Gin, a gin flavored with cucumbers and rosewater that took off with foodies and mixologists. Next up, the advertising vet turned Sailor Jerry spiced rum into a hugely successful lifestyle brand, built around the legacy of prominent American tattoo artist Norman "Sailor Jerry" Collins.* But the inspiration for Root actually sprang from folks who'd tried to suppress the demon firewater. A history buff, Grasse found himself increasingly curious about the drinking habits of Americans before the Volstead Act (the National

* He subsequently sold both drinks to William H. Grant & Sons, the Scottish "Independent Family Distillers since 1887," which owns Glenfiddich whiskey.

Prohibition Act, passed in late 1919 and put into effect in 1920) outlawed liquor. He read up on the subject and was intrigued by what he found.

"When the temperance movement started, people used to drink some pretty wild stuff. A lot of it was made from the grains and herbs found on their own property, or within walking distance." That pioneer ingenuity was distilled into sarsaparilla and birch beer, "small beers" that historically often had a modest alcohol content. It also inspired Philadelphia pharmacist Charles Hires to create a nonalcoholic variation, the carbonated soda fountain favorite root beer, in the late nineteenth century. But the origins of all those drinks went back even further, to the 1700s, with root tea, a medicinal beverage passed from Native Americans to colonials. Modern spirits inventors had forgotten to check history's back pages. "No one thought to look in their own backyard."

A USDA-certified organic drink, Root incorporates a dozen different natural flavors, including birch bark, smoked black tea, cinnamon, and wintergreen,* plus pure cane sugar . . . and an alcohol content of 80 proof. "It's technically a liqueur, but it'll put hair on your chest." Grasse's adult beverage smells like root beer, but the viscosity is lighter than most liqueurs, and its vibrant mix of flavors yields notes of vanilla, pepper, and licorice.

The bottle and label were also crafted to evoke the sort of eighteenth-century herbal elixir peddled at medicine shows. Very simple. Anti-design. "When we showed people in the business the bottle initially, they said we were insane," Grasse admits. "Now they think it's genius."

Next up, Grasse plans to launch another spirit, with even closer ties to its native soil. In 2009, he purchased a farm in Tamworth, New Hampshire. "The idea is for it to be off the grid, and fully sustainable, and pay for itself, through agriculture, over the next five years." Using ingredients

* But not sassafras. The traditional root beer flavoring agent contains a chemical banned by the FDA

grown at his Great Hill Farm (he eventually hopes to build a distillery on site too), the new liquor will be inspired by the Granite State.

Grasse shills his products using Facebook and Twitter but also promotes Root at regional farmers' markets, in the form of soda bread studded with raisins marinated in Root. "A lot of times the green movement are really bad marketers. Which is good, because, first and foremost, they should be thinking about their products." Marketing is second nature to Grasse, but in this case he's hoping an intriguing history, plus philosophy and ethics, will make a success of Root, without bells and whistles.

The Boys in the Back Room

Milk and Honey. It sounds so innocent, yet gaining entrance to the exclusive New York watering hole, which opened in 2000, was once quite an adventure. Robert Hess first visited in 2002, as the guest of a member. Before they even set out, his host had to excavate a card key and call an unlisted number to make a reservation.* The duo soon found themselves looking for a mysterious no-man's-land in lower Manhattan. "We're getting into scary areas of town, there's no people around, all the businesses are closed up, streetlights are broken out," he recalls.

Eventually they found the address. His host waved the card key over a sensor, and the green light blinked. They passed through a heavy door, then a black velvet curtain, and made their way into . . . an empty room. The bartender looked up and asked if they had reservations. "It was so mysterious, like there was a secret handshake required," Hess says with a chuckle. "That was kind of fun."

Milk and Honey is not a private club, says owner Sasha Petraske, and is open to anyone with the foresight to make a reservation (preferably by e-mail;

* The number at Milk and Honey still remains something of a secret, although it is given out to anyone who knocks on the door and asks.

the elusive phone number is for same-night bookings only, after midnight) and show up for it. Petraske prefers to think of Milk and Honey as "discreet," not secretive. "Our stated purpose is to provide a quiet, civilized drinking environment that does not negatively affect the quality of life of our neighbors. The hidden entrance, rules, reservations, etc. are in the service of this."

In light of Prohibition's hard lessons, perhaps we should all breathe a sigh of relief that there is really no such thing as a speakeasy in twenty-first-century America. The sale of liquor for public consumption is, after all, legal (and after-hours clubs that violate blue laws don't usually trumpet their drink specials). But across the country, a number of bars serving quality cocktails also go to varying lengths to keep their locations quiet. Like their old-school predecessors, some assign customers passwords or membership cards; others lurk behind secret passageways and unmarked doors. Getting the once-over twice from a sentry is often part of the ritual.

The goal isn't to dodge the law but to make patrons feel elite. "It's always fun to feel you're a part of something that is, if not exclusive, not known to all," observes A. J. Rathbun. Other folks may have heard about said establishment, but could they actu-

ally find it, or gain entry? That added layer of mystery makes a night out seem more exceptional. At the heart of such ventures beats the basic tenet that if you make something seem off-limits, it immediately becomes more intriguing.

Sam McNulty never planned to open a speakeasy. Nevertheless, he reopened one—quite unintentionally. Six years ago, the Cleveland restaurant owner was making renovations to the basement of his Belgian beer bar, Bier-Markt, late one night. At two in the morning, while trying to expose original brickwork that had been covered over in concrete, he broke through a hollow wall.

What he found appeared to be an abandoned storeroom. "I look inside, and see these old gin bottles." At least, that's what they claimed to be. In

paint or crayon, someone had crudely scrawled "gin" on the now-empty bottles at some point. McNulty knew immediately what to do with the unused space. "The decision was made back in the twenties or thirties that the gods want this downstairs to be a speakeasy."

McNulty's bar, simply dubbed Speakeasy, doesn't go in for the cloak-and-dagger routine. On the other hand, they don't do any marketing, or even display signage for Speakeasy, on site or off. A chandelier hangs over the basement stairwell leading to the bar. When it's illuminated, usually on weekends only, Speakeasy is open.

Despite its name, Speakeasy has more in common with other venues that champion old-school cocktails and embrace a vintage look, but don't hide behind a veil of secrecy. Los Angeles watering hole the Varnish is tucked away behind a heavy oak door in the back room of Cole's French Dip, but its phone number and address are easily found on the bar's Web site. Brooklyn's Clover Club (named after a Philadelphia social club for journalists that operated in the late nineteenth and early twentieth centuries) boasts a menu full of cobblers, fizzes, and punches—all accompanied by detailed annotations. Tavern Law, a modern Seattle bôite that specializes in Prohibition- and pre-Prohibition-era cocktails, is designed to look like a law office or old library, with plenty of bookshelves. "We want our guests to take their drinking as seriously as if they were studying in law school," says bar manager David Nelson. Obviously, he wants the environment to be lively and fun, but also one where customers can appreciate and learn about their drinks.

"Almost every classic drink has a good story behind it," adds Nelson. "And being able to share histories of cocktails and spirits with patrons helps them appreciate what they're drinking a little more."

It is a new golden age for cocktails. However, Nelson squirms at the notion of calling it a renaissance. "It's just people who are actually doing the research, and know what they're doing. In some sense it's a rebirth, but it's just the way it should've been done all the time."

4

Shave

and a

Haircut

Grooming

Barbershops

Entering a barbershop—even one outfitted with modern conveniences like flat-screen TVs or Wi-Fi—feels like stepping back in time. Not surprising: the trade boasts a long history. Records of barbers have been found in tombs of the Egyptian pharaohs, but it was the Romans who introduced such lavish amenities as hot water and made barbering more widely available to plebeians as well as ruling classes.

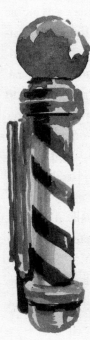

Barbers are an integral part of American heritage too. Try to imagine a classic Western without a scene set in a barbershop—one that often concludes with the hero tearing off his apron and storming toward a showdown. "There's one other profession that's older than barbering, but it's not honorable," jokes Charles Kirkpatrick, who serves as executive officer for the National Association of Barber Boards of America.

Nevertheless, in the late twentieth century, the traditional barbershop was at a low point. At the height of the profession's popularity, around 1965, there were 360,000 licensed barbers in America. By the mid-1980s, hippies, disco fans, and other shaggy free spirits had reduced that number to 195,000. For those seeking tonsorial style, multipurpose hairdressers and unisex salons held sway.

Today, the barber's trade is rallying: 235,000 licenses were issued in 2008. "All the old barber schools are full," says Kirkpatrick (who first picked up his shears in 1959, and still cuts at his shop, the Cutting Edge, in Arkadelphia, Arkansas, on weekends). Savvy business folks are opening new barber colleges, and enrollment is brisk. African American communities, where shorter styles require frequent maintenance, have been particularly booming. Indeed, barbers remain bastions of small business. Mass production might work for T-shirts and hamburgers, but chains like Supercuts come up short in providing customers with the uniformity of the Gap or Burger King—and nobody outsources their haircut to China or India.

The bond between a barber and satisfied customers is a powerful thing. Most guys can recall their childhood barbershop as vividly as their first kiss. Over time, the connection between a patron and the man wielding the scissors only intensifies, as the barber learns the idiosyncrasies of each customer and his locks.

Then there's the community aspect. At a salon, one-on-one interaction between stylist and client rules: "only my hairdresser knows." Barbershops are forums, bullpens, with everyone weighing in, and barbers serving as moderators. "A barbershop is a bureau of information," reaffirms Kirkpatrick. Are the fish biting? What are they building next door? Is my girlfriend sleeping around? In the days before search engines and chat rooms, our grandfathers sought answers to such questions with a regular visit to clean up the back-and-sides. The same is true today—aside from the locker room (and, let's face it, talking with strangers while sweaty and naked feels weird), barbershops are one of the few remaining all-male social spaces. During a haircut, the conversation can veer from classic cars, baseball, and lap dances, to fine art and punk rock.

Guys talk about stuff at the barber they wouldn't normally discuss in public, encouraging much-needed social interaction and fraternity. Some high-end clip joints have deliberately opted not to install free Wi-Fi, the better to encourage patrons to chat with their neighbors and fellow customers while they wait. If you don't feel sociable, pick up a magazine and take a well-earned moment to slow down and relax.

The barbershop's enduring tradition as a social hub makes it an attractive venture to entrepreneurs. That was the case with Wade Weigel, one of the three founders of Rudy's Barber Shop, which originally opened in Seattle's Capitol Hill neighborhood in 1992. The grandchild of a barber and a beautician, Weigel still loved patronizing barbershops into adulthood. Waiting for his turn in the chair, he contentedly flipped through dog-eared periodicals and shot the breeze. Unfortunately, the time warp older shops existed in—with their hunting and fishing periodicals, pinup calendars, and glistening jars of disinfectant Barbicide*—extended to the styles on offer too. And he thought that was a drag.

"Traditionally, the barbers were older guys, and they just want to do a buzz cut or a flattop," reflects Weigel. The Rudy's solution? Install hip, young hairdressers in an old-school barbershop environment. No appointments, low prices, reliable service . . . and lots of opportunities to socialize. "We didn't really go for the whole male-bonding element, but more so just hitting on the community aspect of the old barbershop," Weigel admits. They worked closely with local rock show promoters to tap into Seattle's vibrant music scene. The owners of Rudy's encouraged their barbers to talk with one another, with folks in their chair, and the ones waiting on the bench. The experiment worked. Today there are thirteen Rudy's Barber Shops, in Washington, Oregon, and California.

When the rustic Lower East Side boutique Freemans Sporting Club opened in 2006, just around the corner from Taavo Somer's popular Freemans Restaurant, it upped the shop's already Ernest Hemingway–worthy levels of testosterone by installing a barbershop in back. Somer and store

* The insidious name of the turquoise blue fluid used to sterilize scissors and combs is intentional: inventor Maurice King allegedly despised barbers.

manager Sam Buffa envisioned the combination space as an overall haven for men. Two years later, Buffa expanded the operation, adding the eight-chair F.S.C. Barber in Greenwich Village. He drew inspiration from 1930s Art Deco, locker rooms, and old subway stations. The interior featured antique oak floors, a 1920s barber station salvaged from Key West, Florida, vintage chairs and foam dispensers, and old-fashioned light fixtures.

Décor wasn't Buffa's only concern. He also focused on scents, which are powerful triggers for memory. "Being a guy, I always felt a little off going into a salon," he admits. "A little embarrassed to ask certain questions. Or it smelled like a women's environment, with all these chemicals, or the smell of burnt hair in the hair dryers."

Visually, F.S.C. Barber echoes the pre–World War II golden age of U.S. shops, when a weekly visit to the barber was as regular—and, in some regards, as restorative—as church on Sundays. And for those sorts more disposed to getting their kicks on Saturday nights? F.S.C. does brisk business on weekends with their "Hangover Relief," a rose-water-and-eucalyptus-infused shave accompanied by neck and hand massage.

There's an element of novelty, too, especially with uncommon practices like getting a straight-razor shave. "You get all these guys, this new generation that grew up going to salons, and it's their first time," adds Buffa. "They're excited to do something that reminds them of a different generation . . . going back to your roots."

Visiting the barbershop is a way to feel manly without being politically incorrect. Some dudes have taken to integrating a group visit to the barber as the kick-off for a bachelor party. A refreshing alternative, or at least precursor, to stuffing dollar bills into some gyrating stripper's G-string. "There's this resurgence of being masculine in a simple way," he observes.

Straight-Razor Shaving

Man, vain creature that he is, has been shaving since prehistoric times; sharpened pieces of flint (ouch!) were the first razors. Other primitive societies used instruments made from seashells or volcanic glass. Roman legion-

naires rubbed pumice on their faces to keep them hairless. Razor magnate King Camp Gillette used to peddle a tall-sounding tale about using a piece of ice to shear his whiskers in a moment of extreme duress. At the other end of the spectrum, fat cats in ancient Rome and Egypt had blades fashioned from precious metals—copper, brass, even gold—and festooned with jewels.

The straight razor, with a blade that folds into its handle, came on the scene in the eighteenth and nineteenth centuries; both the French and English have claimed credit for its invention. In the wake of World War I, when U.S. soldiers were issued safety razors instead, the straight razor (also known as a cutthroat or open razor) fell out of fashion with American men.

Barber colleges still require students learn straight-razor shaving. But as with finger waves (another tonsorial classic), the demand for the technique has diminished. Most barbers don't even offer shaves anymore, and old-timers will tell you they like it that way; in the time it takes to administer a proper shave, with the hot towels and facial massage, another barber might polish off two or three haircuts . . . and make more dough.

Yet at select joints, like the outposts of British barber Truefitt & Hill in Chicago and Las Vegas, straight-razor shaves are still a draw. "It's a rush," says Rudy's Weigel. "All of a sudden there's this razor coming at you." If your barber is having his own "bad hair day," the customer could quickly wind up like one of Johnny Depp's victims in *Sweeney Todd*.

If they opt to indulge in a straight-razor shave, most guys entrust the job to a trained professional, but Michael W. Haar ("Mike the Barber") is happy to teach curiosity seekers how to take matters into their own hands. "Most men shave every day," he says, "so why not do it with some elegance?" A barber and shaving instructor who has worked at both the Art of Shaving and Freemans Sporting Club, Haar knows for a certainty that twenty-first-century guys can shave successfully with a straight razor. He taught himself, when he was still a freshman in college, "without any human, personal assistance."

He began his adventure by perusing vintage barber manuals. Eventually he found a straight razor at a Manhattan antiques fair. The rest was trial

and error, and lots of practice. He figured out the correct angle to hold the razor, how to find out if it was sharp enough, and how to do his own sharpening. Haar's progress was slow. Some mornings his face was dotted with bloody bits of toilet tissue, but he knew history was on his side; it was only at the turn of the twentieth century that King Gillette introduced the safety razor. Prior to World War I, shaving with a straight razor was the norm. It was part of a daily ritual, not a death wish.

Why go to the extra hassle? Haar names three good reasons. "Number one, it's the right way to shave," he says. He finds that the hair doesn't actually grow back as fast when you shave with a single blade. Multiblade razors also operate on the theory that the first few pull the hair out from the skin, and the rest cut behind. All those blades running back and forth can promote ingrown hairs and bumps. A straight razor minimizes such nuisances, delivering a tight, clean shave on the surface of the skin. To get even closer, a gent may opt for two rounds: the first going with the grain of the beard, followed by one in the opposite direction.

Secondly, though the practice may date back to an earlier time, straight-razor shaving is decidedly in step with contemporary mores. You're not constantly buying new blades and chucking out dull ones. Instead you have a single blade and keep it sharp by honing it on a strop, a flexible strip of leather or canvas.

Lastly, the biggest incentive, says Haar, is peace of mind. That's right: dragging a sharp instrument over your delicate flesh can be contemplative. "People look at it as being such a scary thing, but you take an extra ten or fifteen minutes in the morning and you already feel accomplished. You actually worked for something, in an era when everything is so disposable and fast. It makes you slow down, and appreciate the morning, and feel like you started the day doing something your neighbor can't." In a nutshell, it gives you confidence.

It does, however, require practice. "You have to throw out all the ideas that you learned over the years while shaving with your Mach Three or whatever." Students who sign up for Haar's classes sign a waiver acknowledging the likelihood of injury. Frustrations can run high. Just holding the

razor correctly—at a thirty-degree angle to the skin—means assuming an "unnatural position" with the hand. Too much pressure can cause nicks and cuts, and the skin of the kisser has to be properly stretched to ensure a clean shave. "And a blade that's not sharp enough is horrible, like trying to shave your face with a butter knife." Or a seashell.

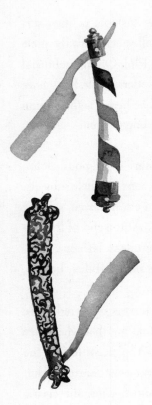

Straight razors look cool too. Whether vintage or new, handles may be fashioned of anything from plastic, Bakelite, or celluloid, to ivory, wood, tortoise shell, mother of pearl, or bone. Online, straight razor collectors host galleries of exotic antique specimens, with handles depicting nautical scenes, birds and reptiles, even chariot races. If properly cared for, straight razors last for decades and can be handed down as heirlooms.

Although most of the manufacturers of open razors have gone the way of the rotary phone, a handful still exist. Edwin Jagger of Sheffield, England, peddles contemporary models made from buffalo horn and ebony. DOVO Steelware in Solingen, Germany (which manufactures Jagger cutthroat razors), has been around for more than one hundred years, and Thiers-Issard in France dates back to the late nineteenth century. For the gentleman reluctant to do his own sharpening, Feather Safety Razor of Osaka, Japan, manufactures a straight razor that uses disposable injector blades.

Perhaps the most extravagant razor on the modern market comes courtesy of Black Sheep & Prodigal Sons. Each limited-edition Mammoth Straight Razor boasts a handle individually carved from ivory of the prehistoric woolly mammoth, extinct for more than ten thousand years. These tusks are highly prized fossils—and a cruelty-free alternative to poached elephant ivory. In addition to a refurbished vintage steel blade and Austrian sterling silver trim, there's even a microscopic tidbit of vintage erotica and

minuscule magnifying lens hidden in the handle—although with a price tag of $750 to $1,250, the Mammoth feels decadent even without the dirty picture.

Beards

Homo sapiens grow facial hair for numerous reasons: fashion, politics, survival, warmth, or to attract a mate. "In most, if not all species, it's the male with the more flamboyant appearance," observes Phil Olsen, unofficial leader of Beard Team USA. "Male moose have antlers, male lions have manes, peacocks have these very colorful feathers. The beard is the human male's extra feature that women don't have." (Well, one of them—but you get the point.)

To beard or not to beard? Throughout the centuries, religious, political, and military leaders have often made these decisions for their subjects. Alexander the Great insisted that his soldiers remain clean-shaven, so their beards couldn't be grabbed in hand-to-hand combat. At the end of the seventeenth century, in an effort to emulate Western European fashions, Russian ruler Peter the Great demanded that his citizens shave off their beards, and imposed a tax on those who failed to do so.*

Even in the corridors of power today, a smooth puss is preferred. "I've talked to Fortune Five Hundred CEOs who have told me that when they were coming up through the ranks, they were told, 'You've got to lose the facial hair if you want to move up,'" says mustache evangelist Aaron Perlut. "Beardism" and negative stereotypes still persist, and not just the classic misconceptions, for example, that all men with beards are religious zealots,

* Bad call. Prior to the reign of Peter I, all adult Russian males wore whiskers. His anti-beard edicts were met with widespread discontent, and fostered talk of assassination and open rebellion. Since all the saints in the Greek Catholic Church were bearded, some even put forth the idea that Peter's position proved he was the Antichrist. Beards would remain a flashpoint in Russian politics for more than 150 years, and the mandatory shaving laws were not repealed until shortly after Alexander III was crowned emperor of Russia in March 1881.

criminals on the lam, and marauding barbarians (or closeted Hollywood actors).

On the flip side, some scruff serves as an easy signifier of down-to-earth values, whether the wearer is a cheese maker or an independent musician, especially if he lets it grow wild. Seattle folk rock quintet Fleet Foxes sound mellow, yet their generous whiskers speak volumes about their place in pop culture: at the fringe.

Karl Marx, Che Guevara, Fidel Castro . . . many of history's greatest rebels had beards. If you want to gain attention for your cause, put down your arms, and your razors—stage a whisker rebellion. In 2007, workers at the Terrapin Beer Company in Athens, Georgia, grew mustaches to draw media attention to their frustration over delays in obtaining a state brewing license. Two years later, disgruntled Brazilians staged a "greve de bigode" ("mustache strike"), sporting them as a gesture of displeasure with José Sarney, unpopular president of the nation's senate.

In 2009, the New York Beard & Moustache Championships, a facial hair competition in Brooklyn, added a new category directly inspired by current events: the Recession Beard. Entrants had to be out of work and proud to boast "a beard with a story" related to the U.S. financial mess. The prize went to Rochester, New York, resident Nate Stahura, who let his follicles go unchecked after being laid off from his banking job.

The rise of the Recession Beard makes sense. Razor blades are expensive. An eight-pack of Mach 3 or Fusion refills can set a guy back twenty to thirty bucks—half a day's pay at minimum wage. Growing a beard takes time, something the unemployed have in abundance; Stahura had five uninterrupted months to work up his prize-winner. Plus a face full of manly whiskers signals to the world that losing one's job has not emasculated the individual.

Look at Al Gore. In the summer of 2001, the presidential contender returned from a six-week sojourn abroad, his baby face now hidden by a beard. The media went gaga. Did this signal a retirement from politics? Or bold plans for a rematch in 2004? In the New York Times, Erica Jong cooed, "It represents non-conformity, masculinity and unruliness." The hint

of recklessness and daring that his White House bid had lacked had been right in front of his face—literally—the whole time.

Some people assume that the only reason a fellow grows a beard is that he's too lazy to shave, which feeds into the notion that having a beard somehow equals being unkempt or unclean. Preposterous! "People are surprised to hear that I shampoo my beard," says Beard Team USA's Olsen. "Yet if I walked around with hair as long as my beard and told people I didn't shampoo it, they would be shocked. It would be pretty greasy and gross and disgusting. Of course it needs to be cleaned!"

Conditioning facial hair has pluses too—especially for romantics. Softening a beard or mustache with periodic conditionings will cut down on complaints about bristly kisses. It also heightens the pleasure of stroking one's whiskers thoughtfully.

·≈[LIFE AFTER PEACH FUZZ]≈·

Tips for Novices

1. Resist trimming and shaping until some good growth has sprouted. Allow three or four weeks. If you aspire to a particular style, this foundation will give a better sense of whether or not your natural beard is going to cooperate.

2. Beware the dreaded neck beard. Look at your profile: the neck is vertical, and the chin is horizontal. If you want your beard to look full yet tidy, make sure to keep the neck clean-shaven, while allowing chin hairs to grow in.

3. Don't scratch! Initially beards can be pretty itchy. Resist the urge to claw at your whiskers, or you'll irritate the skin and increase the risk of bumps and ingrown hairs. Starting a beard in colder weather, when the face is less likely to get sweaty, helps.

4. Some studies suggest that vitamin B_{12} and frequent sexual activity accelerate facial hair growth. Hmm . . .

If more inspiration is required, fire up "The Longest Way 1.0" on YouTube. In 2007, clean-shaven Christoph Rehage set out to walk from Beijing, China, to his home in northwest Germany. Over the next year, as he traversed 2,885 miles, Rehage took reams of photos as his hair grew. Upon his return, he edited the images into a five-minute time lapse masterpiece that became a viral hit. A long beard looks tough. And a long beard being buffeted about in a sandstorm, or weighed down with ice and snow, is off the charts.

Mustaches

Some men consider a hot shave a luxury, but others would just as soon wax their upper lip. "We view shaving as a crime against nature," deadpans Aaron Perlut, chairman of the American Mustache Institute (AMI). "It's written in the Dead Sea Scrolls that each time a mustache is shaved, an angel in heaven dies and falls to earth." Based in St. Louis, the AMI is dedicated to "protecting the rights of, and fighting discrimination against, mustached Americans by promoting the growth, care, and culture of the mustache." Sound ridiculous? The AMI acknowledges that humor—be it through their own Web site or hit films such as *Anchorman* and *Borat*—is a great way to spread the good word. "We are willing to recognize that mustaches can be very funny."

During the Nixon era, nose gardens were practically de rigeur for the manly man. But when mainstream disco culture collapsed at the end of the 1970s, and the clean-cut reign of Ronald Reagan commenced, mustaches vanished. In the dark years that followed, role models were few and far between; what sane dude takes his fashion cues from Geraldo Rivera and Ned Flanders? "If you talk to people that grew up in the eighties and nineties, the mustache was something their fathers and grandfathers might have worn, but there was no way they'd be caught dead wearing one," says Perlut.

Given the cyclical nature of pop culture, it was inevitable that mus-

taches would make a comeback. Today's young bucks are exploring stylistic extremes previously limited to the antiquated realms of sideshow strong-men. (Will Urban Outfitters soon start peddling striped unitards?) "The mustache has become very popular with Millennials, and they are a very expressive generation," observes Perlut. "This is just one more way for them to express their sense of self." Unlike a tattoo or body piercing, a mustache can also be removed quickly if circumstances dictate. Facial hair makes a bold statement. The man with enough time and courage to boast elaborately styled facial hair projects self-confidence and personality.

Mustaches can also be harnessed as a force for community good. The AMI hosts an annual 'Stache Bash, a huge benefit for Challenger Baseball, a league for children and adults with disabilities, and in 2008 they found a corporate sponsor: Just For Men, the brush-in color gel for facial hair. The Whisker Club assists charities including Seattle Children's Hospital, United Way, WIN (Women In Need), veterans homes, and others. The "826" literacy tutoring centers, cofounded by author Dave Eggers, sponsor annual Mustache-A-Thons, where clean-shaven lads volunteer to grow a lip sweater in exchange for financial contributions; the 2007 Son of 'Stache competition brought in more than fifteen thousand dollars for 826 Seattle.

Contemplating growing a mustache? There are plenty of options, requir-ing different levels of commitment. For growing a longer style, groom the mustache as it grows, with a comb or your fingers, and it will be easier to keep out of your kisser as it fills in. Whatever look you may choose, maintain your mustache's upkeep, lest it start looking scruffy and make a bad impression.

·⊰[A FIELD GUIDE TO MUSTACHES]⊱·

CHEVRON: The look that made Tom Selleck fa-mous, and the butchest thing about Queen's Fred-die Mercury. Wide and thick, typically concealing the upper lip.

DALI: Named for the famed surrealist. Slender and elongated, with points curved or bent upward, like a pipe cleaner.

ENGLISH: Narrow mustache with thin divide of exposed skin in the middle. Long whiskers pulled outward from center.

FU MANCHU: The choice of super villains. Long, thin, and droopy, hanging past the mouth and chin. Says Perlut: "If you want to toughen up your image a little bit, a great way to do it is grow a Fu Manchu."

HANDLEBAR: An eclectic favorite, as worn by Oakland A's pitcher Rollie Fingers and film critic Gene Shalit. Size varies, but must be bushy and long enough that the ends can be styled into curls.

HORSESHOE: Think Hulk Hogan and that biker dude in the Village People. Frames the mouth and chin with a horseshoe shape.

IMPERIAL: For those who miss the Ottoman Empire. Big-ass mustache incorporating whiskers of upper lip and cheeks, groomed to dramatically sweep upward.

PENCIL: The fine line between debonair and pervy. Cult film icon John Waters and William ("The Thin Man") Powell favor this thin, narrow stripe.

REGENT: An elegant little mustache, the width of the upper lip. Two splayed "wings," with curved tops.

TOOTHBRUSH: A controversial choice. Pros: Charlie Chaplin, Ron Mael from Sparks. Cons: Adolf Hitler. Thick growth, an inch or so wide, neatly centered.

WALRUS: The ultimate soup strainer. A Chevron on steroids. Oversize, full and droopy, often obscuring the entire mouth.

Mustache Wax

What keeps the most outrageous styles aloft? Mustache wax, an invaluable aid for achieving looks that defy gravity or must hold a particular shape. Depending on the brand, it may come in a round tin, tube, or stick form. The Web site for London's Handlebar Club includes product reviews of more than two dozen different brands.

Wax can be applied to the whole mustache, or simply worked through the ends. A supple wax is okay for small details, but a larger lip sweater requires stronger stuff to stay firm. Since mustaches reside in that delicate zone

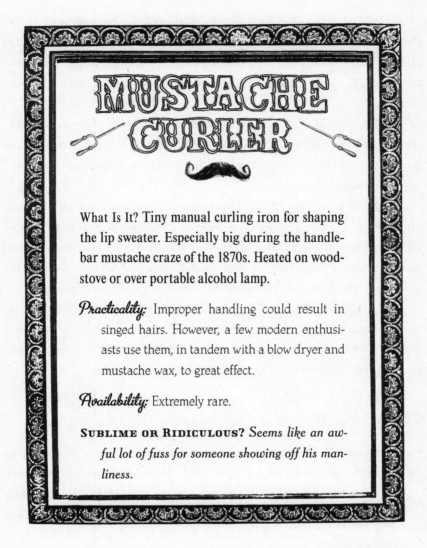

MUSTACHE CURLER

What Is It? Tiny manual curling iron for shaping the lip sweater. Especially big during the handlebar mustache craze of the 1870s. Heated on woodstove or over portable alcohol lamp.

Practicality: Improper handling could result in singed hairs. However, a few modern enthusiasts use them, in tandem with a blow dryer and mustache wax, to great effect.

Availability: Extremely rare.

SUBLIME OR RIDICULOUS? *Seems like an awful lot of fuss for someone showing off his manliness.*

between the nose and mouth, fragrance and flavor are essential concerns.* Many vendors manufacture multiple colors, including black, dark and light brown, and neutral. Pick a shade that's too dark for your whiskers and you could end up looking like you have an upper lip full of Oreo crumbs.

* Allergy sufferers should be careful too. I favor the hold of Brothers Love, but it makes me sneeze uncontrollably.

PINAUD-CLUBMAN MOUSTACHE WAX: "Famous since 1810," the most widely available brand gets the stamp of approval from Mike the Barber. "Most waxes that I've come across aren't strong enough. They don't have enough hold." Clubman is water-soluble, which also makes for easy cleanup.

BROTHERS LOVE: The Whisker Club peddles this German *Schnur-rbartwichse* on its Web site. "It comes out of the tube in a gel consistency, so it's really simple to apply, but has hold that goes way beyond anything else," says club founder Bruce Roe.

OREGON WILD HAIR: This boutique wax, manufactured in southern Oregon, combines beeswax, petroleum jelly, lanolin, and natural musk oil. Developed by visual artist and coffee drinker Mark Coyl, after he tired of waxes with a bitter taste or noxious perfume, both of which ruined hot beverages. Recommended by burlesque big-shot Evil Hate Monkey.

FIREHOUSE MUSTACHE WAX: Want an extra-manly wax? Mississippi firefighter John Pitts concocted this formula to withstand heat and humidity while toiling outdoors during sweltering summers. Bonus points: partial proceeds from every tin sold are donated to charity.

The World Beard & Moustache Championships

Athletes have the Olympics, musicians the Grammys, actors dream of an Oscar, but for the fur face set, it's the World Beard & Moustache Championships (WBMC). Once every two years, hundreds of gents assemble in a foreign locale and square off in various categories of Mustache, Partial Beard, and Full Beard.

The creativity and showmanship displayed can be breathtaking. Take a gander online at Willi Chevalier, a repeat winner in the Partial Beard Freestyle categories—were it not for his beaming smile, one might think the kindly German's face was being ravaged by a furry squid. The novelty component has heightened interest among the general public,

and Internet photo galleries of the more outrageous displays of facial hair creativity have played a pivotal role in building up excitement around the WBMC. Enhancing the pageantry, many competitors wear historical costumes, rugged cowboy and nautical duds, or elegant military uniforms, as their look dictates.

At first the WBMC was a decidedly Eurocentric venture, an outgrowth of groups like London's mustaches-only Handlebar Club and social organizations for bearded men in regions such as Germany's Black Forest, but the game changed in the late 1990s. After meeting a Norwegian facial hair enthusiast at a wedding in Washington state in 1997, Bruce Roe attended the WBMC in Trondheim, Norway. When he returned to the States, he founded the Whisker Club (hosts of the 2008 and 2010 North American Beard and Moustache Championships), the first U.S. counterpart to the European beard clubs.

Phil Olsen, founder of Beard Team USA, took in his first WBMC two years later, in Germany. He was hit immediately by the potential for global expansion. "The United States was completely underrepresented," he recalls. Fluent in German, Olsen made friends quickly with his hirsute European colleagues. In 2003 he was asked to organize the championships in the United States for the first time, in Carson City, Nevada.

Olsen founded his own stateside organization, Beard Team USA ("Growing beards for America!"), as an umbrella group for U.S. nationals interested in participating in the WBMC and beard culture in general. Today their rolls stand at about twelve hundred members, not that encouraging enrollment is especially difficult. There are no dues, no rigorous application process, and no governing board handing down "yea" or "nay" verdicts on new members.

As the ranks of U.S. groups like Beard Team, Whisker Club, AMI, and others swell, that influx is pushing America to the forefront of the WBMC, injecting it with new ideas. The last two competitions have brought in more participants than previous tournaments, and younger guys are showing up in greater numbers. "The average age of the Americans [at WBMC 2009] in Alaska was probably under thirty, while the average age of the Europe-

ans is probably over sixty," says Olsen. "The Europeans are so wedded to this idea that this event is all about the local clubs that they have formed, and none of the local clubs are very good at recruiting younger people."

The young Americans take a more open-ended approach to the enterprise, too, rather than growing very specific, established mustache or beard styles to compete in a particular category, à la their senior, European peers. As Olsen writes on his Web site: "For most BTUSA members facial hair is more an expression of individuality and non-conformity, so members are encouraged to grow the hair they like best and then enter the category where they happen to fit."

That strategy, or lack thereof, has paid off. At the 2009 WBMC, hosted in Anchorage, Alaska, Americans took twelve titles in eighteen possible categories, snatching global supremacy from the longtime champions, Germany. And they did so with American flair. Rather than adopt a traditional style, Grand Champion David Traver drew inspiration from his surroundings: the Anchorage resident dyed and plaited his twenty-plus inches of beard to resemble a snowshoe.

Granted, the spoils of victory are modest. The winners at WBMC 2009 were awarded engraved gold prospecting pans. None of them has been tapped to appear on a box of Wheaties, or even Just For Men. So far, Madison Avenue still seems to suffer from a bad case of beardism. Olsen was once approached about shaving off his beard for a TV commercial, but balked at the amount offered: twenty dollars.

The big incentive behind whisker clubs and competitions isn't so different from the barbershop's enduring allure. "The camaraderie is the most important part," concludes Roe. "Going to the competition is good because you see your friends. If you don't take a trophy home, that's okay too."

5

A RUGGED EXTERIOR

Fashion
and
Apparel

You think sending your latest collection down the runways of Paris and Milan before an audience of fashion-crazed critics is grueling? C. C. Filson knew tough audiences, and they looked nothing like Anna Wintour. His original customers were Gold Rush prospectors in the 1890s, men who confronted some of the harshest conditions imaginable in the Alaskan Klondike. Working in winds and snow that cut to the bone, their choice of the right garment wasn't a statement about personal style, but a matter of survival.

Most timeless American clothing brands, especially in men's work and sportswear, eschew the whims of fashion and instead emphasize function. Every part of an army jacket or original jean was designed for a purpose. Carhartt originally made clothes for railroad men. When the Gold Rush ended, Filson focused on the logging industry. Such ties to our nation's hardworking past are essential to its place in the history of international fashion. America is best known for jeans and work wear, pieces born with specific purposes in mind.

With their double stitching and metal rivets at stress points, these garments are designed to last decades. Novelty colors, inappropriate trims—anything that might date the garment is ideally avoided.* These are pants,

* New synthetic fabrics are another story; companies respected for their outerwear (Filson, Woolrich) have been increasingly receptive to using man-made fibers in certain applications.

shirts, and jackets built as tools. In time, the oversize pockets and loops engineered to accommodate tape measures and hammers have become signature details too. Take the pleated pocket on a Filson canvas shirt. It expands, to allow for extra storage, rather than lying flat. That functional element also augments the overall rough-hewn look that distinguishes the brand.

Today folks might be just as likely to don a pair of heavy-duty carpenters pants before a hard day of designing video games. And why not? The world is still a dangerous place, even if you're more likely to splash those heavy denim trousers with a nonfat vanilla latte than with hot tar. The reasons for championing work wear now are just a little different. America used to be a nation where we manufactured goods and put in a lot of hard labor, but that landscape has changed over the last century. If you spend all day doing intangible things in a cubicle, manipulating ones and zeroes, then dressing as if you could do something more physically taxing—you know, if you had to—is a way to feel more anchored. The trick, of course, is integrating those pieces into a wardrobe tastefully. "It needs to be mixed in," says Michael Williams of influential Americana style blog A Continuous Lean.* "You can't dress like you're going to a construction site, and show up at your consulting job."

In our celebrity-driven culture, these brands actually duck the limelight. "The moment we start saying that we're cool, we're not," admits Filson CEO Bill Kulczycki. He recalls the episode when a dealer reported it had just sold ten pieces of Filson luggage to hip-hop impresario Sean "Diddy" Combs. At the time Filson was engaging the services of an outside PR firm, and they were drooling to get out a "Diddy Loves Filson" press release immediately. "Absolutely not! That's the worst thing we could do," replied Kulczycki. Why? Because these long-lasting companies have an asset no amount of marketing can generate: real history. Designers like Ralph Lauren and Tommy Hilfiger celebrate America's past, but have only been popular since the 1980s. Companies like Filson have their reputations as authentic originals at stake, and safeguarding that means keeping trends at a healthy remove.

* www.acontinuouslean.com/.

There is no substitute for experience, but that doesn't stop some folks from trying to fake it. Kulczycki recalls being approached by one of their dealers with a proposition. It concerned Filon's wax cotton travel bags, one of their most popular items. "They buy our luggage, and garment-wash it. They charge a premium for it—and our luggage is already expensive." This dealer was doing booming business with the customized bags. Might Filson be interested in carrying such a preweathered specimen too?

Absolutely not. New Filson bags are inherently stiff and hard. From a commercial standpoint, selling a softer, prewashed version might make sense, but not ethically to Kulczycki. "One of the things that people love about that luggage is it takes forever to break it in, to get it to that soft, comfortable feeling—and what that luggage then represents when it's gotten there is all those experiences that you've had." If you simply run that bag through the laundry, you synthesize the experience. It's like scribbling graffiti and slapping up band stickers in the restrooms of a rock club before it opens, to simulate a legacy that isn't there yet. "Filson isn't a manufactured brand, and we can't be selling manufactured experiences, either."

It takes guts to admit your age. Woolrich has been in business since 1830. Carhartt's tagline is "Hard at work since 1889." One of Filson's signature slogans, "Might as Well Have the Best," has been used since 1917. "They're almost antiquated statements that people are intrigued by," says Filson's Kulczycki. Other enduring brands, like Coca-Cola, constantly reposition themselves as modern and cutting-edge. The insistence of staying true to tradition lends these American clothing favorites quiet allure.

On occasion, older brands just stumble into the spotlight.* The Portland Outdoor Store has been in operation since 1919, selling

* A classic example is how Carhartt caught on in the hip-hop world in the early 1990s.

lines like Filson, Pendleton, and Woolrich. Brad Popick, who started working there in 1960, clearly delineates why heritage brands endure: fashion comes in waves and bell curves; most trends only have a shelf-life of eighteen to twenty-four months. But the brands stocked at Portland Outdoor Store have remained more or less the same for countless decades. Their style is mapped out on a straight line. Inevitably and periodically, these two lines intersect. When they do, the latter camp must be careful not to be sharply swayed from its long-term mission.

In 2008 and 2009, almost all the aforementioned work and outerwear brands found themselves on the end of generous media coverage and fashion buzz, as shoppers came to grips with a painful recession. Dressing down was a way to signal practicality, frugality, and confidence in America.* But how do these manufacturers reach new customers when the stars don't align so conveniently? By sticking to core values: history, quality, brand recognition, and affordability. Tad Uchtman of Dickies says their clothes do well even in lean times because they've established "a heritage of being durable, having quality, standing the test of time. Of never really being quite out of style—and never quite in style."

While Nehru jackets and Members Only jackets have come and gone, classics like Woolrich's rugged wool field coat have endured. These brands are imparted with transgenerational allure. Jordan Sayler, who operates the Winn Perry men's boutique in Portland, Oregon, remembers his grandfather wearing Pendleton wool shirts. "And I look in my dad's closet now, and he's had items for thirty-plus years that are still functional and great-looking today."

For decades, these brands have remained consistent, but they do step outside the box sometimes, with varying degrees of success. Carhartt launched a women's line in 2007, after the company identified that more than 25 percent of the company's customers were already women who

* Even if many of America's best-loved brands now outsource some production. And not just the household names, like Levi Strauss and L.L.Bean. Filson, Pendleton, Williamson-Dickie, and Carhartt all use factories outside the United States for select products.

simply modified existing men's pieces to meet their specific needs. But the changes introduced were structural, not superficial; the waistbands may be slightly different, but the garments still come in standard colors like brown and black, not robin's egg blue.

Other forays have been less successful. In 1998, Dickies completely missed the point of grassroots street fashion when it tried to capitalize on its unexpected credibility with urban dwellers through a collection actually called Street. When former Polo Ralph Lauren executive Doug Williams was brought in to head Filson in 2005, he hatched the ill-fated Lodge line of casual wear. Even with advertising in mainstream media outlets such as the *Wall Street Journal*, the collection tanked. "It was too far removed from the core Filson brand," says Kulczycki, so their devoted base rejected it. Kulczycki's job isn't to dictate new trends, but to act as a steward and make sure the company remains true to its fundamentals. "Whenever you've had a brand like Filson, that's been around for over a hundred and ten years now, you have to recognize that the customer is the one that really owns the brand."

Community

A commitment to durability is also one way heritage clothing brands can lay some claim to operating environmentally sustainable practices. Fashion uses more water than any industry besides agriculture, and thousands of chemicals are required to transform raw materials into textiles. The less often a garment has to be replaced, the smaller its carbon footprint.

Besides, most work and outer wear takes on added character after it's been lived in for a spell. You can beat the crap out of a pair of overalls, and not only can they take the abuse, but they can look better for it.

Everyman allure and guaranteed functionality give these brands broad communities to tap into, both virtually and ITRW ("in the real world"). Carhartt features a blog called Tough Jobs, where customers send in anecdotes and photos detailing their gigs as welders, dairy farmers, railroad conductors, and even undercover police officers. At the same time, they also give money to blue-collar organizations including 4-H and Future Farmers

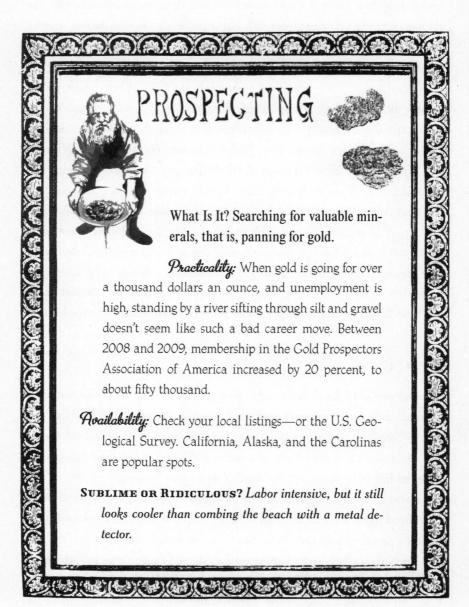

PROSPECTING

What Is It? Searching for valuable minerals, that is, panning for gold.

Practicality: When gold is going for over a thousand dollars an ounce, and unemployment is high, standing by a river sifting through silt and gravel doesn't seem like such a bad career move. Between 2008 and 2009, membership in the Gold Prospectors Association of America increased by 20 percent, to about fifty thousand.

Availability: Check your local listings—or the U.S. Geological Survey. California, Alaska, and the Carolinas are popular spots.

SUBLIME OR RIDICULOUS? *Labor intensive, but it still looks cooler than combing the beach with a metal detector.*

of America, and are a NASCAR presence too. Dickies sponsors Big Tex, the towering cowboy mascot of the Texas State Fair in Dallas. Big Tex has his own Facebook page, and for every user that signs up to be his friend, Dickies donates a school uniform to a child in need. The Pendleton Woolen Mills celebrates one hundred years of affiliation with the historic Pendleton Round-Up rodeo in 2010.

A Brief History of Four American Favorites

Filson

The Gold Rush might not have panned out for everyone, but Clinton C. Filson did all right. In 1897, he opened Filson's Pioneer Alaska Clothing and Blanket Manufacturers in Seattle, Washington, a store that outfitted fortune hunters headed north to Alaska. As the Gold Rush dried up, C. C. Filson catered to loggers, mariners, fishermen, and others working in the rough environs of the Pacific Northwest. Filson's famous Tin Cloth is a heavy cotton canvas, treated with paraffin-based wax, making it water repellent, wind resistant, and stiff as plywood. Their Tin Cloth jackets and Mackinaw cruiser coats (short, heavy wool coats with numerous pockets, in plaids or solids) have become American classics. In the 1920s, the "Alaskan Tuxedo"—a Mac and trousers—was the ensemble of choice for discerning loggers.

Then, as now, every Filson item carried an unconditional guarantee. "The goods we quote must not be confounded with the cheap and vastly inferior grade with which the market is over-run," wrote the great man in a 1914 catalog. "Such goods are not only useless for the purpose for which they were intended, but the person wearing them would be better off without them."

One individual whose life would certainly be worse were it not for Filson is Robert Wener

of Delta Junction, Alaska. In 1993, Wener barely survived when the small two-person plane in which he was a passenger crashed into a mountain. He found himself stranded in the snow, with a broken leg and lower back, and severed fingers. By his own account, his Filson double Mackinaw wool jacket kept him "warm and dry" in subfreezing temperatures until he was rescued over twelve hours later.

Pendleton Woolen Mills

A nine-letter synonym for men's plaid wool shirt? *Pendleton.* While there is certainly more to the story of this long-running Oregon operation, from its celebrated Indian blankets to its classic ladies' 49er jacket, the Pendleton plaid shirt remains its signature piece in American sportswear.

In 1909, brothers Clarence, Roy, and Chauncey Bishop purchased and resurrected an idle woolen mill in Pendleton, a popular trading post in northeastern Oregon. They christened the new venture Pendleton Woolen Mills. Their grandfather, the English weaver Thomas Kay, had operated a mill in nearby Salem, and their father was retail magnate C. P. Bishop.

Pendleton first made its mark producing Indian blankets, inspired by the vivid palette and complex designs of Native American nations both nearby and in the Southwest. The heirloom-quality blankets were treated as a standard of trade among Native Americans—a sort of vibrant woolen currency—and they also used them as apparel, even for tribal ceremonial dress.* These colorful, intricately woven fabrics (called jacquards, for the type of loom on which they are woven) also served as an inspiration for Pendleton's famous plaids. Prior to 1924, men's woolen shirts came in drab, utilitarian solids. Pendleton plaids brightened up the available options.

In the 1960s, Pendleton plaid shirts were a staple of surf culture. In 1963, girl group quartet the Majorettes scored a goofy hit with "White Levis (Tennis Shoes, Surfin Hat, and a Big Plaid Pendleton Shirt)." The

* Carrying on the tradition, Pendleton blankets have been gifted to every American president since Warren G. Harding in 1923.

Beach Boys released their debut 1961 single, "Surfin'," under the moniker the Pendletones and were frequently photographed in the trademark plaid tops, as on the album covers of *Surfin' Safari* and *Surfer Girl*.

Carhartt

Carhartt was closely affiliated with the rigors of hard work long before it became a favorite among construction workers, farmers, and ranchers. In the late nineteenth century, after discussions with a railroad engineer, Hamilton Carhartt designed an overall specifically for men who worked on and built the railroads. (Hamilton also displayed business savvy at the outset, adding a *t* to his surname to set himself apart from any competition.)

Founded in 1889, the success of the small Carhartt company—which specialized in overalls made from denim and duck fabric*—owed much to Hamilton's diligence. In the early days, he would travel from town to town and sell his goods at each railroad division. Although Hamilton started out in Michigan, Carhartt's operation eventually expanded to include mills and plants in Dallas, Atlanta, San Francisco, Vancouver, British Columbia, and Liverpool, England. By 1925, Carhartt had even established bases in Paris and New York.

The Great Depression dealt Carhartt significant setbacks, as did an unsuccessful venture into sportswear during those lean years. But the company survived on the strength of its reputation, concentrating on the signature details that distinguish its products today, including rivets at stress points, heavy-duty thread, triple-chain stitching over felled main seams, and durable materials that resist water, fire, and abrasion.

Woolrich

You want to talk about tenacity? Endurance? Established in 1830, Woolrich has forged ahead through the Civil War (providing blankets for Union

* A canvaslike material made from 100 percent cotton.

soldiers), the Great Depression, two world wars, the moon landing, and the inexplicable popularity of polyester. The wool hat and red-and-black plaid jacket automatically associated with New England outdoor gear have been staples of the Woolrich line since the nineteenth century.

English immigrant John Rich built his first woolen mill in Plum Run, Pennsylvania. Back then, Rich sold his woolen fabric, socks, coverlets, and yarn out of a mule cart that he drove around nearby lumber camps. Fifteen years later, in 1845, he established a new mill, a couple of miles away alongside Chatham Run, which provided a better water supply; the community that grew up around that mill is now known as Woolrich.

Like Carhartt, Woolrich benefited from the locomotive boom: one of the most enduring items, still featured in the catalog today, is a four-pocket Railroad Vest first made in the 1880s for railroad workers. Legend has it Woolrich was also the first company in the world to use a zipper in men's trousers. In the late 1920s, Woolrich expanded into leisure wear, including wool bathing suits and golf trousers. The government also tapped Woolrich to outfit Admiral Byrd's historic expeditions to Antarctica in 1939–41.

Classic American Redux

While deliberate attempts by heritage brands to court the fashion crowd have often flopped, there are, nevertheless, plenty of episodes where the two worlds have intersected with stellar results. Hot young brands like Engineered Garments, Rag & Bone, and Band of Outsiders all draw major inspiration from classic American looks. Collaborative endeavors between the two camps put a twist on classics, introducing the old guard to young followers of fashion who might not find them through traditional channels, in other words, family or work. "And then hopefully that new audience can grow old with their products, like so many of their older customers have now," says boutique owner Jordan Sayler. "And the more people that get interested in these companies, the more they're going to thrive and, hopefully, continue producing good items."

Ironically, contemporary interest in all-American style has deep roots in

Japan. *Take Ivy*, a book of photos of East Coast campus life shot by Teruyo-shi Hayashida in 1965, was commissioned by Japanese designer Kensuke Ishizu to whip up interest around his preppy-inspired clothes for Van Jacket. Today, the tome can go for over a thousand dollars on eBay. The monthly Japanese periodical *Free & Easy* is billed as a "magazine for the young and the young-at-heart," yet much of the classic American culture it celebrates is what the guys at the Filson store in Seattle affectionately call "grandpa style."

Bob Clark, vice president of sales for New England shoemaker Alden, was astonished when he discovered this devotion for American clothing and the meticulous attention to detail some Japanese publications lavished on it. For example, Alden designed a special cordovan penny loafer exclusively for select Japanese clients a few years back, and because the shoe was un-lined, it had a different kind of box toe. A few months after launch, someone sent him a Japanese magazine layout featuring the limited-edition loafer. "And they'd taken a photo, as far inside the shoe as they could, just to point out that special, rubber, box toe."

In the 1970s and '80s, U.S. favorites like Red Wing boots and Levi's jeans became popular staples in Japanese street fashion. Carhartt began selling its wares in Japan strictly as fashion apparel in 1987. In 1993, Japanese designer Takeshi Ohfuchi rolled out Post Overalls, a line that married classic American construction with unusual fabrications. (The first collection included a 1940s railroad jacket in polar fleece, and a pullover work shirt in heavy gingham chambray.) The line was based, and made, in America—but only began retailing in the States in 2009. Americans weren't as interested in "Americana" as our Japanese brethren.

Engineered Garments

Daiki Suzuki is the designer and founder of Engineered Garments (EG), a line infused with the spirit of classic American work wear. Before he launched EG in 1999, Suzuki spent ten years in the United States working as a scout for a large Japanese store, seeking out new American designers

SELVAGE DENIM

What Is It? Denim manufactured on an old-school shuttle loom. Certain types of selvage denim can be distinguished by the different colors of the denim's outermost warp (lengthwise) threads.

Practicality: Manufacture on a shuttle loom takes longer, and makes a narrower piece of fabric, but yields a heavier, more tightly woven cloth that is also more durable—so those pricey jeans last longer and look cooler with age.

Availability: Newer technology, coupled with increased demand for blue jeans, drastically impacted U.S. selvage production in the 1950s. Japanese producers bought up vintage shuttle looms in the '80s. Cone Denim in North Carolina still manufactures selvage used by such high-end purists as Freemans Sporting Club and Stronghold.

SUBLIME OR RIDICULOUS? *Whether American or Japanese, this is the gold standard for denim.*

as well as hard-to-find classic brands. (Spokane, Washington, may not be a fashion hotspot, but it is the home of White's Boots, just one of many American items that stylish Japanese shoppers snapped up when Suzuki dispatched them overseas.)

Growing up in Japan, Suzuki was fascinated with old movies, especially American films, which he considers a huge influence today. "The main thing that lingered were the clothes," he says. "Everyone looked so cool." They looked both dressed up and casual, effortless yet stylish. For Suzuki, this balance would define American sportswear. The other thing that struck him was the attention to detail. "There are such great ideas behind so many small and large details that are really utilitarian, designed for the sake of function. There is an authentic feel to American sportswear that really cannot be replicated."

Suzuki launched Engineered Garments in 1999, after the explosion of the Internet had curtailed the value of his ability to uncover hard-to-find American brands and sell them in Japan. Part of his inspiration was to introduce a more modern take on American work and sports wear, drawing on his experiences as a retail buyer as well as an aficionado. However, he also wanted to preserve and reinstate the manufacturing methods used to make the classics he admired, and he insisted on producing garments in the United States. For its fall–winter 2008 collection, EG commissioned western Washington's Centralia Knitting Mills (a family business founded in 1939, and primarily known today for letterman jackets) to make rib cuffs, collars, and bottoms for various jackets. "When things are mass produced, you really lose out on the detail [in favor of] more profit, and what I want to do is showcase what it is still possible to do here in the U.S.," says Suzuki. But like Post Overalls, Engineered Garments were first sold only in Japan. Americans would have to realize what they'd lost before they began craving it; today EG can be found at retailers across the United States, including Bloomingdale's, Fred Segal, and Barneys. "The general appeal and drive for 'Americana' at the moment seems to be because there is a demand for this type of product and no one is really filling it."

Rag & Bone

When designers Marcus Wainwright and David Neville launched Rag & Bone in 2002, there was nary a hint of glitz and glamour to the British duo's mission statement. Their goal was simply to make clothes that honored the "history, authenticity, and fundamentals of classic work wear," blending a strong British tailoring influence with old-school American craftsmanship. Since they didn't know the first thing about the trade, they visited Kentucky Apparel, a shop "in the middle of nowhere, in a dry town in a dry county," and where folks had been making patterns, cutting cloth, and sewing for generations, to learn how.

Today, Rag & Bone is fashion gold, winner of the 2007 Swarovski Award for emerging talent in menswear, with celebrity fans that include Brad Pitt and Angelina Jolie, Cameron Diaz, and Jude Law. But that remote factory, and the craftspeople Wainwright and Neville met there, still exert a powerful influence over the aesthetic of their whole line.* "In many ways, that set the groundwork for a philosophy in our company of trying to make things, as much as possible, in that kind of environment, where people have been doing what they do for a very long time," says Wainwright.

Even their brand name is down-to-earth: in pre-automotive England, rag-and-bone men† were gents who traveled with horse-drawn carts, collecting salvageable household rubbish that could be reused by manufacturers of paper, glue, cheap fabric, and other goods. Wainwright says they chose the moniker for multiple reasons. For one, traditional rag-and-bone men wore suits, which tended to look dapper yet rumpled, a look that mirrored the designers' visual aesthetic. "Our clothes are very sharp, but often disheveled. And, at the same time, very well-made, crafted pieces of clothing that hold up and last for a long time."

The name also nods to their practice of rejuvenating the time-tested,

* Unfortunately, that factory has since closed, unable to compete with less expensive foreign labor.

† Also known as "totters."

taking iconic garments from the past and giving them a modern spin with new fabrics and fits. Work jackets, hunting vests, and even a Civil War–style double-breasted greatcoat have all featured in Rag & Bone collections. They also source materials from vendors such as Waterbury Button Company, who have been manufacturing quality brass buttons in Connecticut since 1812.

Harking back to such older looks seems to resonate especially well with male clientele, who tend to be more conservative in their fashion choices. "Most guys won't take a big risk on a piece of clothing they've never worn before, in a color they've never, ever worn," says Wainwright. "It's just a fact." The key to getting them into something dressier is to find a gateway, a reference point that provides a sense of familiarity, a memory of something an uncle or grandparent wore, or perhaps a character in a favorite film. (Thus the gent who enjoyed *Tombstone* or *Gangs of New York* can be coaxed into wearing a long frock coat.)

Get the Balance Right

For lines like Engineered Garments, Rag & Bone, and Band of Outsiders the trick is to achieve a balance, referencing classic details and construction without creating a walking museum piece. "The mistake a lot of people make is by copying something literally, when it was really built for driving a tractor or sitting on a horse," says Wainwright. What looks right behind the wheel of a John Deere isn't always appropriate striding along big city streets. "You have to take the elements of the functionality and make it much more modern."

It's also good to recognize when something timeless doesn't need much improvement. A military M-65 field coat in pink and gray may not be standard issue gear, but it isn't reinventing the wheel—just throwing on some fancy rims. "Look, it's the same jacket that's been around forever," says Michael Williams, who runs the blog A Continuous Lean. "That makes me nuts."

At the same time, there is definitely a market for restoring items that

have disappeared in a more faithful re-creation of the originals. Since 1996, Levi Strauss & Company has been turning out its Levi's Vintage Clothing line, which specializes in older styles of jeans and other archival items brought back to market with exacting historical accuracy (although LVC gear is sold primarily in Europe and Japan).

Then there is the story of Stronghold Denim. While not as famous as Levi's, Lee, or Wrangler, Stronghold was another early pioneer in the jeans field. Founded in 1895, Stronghold lays claims to being the first denim manufacturer in Los Angeles, and operated continuously until 1949. In 2004, experienced fashion entrepreneurs Michael Cassel (of the highly visible Von Dutch line) and Michael Paradise revived Stronghold. The modern incarnation hews closely to its ancestors, using selvage denim, indigo dyes, three-piece buttons, and hand rivets. They still have buttons on the waistband (along with belt loops) to affix your suspenders to—and all of it is made in America, and carries a lifetime guarantee.

Los Angeles is also home to the famed Mister Freedom, designed by Christophe Loiron, a Frenchman who's lived in California for twenty years. Since 2003, he has operated a design and retail space in Hollywood. On the ground floor, Mister Freedom sells vintage clothing, footwear, accessories, and other items, dating from the 1850s to the present. Military uniforms, Depression-era work wear, Western wear, it's all here, collected and displayed with a curator's eye. Up on the mezzanine, Loiron creates Mister Freedom originals inspired by the past. In cahoots with Japanese manufacturer Sugar Cane Co., he produces a line of "historically plausible" duds that could have existed in an earlier era—even if there is no specific precedent for the Mister Freedom piece—inspired by merchant marines, old-school motorcycle clubs, and other themes that strike his fancy.

Then + Now = Wow

Another fruitful point of intersection between old and new occurs when long-running lifestyle brands join forces with new, younger designers for special collaborative projects. In honor of Pendleton's hundredth birthday,

trend-setting boutique Opening Ceremony—which had previously dedi-
cated a pop-up Pendleton shop within its Manhattan store—rolled out
a Pendleton Meets Opening Ceremony line. The inspiration and fabrics
came from Pendleton, trademark plaids and Indian jacquards, but the cut
and drape of the garments was much younger and hipper, and some of the
color combinations were explosively edgy. Seeking a full wool miniskirt and
motocross jacket in eye-popping turquoise, with accents of amber, orange,
and fire-engine red? Look no further.

Another successful collaboration was the hookup between Mark Mc-
Nairy, creative director for J. Press and architect of his own English shoe
line, and Maine-based Bass Weejuns. For the colabeled Mark McNairy for
Bass Weejuns collection, he used some classic shapes (boat shoes, loafers)
and fine quality materials (cordovan, alligator), but also mixed in contem-
porary colors and different silhouettes. As with Pendleton Meets Opening
Ceremony, the outcome carried a higher price tag—$3,675 for the alligator
kicks—but were also very pointedly Made in America.

Thanks to a collaboration with Japanese designer Junya Watanabe, even
Dickies work wear has been sent down the runways of Paris: he used select
pieces, modified to suit his style, in his spring–summer 2009 eYe collection
for Comme de Garçons. Tad Uchtman from Dickies says that when fashion
brands like Comme de Garçons or Stüssy approach the work-wear maker
about such ventures, they don't propose to radically overhaul the basic ele-
ments that make them classics. "They want to take our core product and
put a small twist on it. To me, that says our products are a blank canvas,
something that's just really cool because it isn't trying to be something else."

Woolrich Woolen Mills

Perhaps the most successful hookup of all between a historic brand and a
fashion visionary has been Woolrich enlisting Engineered Garments' Su-
zuki to design the Woolrich Woolen Mills line. These creations, which first
launched to raves in Milan in 2006, acknowledge Woolrich's heritage in ac-
tivities like fishing and hunting; but don't look for them at your local sporting

goods or outdoor store. In addition to using the Woolrich Mill in Pennsylvania to create the textiles (as he had with Engineered Garments), his work for WWM Suzuki also aimed to revive small, functional details that aren't often seen today—such as game pockets, or the reinforced shoulders on a corduroy shooting jacket—that could have new uses for the modern wearer. "I am not trying to do a straight reproduction of something," says Suzuki, apropos of both of his lines. "I want it to have an appeal to someone who wants to live in the garment, leave their fingerprint somewhat, really make the garment their own."

As the Woolrich Woolen Mills project has continued, Suzuki has allowed himself to take additional risks. The fall–winter 2009 collection included a modified Polo Coat—not a Woolrich standard—but shortened, more tailored, and fabricated with camouflage wool. For spring–summer 2010, he experimented even more, working with an overall theme inspired by West Coast surf culture from the 1950s through the '70s. (Just stay away from the Beach Boys, dude, or another woolen mill may come calling.)

Boutiques and Shops

Interest in these timeworn Americana looks, both the originals and updated interpretations, has spawned a host of new independent boutiques that take their dedication to this aesthetic very seriously. One of the first, Freemans Sporting Club on New York's Lower East Side, takes its aesthetic from the old-time "sutlery." Yeah, we had to look that last one up too. The historical term *sutler* refers to a civilian merchant who peddles provisions to an army. (Today, the word *sutlery* is used almost exclusively by Civil War reenactors.)

Terms like *dry goods* and *mercantile* get tossed around a lot too. Seattle's Field House evokes the classic general store that once dot-

ted small towns nationwide, with shelves teeming with work wear and vintage goods, plus locally sourced beef jerky and camping gear. The Field House name comes from a Depression-era community center where owner Nicole Miller's grandmother developed her love of crafts, which in turn led Grandma Mable to raise sheep, spin yarn, and delve into fiber arts. "The goal of the Field House is to inspire you the way the original inspired my grandma."

The inventory at the Stronghold's retail outpost in Venice, California, is governed by a general principle: they like companies that were in operation during the heyday of the original Stronghold. That means brands that date from before World War II, are still made in America, and ideally use original patterns. So in addition to their own line, they also sell Filson, Pendleton, White's boots, Stetson hats, and Russell moccasins.

At Winn Perry in Portland, Oregon, shoppers can stock up on custom pieces from Alden Shoes, Billykirk and Makr leather goods, chambray scarves and neckties from Brooklyn vendor the Hill-Side, caps by local knitter Laura Irwin, and grooming products courtesy of Baxter of California and Taylor of Old Bond Street. Owner Jordan Sayler's criteria for the brands he carries reflect his own discerning attitudes as a consumer. "When I go into other stores, I have to think, 'How long is this going to last?' I don't want any of my products to do that. I want my customers to know that the quality control has been done on several levels already, so they don't even have to worry about it."

⋯≫[VINTAGE]≪⋯

Maybe you don't want the modern interpretation of a classic, or even a faithful reproduction. If you want the original, vintage is the way to go. It shows individual style and conserves natural resources.

WHERE TO SHOP: Check local listings and posters for garage and estate sales. Look off the beaten path, particularly around ritzier zip codes. There are also plenty of meticulously stocked, specialized vintage and consignment shops, where prices may run higher, but you're paying

SLEEVE ✦ GARTERS

What Are They? In the late nineteenth century, gents who didn't splurge on custom-tailored shirts had one choice in sleeve length: extra long. These bands allowed them to adjust accordingly, without rolling up their sleeves. Favored by tradesmen seeking clean cuffs (bartenders, bookkeepers), increased hand mobility (musicians), or the appearance of honesty (card dealers).

Practicality: How short are your arms?

Availability: Some costume and old-time apparel vendors still stock them. London accessories merchant Albert Thurston carries a nickel-plated version.

SUBLIME OR RIDICULOUS?
Flat-out silly, unless your boss at the ice-cream parlor insists.

for the time and experience someone else has invested in selecting and restoring the pieces. Chains like Goodwill and the Salvation Army are also increasingly aware of the value of select vintage pieces and may segregate them in a pricier "boutique" section. If you find a place you like, visit often since inventory turns over all the time.

If you shop online, ask the seller questions. Are there enough photos? You need to be able to see all aspects of the garment. Everyone's monitor is different; a piece that appears olive on your MacBook may in fact be charcoal or kelly green. Is there a return policy?

TRY THINGS ON: Visit the dressing room, look at yourself from all sides in a mirror, and don't be afraid to ask for a second opinion. If shopping at a place that may not offer such amenities, such as an outdoor flea market, dress in layers—you may be able to toss on a potential purchase over tights, long underwear, or a tank top, or under a full skirt or dress.

KNOW YOUR MEASUREMENTS: Sizes vary wildly from decade to decade, so don't trust them. If possible, carry a measuring tape. A garment that is too big for you can be taken in, but one that's too small rarely has enough seam allowance to be let out.

INSPECT THE DETAILS: Turn the garment inside out, and look closely at seams and hemlines. Check for fraying, and for broken zippers, snaps, and buttons. Know your fabrics: naturals (cotton, wool, silk) and semisynthetics (rayon) last longer and hold color better. Look at the item in natural light. Prolonged exposure to sunlight can cause fading and discoloration; make special note of side seams and shoulders. Is fabric stretched or sagging, losing its shape? The more complicated something is, the better the possibility of it being high quality, since more work had to be put into construction.

SOME THINGS CAN BE FIXED, OTHERS CAN'T: Everyone should know how to sew a button, and most zippers can easily be replaced. Holes along seams can be stitched back up. Moth holes, cigarette

burns, and certain stains, however, are nearly impossible to vanquish. Ditto for rips that aren't along a seam: patching it would require another piece of the exact same fabric. (That said, if you can cover the flaw with an accessory or jacket, and it really sings to you, maybe you can talk the dealer down.)

Mothballs, cigarette smoke, mold, and mildew: if that sweater smells like it has been folded in the bottom of Great-Aunt Ida's dresser since the Eisenhower administration, proceed with caution. Nothing adds insult to injury like shelling out for a cool but smelly garment, then paying to have it professionally cleaned, to no avail.

KNOW YOUR PERSONAL STYLE: Otherwise that antique red velvet cloak that seemed adorable in the store could look like something you'd wear to go skipping off to Grandmother's house once you get it home.

Tailoring

The ultimate marriage of all these recurring sartorial themes—top-notch materials, quality construction, attention to detail, and the desire for a garment that becomes an extension of the owner's personality—is custom tailoring.

Prior to opening Freemans Sporting Club shop in New York in 2006, entrepreneur Taavo Somer had already garnered attention for his original T-shirt designs. You can still find TAAVO Tees on the clothing racks at Freemans, but the focus is on finely made, lumberjack-worthy fare, classic work shirts, pea coats, selvage denim jeans . . . and handmade suits. Even the off-the-peg suits at Freemans are exquisite. The garments are fashioned from dead-stock wool over a half century old and made by union craftsmen based in Brooklyn. Buttonholes are hand-sewn. Over time, the hand-cut, polished ox buttons will take on a patina that speaks of the garment's history.

For the gentleman who wishes to go one step further, Freemans also

offers its Made to Measure service, a ten-to-twelve-week process that allows the customer to collaborate with a designer and tailor on everything from fit to fabric, yielding a one-of-a-kind suit. These are suits that promise the longevity of Savile Row's finest, heirloom garments that can be passed down through generations. More than thirty-two different measurements are taken of the client's body, and there are multiple fittings at various stages of construction. In British parlance, this specialized degree of customization is traditionally known as bespoke tailoring.* As Americans become more concerned with investing in clothes of quality and distinction, interest in custom tailoring, and bandying about of the word *bespoke,* are also on the rise.

"A lot of people throw around the term *bespoke,*" says Ryan Matthew, "but very few celebrate it." Amber Doyle and Jake Mueser, who sell their bespoke suits at Matthew's New York boutique Against Nature, are two of the few. "People say they do [bespoke], but they don't. Unless it's made on premises, by hand, it isn't truly a bespoke garment."

The custom shirts of New York's Michael Andrews Bespoke feature mother-of-pearl buttons and a choice of dozens of collar and cuff styles. Philadelphia atelier A Fine Tooth offers made-to-measure "Dandy Pants" fitted trousers. Stronghold will manufacture a pair of made-to-measure jeans, from a wide range of fabrics and hardware (although with a starting price around five hundred dollars, you probably won't want to wear them while doing yard work).

Seyta Selter operates Duchess, a clothier in Portland, Oregon, that specializes in made-to-measure suits, and counts rocker Nick Cave and humor-

* Technically, there are differences between bespoke and made-to-measure tailoring. The latter works from a preexisting pattern, modified to the individual client, while the former may involve creating a one-of-a-kind pattern. Another splitting point is the amount of handwork versus machine sewing involved; bespoke garments are hand-sewn, while made-to-measure may use both hand and machine sewing.

ist John Hodgman among its devotees. Working cuff buttons, hand-stitched lapels, unique waistcoats, monograms, and silk linings are all part of the package. Yet her clientele isn't as exclusive as one might expect, including business professionals and plenty of Gen X and Gen Y gents who simply want their first suit to be something special. What they all share, she feels, is an appreciation for something that transcends trends.

Custom-made clothes are an antidote to throwaway culture. You may buy fewer of them, but they last longer and fit better. While Duchess has its share of customers who favor an antiquated look, the steampunks and Victorian dandies are in the minority. "Overwhelmingly, we get people who are simply interested in having something that is not demarcated by a trend or time, and is just constant."

Built

To

Last

Leatherwork
and
Accessories

Never underestimate the timeless appeal of a simple brown shoe; America's heritage footwear manufacturers have had plenty of time to memorize this axiom. Perennial New England favorite Alden Shoes was founded in 1884. Quoddy celebrated its centennial in 2009. As one of their peers notes, "When the Red Wing Shoe Company first started making boots, people still rode horses to work." In a world full of sneaker pimps, staid favorites like the tassel moccasin—an Alden original design—have found a home in discerning men's boutiques. Hip vendors like San Francisco's Unionmade and Epaulet in Brooklyn are selling these brands to young men still new to the workforce, not silver-haired retirees.

Anatomy of a Shoe

The lexicon of shoemaking sounds like it was torn from the pages of Herman Melville. First there are the LASTS, the forms on which the shoes are constructed—which determine such crucial variables as length, width, and left or right.* The SHANK is a support—which may be made from metal, wood, leather, plastic, or other materials—concealed within the sole of the shoe, supporting the arch. A VAMP is a section of leather from which a shoemaker fashions the UPPER—the part (or parts) of the shoe that cover

* This final detail is a relatively new phenomenon. As late as 1850, some shoes were still made on straight lasts, with no distinction between left and right curvature.

the foot and back of
the heel.

Then we enter
the world of WELTS.
There are a variety of
ways to attach uppers to soles.
Cementing or fusing them together
is cheaper and faster. (It also allows for
greater flexibility and lighter weight—a plus
in athletic shoes.) In olden times, soles were at first
sewn directly to uppers, but everyone walked hither and thither, soles wore
out quickly, and the softer leather of the upper could only withstand so many
rebuilds before it gave out. Welt construction involves using an additional
strip of leather, between the supple upper and the tougher stuff of the soles;
this makes for not only a stronger join, but also a shoe that is much more
easily resoled—a big plus when you've shelled out top dollar.

It takes a long time to build a quality shoe, but that shoe also holds up
a lot longer than a cheaper competitor. "Items like an Alden shoe are built
to last," insists Jordan Perry of Winn Perry in Portland. "If you take care
of it, it will last your lifetime. You can send it back to Alden, they'll resole
it, they'll basically send you back a brand-new shoe." That's one of the best
things about top-notch footwear: it can be repaired with the same kind of
workmanship that went into them originally.

One of the fastest ways to learn to distinguish quality shoes is to spend
some time with a cobbler. Marty Krogh of Art & Sole Comfort Footwear
in Portland, Oregon, changed his life path by getting out of graphic design
and turning the shoe repair skills he'd learned from his dad into a new
career. He loves his work, but nevertheless, Krogh passes on three or four
potential jobs almost every day. The alternative would be wasteful for both
Art & Sole and its customers. If the original manufacturer cut corners to
shave costs on their own products, Krogh has to dedicate more time to sal-
vage them, and the bill for those hours can tally up fast.

Back in his workroom, he compares two jobs in various stages of repair.

One is an all-leather dress shoe from Spain. In comparison, the other, a workaday pair made in America by Allen Edmonds, seems a bit humdrum. Upon closer inspection, the Spanish ones don't have stitching; they're held together with glue. They might impress the eye ("and probably cost a fortune"), but weren't a sound investment. Krogh's voice warms as he turns to the others. "This shoe has a traditional welt, and the leather sole is sewn to the welt. It can be reheeled, resoled," and serve its owner much longer.

Even the repair customers Krogh turns down leave Art & Sole with something of value. In a cordial, matter-of-fact manner, he'll show them exactly why shelling out for a repair—if one is even possible—is a bad idea. He is spreading the gospel of good shoes. "The majority of people don't really know," he observes. "Because we don't think about it. You just buy shoes, wear them, throw them out, and buy a new pair." Our grandparents would be appalled—Krogh points over to a crude metal last mounted on a small wooden crate. Now it serves as a prop on his sales floor, but back in the day, plenty of folks used similar ones in their homes or garages. Soles wearing thin? "Dad would hammer on a piece of rubber that he'd cut off an old tractor tire. You made it work."

History

They didn't invent shoemaking in Massachusetts. Cave paintings dating back to 8000 B.C. depict primitive man using some kind of coverings to protect his feet, while Europe's oldest natural mummy (ca. 3300 B.C.) wore ecofriendly shoes made of rawhide bearskin and woven plant fibers. Nevertheless, the Bay State got in on the trade very early, courtesy of Thomas Beard, a London shoemaker who arrived in Massachusetts on the second voyage of the *Mayflower*, in 1629, and set up shop. (Settlers also learned to fashion animal hides into moccasins from Native Americans, and were exporting these back to Europe by 1650.)

Just a few years after Beard, immigrant shoemakers Philip Kirtland and Edmund Bridges came to Lynn (an oceanfront community just north of Boston) and taught the trade to others. Most early American cobblers

were artisans who worked out of their homes or traveled from town to town and specialized in custom work. The trade made a big leap forward when Welshman John Adam Dagyr arrived in Lynn in 1750 and set up the first shoemaking factory, where each employee focused on one task on the production line, rather than making the whole shoe. This allowed Dagyr to streamline operations, emphasize higher standards, and reach new markets. Proximity to harbors in Boston and Salem made it easier for craftsmen in the region to import materials as well as to dispatch them to new customers. Soon eastern Massachusetts towns like Brockton and Haverhill were dotted with small shoemaking workshops called "ten-footers" (because of their modest dimensions). By the turn of the nineteenth century, Lynn was the young nation's shoemaking capital: In 1795, there were over two hundred master craftsmen making shoes in Lynn, assisted by more than six hundred journeymen, turning out shoes at a rate of one pair per man per day.

In the beginning, all this work was done by hand, using techniques that had been around for centuries. With Elias Howe's invention of the sewing machine in 1846, the shoemaking industry grew by leaps and bounds. In 1858, Lyman Reed Blake patented a machine that could sew uppers to soles. By 1875, Charles Goodyear, Jr., had perfected a device that fastened soles and one-piece uppers with a welt in between. Such advances encouraged assembly-line-style production and also increased productivity, reducing the time required to make a pair of shoes by more than 80 percent.

Prior to World War I, shoemaking prospered in different pockets of the country, including western New York, the Midwest, and the upper South, but the Atlantic seaboard states and New England dominated. According to the 1910 census, 40 percent of the nation's shoes came from Massachusetts alone.

Alden Shoe Company

"A century ago, Brockton, Massachusetts, was the home of the finest shoemaking in the world—and today it still is," observes Robert Clark, vice president of sales for Alden. "The only difference is, we're the only ones

left. We are it." While few of their peers survived the Great Depression, World War II, and overseas competition, the company founded by Charles H. Alden the same year Grover Cleveland was elected is still going strong.

There is nothing inherently sexy about Alden shoes. The company has survived by making unglamorous yet dependable dress shoes, as well as orthopedic and medical footwear. One of Alden's claims to fame is its commitment to long-lasting steel shanks, a cool detail but invisible to the eye.

Context Clothing, a high-end denim shop in Madison, Wisconsin, expressed interest in carrying Alden wares—and Clark was intrigued. "We wear ties to come into the office," he says, "and we have this mind-set that that's what our customer does as well. We're selling to business and professional men." Context Clothing was telling them there was a younger generation that could appreciate Alden's quality and consistency. A similar show of interest came from persistent young reps for J.Crew, as it geared up to open its Liquor Store men's shop in New York. The West Broadway boutique, housed in an old liquor store, would stock collaborations with outside vendors and select heritage brands along with J.Crew items and vintage pieces, and they wanted Alden shoes in that mix.

Joining forces with younger vendors has helped long-running companies innovate by prompting casual variations on classic looks, says Clark. "A store will come to us, and they'll say, 'Gee, I love what you're doing here, but what if we did it in this leather, or changed the bottom, or made some other change'—to make the shoe their own." In this way, an outlet like Winn Perry or Context Clothing can enjoy the cachet of stocking Alden goods while also offering something available nowhere else. Sure, certain custom proposals strike the old guard as a terrible idea. "And sometimes we're right. But other times we're not. And we'll make their shoe, and say, 'Wow!' It's a way for us to expand our horizons."

Quoddy Trail Moccasin

Young customers interested in old-fashioned American footwear were not unheard-of by heritage shoe companies, but usually these fans came from

SPATS

What Are They? Little cloth or leather aprons for your shoes, covering the instep and ankle. An abbreviated form of the gaiter (or "spatterdash," hence the name). Popular in the late nineteenth and early twentieth centuries. Designed to protect quality footwear and hosiery from mud, horse plop, and other old-time pedestrian hazards. Still popular with the military, bagpipers, and marching bands.

Practicality: Surely the streets of your neighborhood are paved.

Availability: New York company Spatterdash makes "vintage spats for a 21st century world," selling standard and custom designs at Spatterdash.com. Old pairs surface on eBay.

SUBLIME OR RIDICULOUS? *The ability to accessorize is what separates man from beast.*

overseas—sometimes literally. Quoddy, beloved for its moccasins, is based in Perry, Maine, just about the easternmost point in the continental United States, and halfway to the North Pole. One day several years ago, owners Kevin and Kirsten Shorey were startled by an unexpected visitor. "This guy had just gotten off a plane from Japan, and driven for many, many hours," says company president John Andreliunas. A shopper had flown around the world to purchase Quoddy moccasins.

The Shorey family has been making shoes for more than a century. Kevin's great-great-grandfather, Harry Smith Shorey, who founded Quoddy in 1909, contracted polio as a child. As a consequence, he could only work with his hands and took up making shoes, working at a sit-down bench. Harry Shorey worked for a variety of manufacturers, including L.L.Bean down in Freeport, Maine. His sons, including Kevin's grandfather, Maynard Shorey, were hand-sewers in Burlington. Even Maynard's wife was in on the trade: "We have a pair of moccasins, they're probably size one, that she made for my dad," Kevin says. Today, Kevin and Kirsten's sons, Carlton and Cameron, are the fifth generation of Shoreys in the shoe industry.

The brand name is a nod to the Passamaquoddy tribe of eastern Maine. In addition to moccasins, those Native Americans made beautiful, functional birch bark canoes and woven baskets without using synthetic materials or adhesives—and neither does Quoddy. Their shoes are constructed with one-piece vamps, single pieces of leather that mold to fit the specific contours of each owner's feet over time.

The Quoddy moccasin is a quintessentially American product. "You don't see it anywhere else in the world," says Kevin Shorey. "And they come out of function. Even today, up in Grand Lake Stream, there are guys that are wearing our twelve-eyelet boots as a working boot, because they can feel the ground, the water, whatever is underneath them."

Although its offices are in Perry, Quoddy makes its moccasins in Lewiston, Maine. Like their colleagues at Alden, the Shorey family is familiar with the exodus of New England shoemakers. Manufacturers such as Sebago (makers of Docksides boat shoes), Bass (Weejun loafers), and Dexter have all ceased or curtailed their operations in Maine. The Quoddy workshop resides above the space formerly operated by Cole Haan, another

historic, hand-sewn-shoe company in Maine. In order to survive on U.S. soil, shoemakers like Quoddy have to emphasize quality over quantity, says Kevin Shorey. "We can't compete with the people at Walmart, nor do we want to. That's not who we are. We've had to create an expectation that our craftsmanship is superior, and that standard is what one expects."

These Boots Were Made for Working

Michael Williams, the New York publicist responsible for Americana men's style blog A Continuous Lean, grew up in Cleveland, Ohio, where his father operated a construction company. Family conversations may not have centered around tie widths or suit cuts, but Williams's dad did make sure to instill in his son the importance of proper footwear. "I started working for my father when I was thirteen," says Williams. "There was a Red Wing store in town, and he took me there and bought me boots. I always wore Red Wing."

Function, not fashion, is the rule with work boots. Their rugged looks may appeal to hip urban dwellers, but they're designed for specific jobs, and breaking them in can be a trial. As a young man, Williams got into the habit of buying one pair of Red Wings, then wearing them for a year or so. When he took them in to be resoled, he'd purchase a new pair at the same time. That way he could rotate them, and break in the second pair gradually.

In many cases, much more than the soles can be replaced. Since work boots in particular are subjected to terrific abuse, companies like Red Wing, West Coast Shoe Company (better known as Wesco), and Danner encourage customers to send back treasured pairs to be rebuilt. Heels, shanks, vamps, and even eyelets can be replaced. Since the whole boot can be taken apart, they can even make minor adjustments for size or foot shape.

Red Wing

Red Wing work boots have enjoyed a healthy Japanese following since Americana staples like Levi's jeans took off there in the 1970s and '80s,

which in turn gave these brands new cachet at home, surmises Peter D. Engel, director of marketing and communications for Red Wing. His theory? "The buyers for the J.Crews of the world went on international shopping trips and would see Red Wing in all these places." Engel still recalls his first business meeting with J.Crew. "All the merchandisers were wearing vintage Red Wings that they had bought on eBay, or in Japan, at inflated prices."

Located along the Mississippi River, Red Wing, Minnesota, is home to just over sixteen thousand residents, and it still has a bustling downtown, full of independent businesses. "In the winter, this place looks like Bedford Falls from *It's a Wonderful Life*," says Engel. Snow on the ground, a train station covered in white powder, Christmas lights gleaming. "It looks like Jimmy Stewart is going to come running down the street."

In their promotional materials, work boot makers like Red Wing put a fine point on illustrating how they've helped make America great by outfitting hardworking men and women—and how they've soldiered through hard times too. At the Red Wing factory, workers burned scrap leather for warmth in the wake of Black Friday in 1929. By World War II they were back on top, cranking out boots for U.S. soldiers; for the U.S. Army alone they manufactured almost two hundred and fifty different widths and sizes.

That history, through good times and bad, is a big selling point. "It reinforces the genuineness of the brand and the business," says Engel. "We're real, not made up, invented. We've been making our shoes almost the same way since inception." Cheaper labor and materials from overseas has drastically altered the American shoe industry.* "A lot of people don't make anything in this country anymore. So we need to show folks that we still make them, in a factory in Red Wing, Minnesota, the same way we used to."

* Red Wing makes 2 million pairs of boots annually at its U.S. factories, yet it also outsources a third of its production to China, Engel admits, "to be sure we have shoes that fit all price points."

West Coast Shoe Company

Scappoose, Oregon, does not look like a scene from a Frank Capra classic. There are churches and saloons on either side of Route 30, the highway running through town, but the most prominent roadside attractions are shopping centers and strip malls. Yet tucked away from the main drag, down a few curving side streets and a long driveway, sits the West Coast Shoe factory.

Wesco didn't begin life in a small town. After learning his trade at a shoe factory in Grand Rapids, Michigan, founder John Henry Shoemaker headed west, and worked for other shoemakers in Portland, Oregon, before launching his own business, focusing on logging boots, in 1918. Eventually Wesco had four locations in downtown Portland.

When the stock market crash of 1929 and Great Depression cost him everything but his boot-making equipment, Shoemaker moved to nearby Scappoose. He set up shop in his basement, and enlisted his oldest son, two of his daughters, and their husbands as labor. He rebuilt his company, and by 1937 was able to open a new Wesco factory on the same site where a larger one operates today. The current building is nearly eight times the size of the original, having grown from 2,400 square feet to 19,000, yet Wesco still feels intimate.

As she guides me through the three-story operation, President Roberta Shoemaker—part of the third generation to run the business—rattles off the names of her employees (including her nephew, a factory foreman), details of their tenure, and their areas of expertise. Making a pair of Wesco boots, whether custom or stock, is a process that entails 155 different steps ("give or take"). Working alone, a skilled individual would need a forty-hour workweek just to produce a single pair.

Shoemaking isn't easy work. Roberta Shoemaker likes to move employees around within certain tasks, to ensure they stay efficient, alert, and safety-conscious. The machinery is big and loud. If you turn a blind eye to some of the superficial aspects of the operation—the younger employees with tattoos or Dead Kennedys T-shirts—the Wesco factory could exist in

an earlier era. Shoemaker says she's proud to be part of the Wesco legacy. "It's not really even a job, it's carrying on my grandfather's dream. Besides," she says smiling, "how many people have a trade that is their last name?"

Wolverine's 1000 Mile Boot

Established in Rockford, Michigan, in 1883, Wolverine likes to trumpet how its boots and shoes shod the feet of workers who expanded the nation's highways and constructed its skyscrapers. Though they've kept up with advances in footwear technology since then, when it came time to tell their story to a new audience, they decided to take a step back in time.

Outside North America, Wolverine was largely unknown—after all, they hadn't built the skyscrapers and railroads of Europe. Vendors overseas told the company they needed an attention-getting way to spotlight Wolverine's quality and history. So they revived the 1000 Mile Boot, a product line from 1914 that had set a standard in the previous century, to alert new customers to their legacy.

Fortunately for Roger Huard, vice president of product development, Wolverine had held on to an original pair. "We're not sure exactly how old it is, but it's very old. Someone in the creative department keeps it under lock and key and doesn't let it out of the building."

"Now when people see Wolverine in other product categories[*] they have

[*] They also sell a full line of men's apparel: shirts, jackets, pants, and shorts.

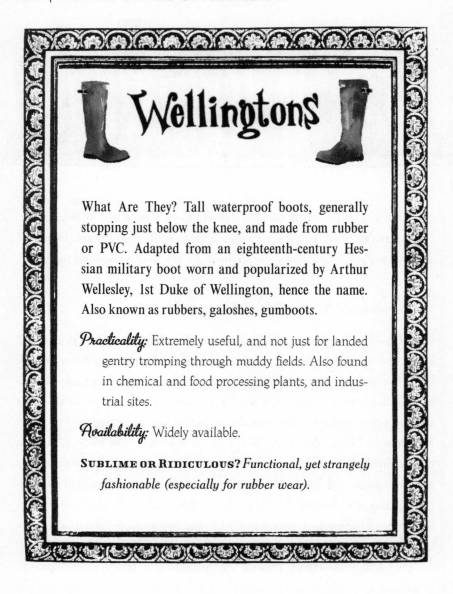

Wellingtons

What Are They? Tall waterproof boots, generally stopping just below the knee, and made from rubber or PVC. Adapted from an eighteenth-century Hessian military boot worn and popularized by Arthur Wellesley, 1st Duke of Wellington, hence the name. Also known as rubbers, galoshes, gumboots.

Practicality: Extremely useful, and not just for landed gentry tromping through muddy fields. Also found in chemical and food processing plants, and industrial sites.

Availability: Widely available.

SUBLIME OR RIDICULOUS? *Functional, yet strangely fashionable (especially for rubber wear).*

that reference: 'Oh, I know this company, because they made boots for so long,'" says Christina Vernon, director of international business development. "It's authentic, it's real, not some fly-by-night company that just showed up." The original 1000 Mile Boot—Wolverine's first nationally advertised boot—had been billed as a product that lived up to its name,

comfortable and durable enough to deliver a thousand miles of wear, and wholly made in America.*

Made with Horween quality leather (established 1905), the revamped 1000 Mile Boot became the centerpiece of a small 2009 collection that also included updated looks inspired by classic dress shoes, and military and outdoor boots; the latter models, the Gentry Collection, benefited from the prestige of featuring exterior panel inserts made by Pendleton. There were a few small concessions made to modernity—feet have gotten wider, for one thing—but overall, it reproduced the original as faithfully as possible.

Although the 1000 Mile Boot embodied the workmanship and quality materials upon which Wolverine has built its reputation, it wasn't aimed at their core U.S. demographic, which Vernon summarizes as an older, blue-collar male, with a lot of brand loyalty, for whom Wolverine work boots are a tool of the trade. "He wears a new pair to church, and once those are worn in he wears them to work."

But the 1000 Mile Collection carries a higher price tag, and was targeted to overseas customers and cosmopolitan gentlemen, not the construction worker.† "He doesn't know Wolverine work boots, because he never had any need to wear work boots before, but he could appreciate the authenticity and quality," says Vernon. Most of the feedback she receives on the 1000 Mile line comes from shoppers who'd never been acquainted with Wolverine before. Although the company did no print advertising to roll out the 1000 Mile Collection, relying instead on blogs and word of mouth, they were featured in *GQ* (modeled by actor Ryan Kwanten of HBO's *True Blood*) even before they hit store shelves.

The next phase of the 1000 Mile project may attempt to reconcile Wol-

* The new version is Made in America, too, but just barely. The outsoles begin life in Mexico but are finished in America. Wolverine also makes Oxfords for the Department of Defense, and is very familiar with what is necessary to be compliant with the Berry Amendment, which sets very strict rules about what qualifies as a domestically grown, produced, or manufactured U.S. good.

† "At best, the Thousand Mile Boot is what I would call a farm boot," says Huard. It doesn't have a steel toe or rubber outsole.

verine's old-school customers with its new fans. Huard hopes to build a boot that combines the ruggedness of their newer models with the craftsmanship of the classics, though they still wouldn't be inexpensive. "So maybe the guy digging the ditch can't afford it . . . but the guy looking at the guy digging the ditch—project managers or whatever—can."

Billykirk: Outsourcing to the Amish

Billykirk's primary labor force isn't exactly ultramodern. Much of their work is done by Amish craftsmen in Pennsylvania. The Amish adherence to tradition and commitment to a plain and simple way of life resonated with brothers Chris and Kirk Bray. "The Amish are about as ecofriendly as you can get," says Chris Bray.

The partnership does pose some unique challenges. The Brays' Amish collaborators don't use electricity.* During the shorter days of autumn and winter, they work by the light of hurricane lamps and wood-burning stoves. Just scheduling initial negotiations required telephoning a remote neighbor, and asking them to dispatch a child to relay the Brays' inquiries to the Amish; for regular communication they use a communal "call box" located off premises to receive messages and return calls. However, the sect's commitment to hard work and no frills dovetails perfectly with Billykirk values. "They've actually suggested loads of great ideas that not only help in production, but save us money," he adds. "That's how honest they are!"

The Billykirk look and feel is very back-to-basics. Brand-new pieces feel aged. "It takes a long time to figure out [leather's] limitations, how it wears in, achieves a certain patina. Leather is always changing." They treat the leather with specific oils and polishes to achieve desired finishes. All metal hardware, even rivets, is tumbled to dull its luster. "We don't like shine."

The Bray brothers had always planned to collaborate creatively, and

* They do permit the use of gas-powered machinery "since gas comes from the earth," says Chris Bray. "They are ingenious in retrofitting old machinery to fit their needs."

Kirk graduated with a degree in fashion design. They were both living in Los Angeles in the 1990s and knew designers—the path seemed obvious, but tackling a whole clothing line felt daunting. Instead they took inspiration from a single source: a vintage watchband found in a pawn shop. "The wide watch strap is nothing new," admits Chris. Elvis sported one in *Jailhouse Rock*. Marlon Brando wore them, too, as did early punk rockers. Leather goods seemed manageable, especially since the Brays' father had taught them how to make scabbards for knives in their youth. They hooked up with Arnold Arons, a retired, third-generation Los Angeles craftsman who still had original, solid metal dies for straps he'd made in the 1960s and '70s, and learned the basics from him. They began producing their own version in 1998. "Before you know it, Gucci, Fossil, and everybody else started doing wide watchbands."

Billykirk was a newcomer, but the Brays launched with a price tag consistent with those of longtime luxury purveyors. "It was all about function, utility, and top-quality materials and hardware. If your brand has those elements, people will feel the quality, and you can justify your price point." Nobody balked. "Billykirk sells really well in our store," confirms Steve Grasse, owner of Philadelphia boutique Art in the Age. "People are drawn to the quality and the design." And the durability. "These pieces are utilitarian, they're meant to be thrown around," says Chris. Billykirk goods hold up, and the Brays hope their bags and belts will become heirlooms, passed down through generations.

The Brays love music, too, especially contemporary Americana. "The bands we like are leather-belts-and-boots guys," Chris says. "They look like us: we're always in work wear, old shirts and trousers, and old boots." One of their favorites is Wilco, and when the Chicago combo passed through New York in 2009, and their management called to order some merchandise, Billykirk learned the admiration was mutual. Despite the time-consuming, painstaking detail that goes into each Billykirk piece, they threw themselves into production. They delivered almost fifty pounds of goods—wallets, belts, bags—for musicians and crew to share.

One of Billykirk's cornerstone products sprang from the assembly line:

the Hidden Buckle Belt. The grandfather of the Brays' L.A. mentor fashioned the original for auto factory workers, featuring an extra leather flap over the buckle, to prevent accidental scratches to virgin paint jobs coming down the line. "We borrowed that design, put our own twist on it, and it's one of our bestselling items." Today it's especially popular with guitarists eager to protect their instrument's finish.

The Bollman Hat Company

When Billykirk began producing men's hats, they didn't have to look too far to find a collaborator—in fact, the collaborator found them. The Bollman Hat Company, based in Adamstown, Pennsylvania, had heard that some of their Amish neighbors in Lancaster County were working with Billykirk. Bollman investigated the Bray brothers' outfit and liked what they saw. "What they were doing was very simple and it focused on quality and craftsmanship," says Bollman account executive Alexis Biondi. "Our stories fit very well together." The two companies joined forces and for fall 2009 developed a line of three wool felt hats, in classic bowler, trilby, and English walker styles, each featuring a Billykirk leather band.

Started in 1868 by George Bollman and Isaac Sowers, Bollman has gradually accumulated a portfolio of exclusive partnerships with many of the leading headwear brands, such as Kangol, Bailey, Country Gentleman, and Timberland. Today they have operations on four different continents but continue to make wool felt, fur felt, and straw hats at their factory in Adamstown, much the same way they always have, according to CEO Don Rongione. "The technology that we have is pretty much the same technology that has been used for over one hundred years." Machines aid some jobs that were once done solely by hand, such as sewing and sanding finishes, but automation hasn't cost too many jobs. "Hat making is still pretty labor intensive."

A well-made hat can be maintained over years of wear, just like a quality shoe. Blemishes can be sanded out, and some tack shops and dry cleaners will steam, reshape, and repair premium hats—that is, if you can find one. "There are so few people that make quality wool hats anymore that there really isn't much need for that in a dry cleaner," Biondi admits. However, she is seeing a resurgence of interest in certain vintage styles, especially with wider brims. "It's your grandpa's hat, and that look is becoming more popular with young people."

Like many companies, Bollman has downsized its domestic manufacturing due to economic pressures. However, the employee-owned company is also fighting back. In 2009, it launched the Save An American Job initiative, aimed at educating customers about the benefits of buying products made in the United States. "There's a heightened awareness among consumers and up-and-coming brands that there's still great technology and know-how and capabilities in U.S. manufacturing," says Rongione, "and if we don't support these industries, they will disappear, and that knowledge and expertise will be gone with it forever."

Makr Carry Goods

Established in late 2007, Florida-based Makr Carry Goods initially made its splash crafting wallets, which still strikes Jason Gregory as funny. "I've always hated wallets," says the man behind Makr. "I don't like billfolds. They're too big."

Although he was fascinated with fine art as a child, Gregory's original career path was far removed from hand-sewing and leather craft. He started working at a design firm developing brand identities for big restaurant and beverage chains. However, one of the tools of the trade at his disposal was a laser cutter, designed to cut sheet materials into patterns, and that machine sparked his imagination.

"I had this leather bag from my grandfather that was falling apart. One of the pieces was big enough to cut and fold in half and make a little card holder. I just cut that on the laser, and hand-sewed it." The result was crude

but simple, and Gregory loved it. He continued experimenting, and when he had the chance to buy a secondhand laser cutter at a drastically reduced price, he did.

Modern technology had provided Gregory a point of entrance into this age-old handcraft, but now he found himself looking backward too. "I started getting interested in the heritage aspects, how things used to be." He learned splitting and skiving, hand polishing and sanding, and how to burnish edges—attention to details that would become hallmarks of Makr Carry Goods. Although he originally used modern tools to add graphic designs to some products, once Makr began working with leather supplied by Horween—one of the oldest continually operating tanneries in America—Gregory let the beauty of the leather and finishes speak for themselves.

"A lot of people call me a craftsman, and I am, but I'm definitely a designer first." Reconciling old and new techniques, Gregory uses 3-D imaging software to realize his visions, yet can also account for every individual piece and process that goes into making one of his wallets, bags, or camera cases. Nowadays, a local factory assembles larger Makr pieces, such as their satchels, but Gregory remains closely connected with every stage of operations. "I'm not just sending a sketch to a factory, and then having them make a pattern, and me editing it. I'm fully, start to finish, designing the whole piece."

Gregory believes that the passion and attention to detail given to the pieces imparts them with qualities that transcend design skills. "If you're edge painting this wallet, and then buffing it, and edge painting it again, and holding it and polishing it, you're going to care about it." And that positive energy is transferred to the customer who buys a Makr good. "They're going to know it was cared for. It wasn't stamped out, sewn really quick, and thrown in a plastic bag."

Songs

of

Pioneers

Music

Like other umbrella terms, *Americana* encompasses a lot of territory. In a nutshell, Americana, the musical genre, stems from contemporary artists using traditional roots music as a jumping off point. Emmylou Harris is an iconic example. She has been a prime mover in both commercial country music and outside it, without compromising her aesthetic. She scored five number-one country singles between 1976 and 1983. Yet in the early '70s, prior to that success as a solo artist, she established herself by harmonizing alongside country-rock pioneer Gram Parsons. Later in her career, in the 1990s, she worked with experimental producers like Daniel Lanois (U2, Peter Gabriel). She even scored a Top 10 pop album when she released *Trio* in 1987 with Dolly Parton and Linda Ronstadt. Harris has recorded everything from Patsy Cline classics, to songs written by underground Nashville icon Buddy Miller, to her own originals.

However, an artist need not be a Nashville star to qualify as Americana. Rock icons Bob Dylan, Bruce Springsteen, the Band, and Neil Young were all Americana artists long before that tag was widely used.[*] At the other end of the spectrum, there are underground acts like Conor Oberst of Bright Eyes, Lucinda Williams, Will Oldham,[†] and the Avett Brothers, who are favorites on college radio and pointy-headed critics lists, yet definitely count as Americana too.

[*] Even if the latter two are Canadian. (Think of it as "North Americana" perhaps.)
[†] Oldham has recorded under many aliases, including Bonnie "Prince" Billy, Palace, Palace Brothers, Palace Songs, and Palace Music, as well as his own name.

Several artists who were keystones for Americana in the 1990s quickly evolved beyond easy categorization. Neko Case, who'd originally cut her teeth playing drums and singing in Canadian punk combo Maow, became an alt-country pinup* with her 1997 solo debut, *The Virginian*. While that disc featured covers of Ernest Tubb, Loretta Lynn, and the Everly Brothers, subsequent releases such as *Blacklisted* (2002) and *Middle Cyclone* (2009) emphasized Case's development as a songwriter and highly expressive singer, and her overall aesthetic embraced a darker, more sophisticated character that wasn't easily pigeonholed. Jeff Tweedy's band Wilco emerged from the ashes of Illinois combo Uncle Tupelo, whose 1990 album *No Depression* is often credited as ground zero for the alt-country movement. Within a year of issuing their country-rock debut, *A.M.*, Wilco was delving into different realms—psychedelia, power pop, and gritty R&B—on its 1996 double-disc follow-up, *Being There*, still regarded as their masterpiece. And Ryan Adams, former front man for Whiskeytown, has made a career out of being unpredictable and contrary. Although his first solo release, *Heartbreaker* (2000), was recorded in Nashville, with assistance from Gillian Welch, David Rawlings, and Emmylou Harris, in the years that followed he zigzagged from polished, radio-friendly rock (2001's *Gold*) to brooding bedsit melodrama reminiscent of the Smiths (2003's *Love Is Hell Pt. 1*), then back to classic country (2005's *Jackson City Nights*).

The Americana genre has also provided a niche for artists who enjoyed mainstream country status at one time or another, yet have evolved beyond the current Top 40 flavors Music Row heavily promotes today, such as Rosanne Cash and Rodney Crowell. Shelby Lynne had actually walked away from a successful Nashville career (and made six prior albums) before she won the 2000 Grammy Award for best new artist for her confessional singer-songwriter set *I Am Shelby Lynne*. On his 1997 album *South*

* Literally—in the late 1990s, Case posed for cheesecake shots published in Seattle zine *Kutie*. However, she very pointedly declined to pose nude for *Playboy* after winning a 2003 Playboy.com poll as "Sexiest Babe in Indie Rock."

Mouth, alt-country icon Robbie Fulks immortalized his frustrating years as a Nashville songwriter-for-hire in the blistering kiss-off "F*ck This Town."

"It is said, and it is true that you can hear a lot more Hank Williams and Webb Pierce on the Lower East Side of New York than you will find in Nashville these days," wrote WFMU DJ "The Hound" in the liner notes for Diesel Only's *Rig Rock Juke Box*, one of the earliest alt-country CD compilations, in 1992. Most of the artists in the Diesel Only family, he noted, hailed not from New York City but outposts like Knoxville, Tennessee, and Terre Haute, Indiana. Their shared purpose was simple, "to form bands that could play music as if all that shit that's clogged up the airwaves for the last twenty years or so never happened."

The Americana universe also includes acts drawing on roots music genres other than country, such as the retro-soul of Sharon Jones and the Dap-Kings and the blues-rock of Black Keys, as well as younger bands—Band of Horses, My Morning Jacket, the Drive-By Truckers—that just as likely discovered roots music through mainstream rock giants like the Grateful Dead, Lynyrd Skynyrd, and Neil Young.

Americana is a wonderful interstitial zone where Dolly Parton, a dyed-in-the-wool country star with crossover pop appeal, can make a trio of bluegrass albums that put renditions of Led Zeppelin and Soul Collective next to traditional favorites like "Silver Dagger." Where a string band such as Old Crow Medicine Show and jam band favorites the String Cheese Incident can comfortably share festival billing—even though their audience may not realize both acts are expanding on an improvisational tradition that stretches back to bluegrass great Bill Monroe.

Legends of American Roots Music

Many musical styles can be classified as "roots music": country, folk, bluegrass, gospel, the blues, even rockabilly and soul. Here's a crib sheet of some of the most seminal figures who forged these genres and brought them into mainstream popular culture, setting the template for the permutations and combinations that would yield contemporary "Americana."

Country

The Carter Family

The most influential ensemble in American country music, period. Featured vocalist, song hound, and patriarch A. P. Carter (1891–1960); his wife, Sara, on vocals, autoharp, and guitar (1898–1979); and their sister-in-law "Mother" Maybelle on vocals, guitar, autoharp, and banjo (1909–78).

When: A.P. and Sara tied the knot in 1915 and began performing locally, but Maybelle didn't start making music with them until 1926. Although the original trio stuck together until 1943, they recorded most of their best-known sides for Victor between 1928 and 1934.

Where: The Carters hailed from the Clinch Mountains, a ridge in the Appalachians that borders Virginia and Tennessee, immortalized in their song "In the Shadow of Clinch Mountain."

Greatest Hits: "Keep on the Sunny Side," "Will the Circle Be Unbroken," "Single Girl, Married Girl"

Outstanding Achievements: A.P.'s relentless collecting of old-time mountain songs, and the Carters' subsequent arrangements and recordings, formed the cornerstone of the modern country music canon. The trio elevated the role of vocal harmony, and Maybelle's innovative bass tunings and "chicken scratch" guitar style influenced generations of players to follow.

Bonus Points: Talent runs strong in these genes. After the original trio split, in the wake of A.P. and Sara's divorce, "Mother" Maybelle continued performing with daughters Helen, Anita, and June. June married Johnny Cash, which extended the family's legacy even wider. Third-generation artists Carlene Carter (June's daughter from a previous marriage) and her stepsister, Johnny's daughter Rosanne Cash, both learned their trade singing backup with various Carter/Cash traveling revues.

Recommended Listening: *Anchored in Love: Their Complete Victor Recordings* (Rounder, 1993); *Can the Circle Be Unbroken?* (Columbia Legacy, 2000)

Jimmie Rodgers (1897–1933)

"The Singing Brakeman" was country music's first bona fide star, discovered at the same Bristol, Tennessee, sessions as the Carter Family. Stylistically, he reached beyond mountain music, incorporating elements of blues, gospel, cowboy songs, and more into his oeuvre; his 1930 cut "Blue Yodel No. 9" paired him with jazz icon Louis Armstrong. With his sweet, unpretentious singing style, he even made yodeling cool. Seriously.

When: He recorded for a mere seven years, from 1927 to 1933, when tuberculosis cut his life short.

Where: Rodgers was born in Mississippi, but grew up in Georgia (which he mockingly disparages in "T For Texas"). During his ten-year stint as a railroad man, he traveled and performed throughout the South and the West Coast, and was exposed to African American musical idioms by black coworkers.

Greatest Hits: "T For Texas (Blue Yodel No. 1)," "In the Jailhouse Now," "Waiting for a Train"

Outstanding Achievements: The original "Blue Yodel" was one of the earliest country records to sell a million copies. Rodgers was the first artist inducted into the Country Music Hall of Fame.

Bonus Points: In May 1933, Rodgers traveled to New York for a final round of recording, the better to ensure his family's financial security. His debilitated condition required attendance by a nurse, and he rested on a cot between takes. He went into a coma the day he finished his last song, "Fifteen Years Ago Today," and died within twenty-four hours.

Recommended Listening: *The Essential Jimmie Rodgers* (RCA, 1997)

Hank Williams (1923–1953)

The most popular country artist of his era, and a significant influence on the rock-and-rollers who would soon follow, and not just musically. (His

hard-drinking, pill-popping life and pandemonium-inducing celebrity had much to do with it too.)

When: Williams won his first amateur radio contest in 1937, singing an original ("W.P.A. Blues"), but he really took off after joining the cast of the popular *Louisiana Hayride* radio show in 1948, scoring his first number-one record ("Lovesick Blues") the following year. He dominated the charts until his death in 1953, at age twenty-nine.

Where: Williams grew up in southeastern Alabama (his father worked for a railway line, and the family had to relocate frequently). He suffered a heart attack and died in the back of his Cadillac in West Virginia, en route to a gig in Canton, Ohio, on New Year's Day.

Greatest Hits: "Lovesick Blues," "Why Don't You Love Me," "Cold, Cold Heart"

Outstanding Achievements: Thirty-six Top 10 hits is nothing to sneeze at. Heck, he racked up three number-one singles *after* he died. A charismatic live performer, he was also incredibly straightforward in his expression of emotions ("I'm So Lonesome I Could Cry").

Bonus Points: Despite his wild reputation, Williams got his musical start singing in the choir of the Baptist church where his mother played the organ. In 1950, when he was already a huge country star, Williams began issuing religious recordings under the pseudonym "Luke the Drifter."

Recommended Listening: *Hank Williams: Gold* (Mercury Nashville, 2005)

Old-Time String Band

Charlie Poole (1892–1931)

Banjo player and band leader of old-time string combo the North Carolina Ramblers. A forefather of both bluegrass and country music. Though he composed few, if any, of his own songs, his custom-

ized renditions popularized many minstrel songs, Victorian ballads, and comedic burlesques.

When: Poole's career was brief but his influence far-reaching. Between 1926 and his death, Poole and his Ramblers cut 110 recordings for Columbia Records.

Where: North Carolina (of course), although he'd been tapped to supply the music for a Hollywood film shortly before his death.

Greatest Hits: "Don't Let Your Deal Go Down," "You Ain't Talkin' to Me," "If the River Was Whiskey"

Outstanding Achievements: Poole's unique, three-finger banjo style (which he allegedly developed as the consequence of a youthful baseball accident) anticipated bluegrass by two decades, while his straightforward delivery—and hard-drinking lifestyle—were echoed in the career of Hank Williams. His first hit, 1925's "Don't Let Your Deal Go Down," sold over 1 million copies, at a time when it was estimated there were only sixty thousand record players in the country!

Bonus Points: Poole purchased his first quality banjo using money he'd earned brewing moonshine. In 2004, John Mellencamp retrofitted Poole's "White House Blues" as "To Washington," a scathing indictment of George W. Bush's administration.

Recommended Listening: *You Ain't Talkin' To Me: Charlie Poole and the Roots of Country Music* (Columbia Legacy, 2005)

Bluegrass
Bill Monroe (1911–96)

"The Father of Bluegrass." Master of the mandolin, an instrument he took up only because his older brothers had gotten to the guitar and fiddle first.

When: Monroe's career peak came in the mid-1940s, but he had begun playing out with his brothers in the early '30s. The '60s folk revival revitalized his profile. Despite heart trouble and cancer, he continued performing into his eighties.

Where: Monroe's home was a suitcase: from the 1950s on, he toured constantly. Other geographical points of interest: He formed the original Blue Grass Boys in Atlanta; born in Rosine, Kentucky, and died in Springfield, Tennessee; opened a music park in Bean Blossom, Indiana (still in operation).

Greatest Hits: "Blue Moon of Kentucky," "Kentucky Waltz," "Footprints in the Snow"

Outstanding Achievements: Monroe created the template for classic bluegrass: virtuoso playing, quick handoffs of solos between players, tight vocal harmonies and "high, lonesome" singing, and rapid-fire tempos. Won a Lifetime Achievement Award at the 1993 Grammys.

Bonus Points: Between 1938 and 1996, over 180 different players were regular members of Monroe's Blue Grass Boys ensemble, including a who's who of notables: Carter Stanley, Jimmy Martin, Del McCoury, and breakthrough act Flatt & Scruggs. And where do you think the term *bluegrass* came from?

Recommended Listening: *The Music of Bill Monroe from 1936 to 1994* (MCA, 1994)

Folk

Woody Guthrie (1912–67)

The individual who injected American folk music with social consciousness. A huge influence on the young Bob Dylan.

When: Guthrie first picked up the guitar in 1929, but he didn't make his first recordings until 1940. In 1952, he was diagnosed with Huntington's disease. As a consequence of his deteriorated condition, he was unable to take much advantage of the folk revival of the '60s and died in 1967.

Where: Born in Oklahoma, Guthrie began traveling through Louisiana and Texas before he was sixteen, working menial jobs. He hitchhiked and hopped trains all across the country

throughout the Great Depression, playing his music wherever he went. He finally settled in Los Angeles in 1937, and relocated to New York a few years later.

Greatest Hits: "This Land Is Your Land," "Hard Travelin'," "So Long It's Been Good to Know Yuh"

Outstanding Achievements: Guthrie's revolutionary songs, many of them based on traditional melodies, have been adopted by subsequent icons including Johnny Cash, Bruce Springsteen, Odetta, Wilco, and hundreds more.

Bonus Points: His guitar was emblazoned with the motto "This Machine Kills Fascists." In 1941, under the auspices of the Works Progress Administration, Guthrie was employed to spend a month writing songs inspired by dam construction projects along Washington's Columbia River. Although known for his left-wing politics, he was refused admittance into the U.S. Communist Party because he wouldn't renounce his religious beliefs. In 1961, a year after reading Guthrie's autobiography, *Bound For Glory*, Dylan made a pilgrimage to visit him at Greystone Hospital in New Jersey, where the folk pioneer spent the last years of his life.

Recommended Listening: *This Land Is Your Land: The Asch Recordings, Vol. 1* (Smithsonian Folkways, 1997)

Leadbelly (1885–1949)

Iconic African American folk musician and self-appointed "King of the Twelve-String Guitar."

When: He entered the world as Huddie Ledbetter sometime in January 1885. Though he displayed an aptitude for music as a child and was performing by his teens, he didn't achieve widespread recognition until the 1930s. He died of Lou Gehrig's disease on December 12, 1949.

Where: Ledbetter was born in Louisiana and grew up there and in Texas. Traveling and working as a sharecropper

and farmer introduced him to songs dating back to the days of slavery. (Along with his originals, Leadbelly's adaptations of older songs comprised a significant part of his repertoire.) He also worked with Blind Lemon Jefferson while in Dallas. He was "discovered" while serving time at the notorious Angola Prison Farm (aka Louisiana State Penitentiary), where he expanded his repertory, and was recorded by musicologists John A. and Alan Lomax.

Greatest Hits: "Midnight Special," "Goodnight Irene," "Rock Island Line"

Outstanding Achievements: Incarcerated on multiple occasions, including a murder conviction in Texas, Leadbelly famously composed musical pleas for his freedom. Texas governor Pat Neff—who'd brought guests to hear Leadbelly sing in prison—did grant him early release from the Harlem prison in Sugar Land, Texas, as a result. (Contrary to myth, authorities claim the same tactic wasn't what sprung him from Angola; he'd earned time off for good behavior.) His song "Goodnight Irene" sold millions of records, albeit as recorded by the Weavers and shortly after his death.

Bonus Points: In 1960, Folkways released the Leadbelly compilation *Negro Folk Songs for Young People*, making him possibly the only convicted murderer with a popular children's album to his credit.

Recommended Listening: *Midnight Special* (Rounder, 1991); *King of the 12-String Guitar* (Columbia Legacy, 1991)

Blues

Charley Patton (circa 1891–1934)

King of the Delta Blues. Influenced Robert Johnson, Howlin' Wolf, and John Lee Hooker.

When: Patton was born in 1891, or maybe 1887. Possibly 1894. Folks were lax about dates back then. By the time he began making records in 1929, he'd already been a popular live performer for fifteen years. He died of heart failure in 1934.

Where: The Mississippi Delta. He was born there, died there, and was a bona fide celebrity throughout the region. His recordings, however, were made in such glamorous locales as Grafton, Wisconsin, and Richmond, Indiana.

Greatest Hits: "Pony Blues," "High Water Everywhere," "Screamin' and Hollerin' the Blues"

Outstanding Achievements: Patton had numerous trademarks, including his bottleneck slide guitar playing, driving rhythms, and a booming voice that legend claims could carry five hundred yards without amplification. He was a notorious showman, playing guitar behind his back or head, and peppering his vocal delivery with vaudevillian asides. His facility with a variety of styles made him popular with both black and white audiences.

Bonus Points: Only one known photograph of Charley Patton exists. In 1929, Paramount Records promoted Patton's second release ("High Water Everywhere") with an unusual contest: the disc was credited to the "Masked Marvel," and customers who bought a copy and correctly identified the recording artist, and mailed in an enclosed postcard with their answer, would receive a second Paramount record free.

Recommended Listening: *Screamin' and Hollerin' the Blues: The Worlds of Charley Patton* (Revenant, 2001)

Blind Lemon Jefferson (circa 1893–1929)

Dubbed both King of the Country Blues and Father of the Texas Blues. Among the most commercially popular blues singers of his day and a huge influence on Lightnin' Hopkins, Leadbelly, T Bone Walker, and B. B. King. As for that moniker, he was blind from birth and, yes, his given name really was Lemon.

When: The actual dates of his birth and death are inexact. July 1897 and September 1893 have been cited as the former, and mid-December 1929 the latter. There are numerous

stories surrounding his mysterious death, all of them grim (poisoning, heart attack, exposure to cold, robbery), but during the latter half of the 1920s he was the bestselling "race records" artist around. His discs "Got the Blues" and "Long Lonesome Blues" sold in the hundreds of thousands.

Where: Jefferson was born in Couchman, Texas. Dallas always served as his home base, though he journeyed and played all through the South and Southwest in the 1920s and performed and recorded extensively in Chicago.

Greatest Hits: "Black Snake Moan," "See That My Grave Is Kept Clean," "Easy Rider Blues"

Outstanding Achievements: Despite his physical handicap and unusual sound—a rather eerie, high-pitched voice and complex guitar figures—Jefferson became the first male blues artist to ascend to widespread prominence, in a field previously dominated by female vocalists (Bessie Smith, Ma Rainey) accompanied by bands. Jefferson's "Matchbox Blues," later recorded by Carl Perkins and the Beatles, is recognized by the Rock and Roll Hall of Fame as one of the songs that fostered rock and roll.

Bonus Points: In a cruel twist, the resting place of the author of "See That My Grave Is Kept Clean" wasn't acknowledged until a Texas historical marker was erected in 1967.

Recommended Listening: *King of the Country Blues* (Yazoo, 1985)

Gospel
Thomas A. Dorsey (1899–1993)

"The Father of Gospel Music." Fused blues and jazz traditions with Christian praise and evangelical zeal to mint a new genre.

When: The son of a Baptist preacher and a music teacher, Dorsey started out playing secular music as "Barrelhouse Tommy" and, later, "Georgia Tom." In 1932, Dorsey established one of the first

gospel choirs. Later that same year, his wife died during childbirth, inspiring his greatest composition, "Take My Hand, Precious Lord." His writing and travel tapered off in the 1960s, but Dorsey remained active in the gospel community until his death, and featured prominently in the 1982 documentary *Say Amen, Somebody.*

Where: Dorsey grew up and started performing in Augusta, Georgia, but migrated to Chicago in 1916, where he found his greatest success working in the African-American churches of the South Side.

Greatest Hits: "Take My Hand, Precious Lord," "Peace in the Valley," "If You See My Saviour"

Outstanding Achievements: Wrote more than four hundred gospel compositions. Founded his own sheet music publishing company. Discovered and nurtured the career of "the Queen of Gospel Music," Mahalia Jackson, who performed "Precious Lord" at the funeral of Dr. Martin Luther King, Jr.

Bonus Points: Before turning away from secular music, Dorsey cowrote and recorded the saucy million-selling blues hit "It's Tight Like That." "Peace in the Valley" was Elvis's favorite gospel song.

Recommended Listening: *Precious Lord: The Great Gospel Songs of Thomas A. Dorsey* (Columbia, 1973)

Alt-Country . . . Whatever That Was

"Alternative? Alternative to What?"

In the 1990s, this was a popular response from musicians when journalists branded them alternative rock. (In retrospect, "where are they now?" contenders like Better Than Ezra and Silverchair should've been grateful people were discussing them, period.) *Alternative* felt like corporate-speak, a buzzword that told audiences these acts weren't ready for wrinkle cream, yet transcended cult status too. They might aspire to headline Lollapalooza, but selling out Madison Square Garden would be . . . well, selling out.

Alternative country, or *alt-country,* was an even more confusing term. Before the even broader *Americana* came along, it was the label most often ap-

plied to modern bands inspired by traditional roots music. The editors of *No Depression* magazine (established in 1995) acknowledged this conundrum early on, amending the slogan "whatever that is" to their billing as an alt-country periodical. It was a definition by process of elimination. Alt-country didn't sound like the mainstream product coming out of Nashville, and while it kicked up just as much dust as alternative rock, alt-country underscored the roots of rock in old-school country and blues in a way grunge rarely did.*

It wasn't even the only name for the ill-defined genre being bandied about. Emmylou Harris, one of the major figures in the *No Depression* pantheon, expressed an affinity for the tongue-in-cheek "y'all-ternative." Bloodshot Records, the seminal roots rock imprint out of Chicago, began chronicling the burgeoning scene with a trio of anthologies titled *Insurgent Country.* Artists showcased on these discs include stalwarts like the Old 97's, Lambchop, and Robbie Fulks. Rob Miller, who founded the Bloodshot label in 1994, with partner Nan Warshaw, has mixed feelings about the "insurgent country" tag today. "When I still see it, yeah, I regret it," he admits. They had to call it *something*, and the critical language to discuss the new music they championed hadn't yet been minted.

Recording artist, writer, and radio show host Laura Cantrell recalls firsthand the tricky business of nomenclature on the frontier of '90s roots music. This wasn't just because her weekly program on New Jersey station WFMU, *Radio Thrift Store*, which mixed vintage and alternative country, was a pivotal media outlet for these sounds.† Her future husband, Jeremy Tepper, started up Diesel Only Records in 1990, specializing in 45s of new alt-country acts intended for truck stop jukeboxes. "I remember Jeremy and his efforts at making *rig rock* a household word," says Cantrell. "You were just trying to get any attention you could."

The notion of alternative country, by any name, wasn't a new one. Reac-

* One exception that made the rule was Nirvana's *Unplugged* version of "Where Did You Sleep Last Night?," which made strange bedfellows of Leadbelly and MTV.

† *Radio Thrift Shop* aired on WFMU from June 1993 to October 2005. It later aired during two summer seasons on BBC Scotland, and Cantrell occasionally returns to the airwaves at WNYC and WFMU.

tions against Nashville norms had been revitalizing the genre for decades. In the 1960s, when Music Row's lush "countrypolitan" arrangements yielded slick commercial crossover hits (Eddy Arnold's maudlin 1965 hit "Make The World Go Away" topped Adult Contemporary charts, and went Top 10 pop), some country fans sought solace in the Bakersfield sound, an electrified update of honky-tonk popularized by Buck Owens and Merle Haggard, instead. During the Reagan years, "cowpunk" bands like Rank & File and Jason & the Scorchers showed kids in combat boots that country music didn't automatically equal Barbara Mandrell.*

No matter how it's classified (cowpunk, rig rock, alt-country, or Americana), often all it takes to make roots music more palatable to new listeners is distinguishing it from commercial country fare. "I was always biased against Nashville," says Robin Pecknold. Today, his band, Fleet Foxes, is heralded as one of the brightest Americana acts around. As an adolescent in the 1990s, Pecknold wanted nothing to do with what was considered country music: Garth Brooks, Shania Twain. Instead he was drawn to oddball artists such as Bobbie Gentry ("*Delta Suite* is probably my favorite country record") and Glen Campbell (who worked with the Beach Boys and psych-rock act Sagittarius long before he hit number one with "Rhinestone Cowboy" in 1975). As Pecknold puts it, "It's the country music that's least like country that I love."

Essential Gateway Albums

Over the decades, plenty of pop and rock artists have dipped their toes into the wellspring of country music, with predictably uneven outcomes; soul icon Bobby Womack's 1976 *BW Goes C&W* can't even get by on novelty value. Here are several seminal records that eased country-phobic listeners a little closer to Nashville and helped define "Americana" as a genre.

* New subgenre names still pop up: In Seattle a couple of years ago, the attention around country- and folk-rock acts like Fleet Foxes, Cave Singers, Grand Archives, and the Moondoggies prompted some wags to start joking about the "grange" movement.

Modern Sounds in Country and Western Music

(ABC/PARAMOUNT, 1962) BY RAY CHARLES

Having conquered jazz (1960s *Genius + Soul = Jazz*) and R&B, Charles threw a chart-topping curveball by mixing barroom ballads and honky-tonk stompers with lush strings and big band swing. Includes the number-one pop hit "I Can't Stop Loving You," which won a Grammy Award . . . for best R&B performance.

Nashville Skyline (COLUMBIA, 1969) BY BOB DYLAN

Greenwich Village meets Music City. Dylan softened his singing style, and integrated steel guitar and a duet with Johnny Cash. Kris Kristofferson was around too—he worked as a janitor at the recording studio. Several of the standouts ("Lay Lady Lay," "Tonight I'll Be Staying Here with You") have become standards.

Will the Circle Be Unbroken

(UNITED ARTISTS, 1972) BY NITTY GRITTY DIRT BAND

Recorded live in six days, roots music's old guard, as represented by Earl Scruggs, Roy Acuff, and "Mother" Maybelle Carter, play songs and even swap anecdotes with the California rock quartet. Despite originally being spread across three long-playing records, the album never feels overblown. Inspired two sequels, including a 1989 Grammy Award winner, but the original's the landmark.

Almost Blue

(COLUMBIA, 1981) BY ELVIS COSTELLO AND THE ATTRACTIONS

The skinny-tie set was bamboozled when their angry young poet deviated from originals for this collection of ditties popularized by Patsy Cline, George Jones, et al. Now it's considered a classic. "People still say to me, 'Until you played such-and-such, I never really liked any country music . . . except *Almost Blue*,'" says radio DJ Laura Cantrell.

Poor Little Critter on the Road (SLASH, 1985) BY THE KNITTERS

Hank Williams was almost as punk as Sid Vicious, so it made sense when members of X and the Blasters retrofitted their own abrasive originals as populist campfire songs. They even brought something truly shocking to their cover of Merle Haggard's "Silver Wings": reverence. Bloodshot later paid homage with 1999's all-star *Poor Little Knitter on the Road.*

Fear and Whiskey (QUARTERSTICK, 1985) BY THE MEKONS

These British contemporaries of Gang of Four retained their punk credibility here by attacking the excesses of the Reagan/Thatcher 1980s in their lyrics, but threw a curveball by adding fiddle, pump organ, and a ramshackle country slant to their rowdy sound. Concludes with a great cover of "Lost Highway." Considered the cornerstone of alt-country by many critics.

O Brother, Where Art Thou?

(LOST HIGHWAY, 2000) BY VARIOUS ARTISTS

For the Coen Brothers' sepia-toned retelling of the *Odyssey,* producer T Bone Burnett (whose credits included Counting Crows and the Wallflowers) put Americana selections by contemporary artists Alison Krauss and Gillian Welch alongside old-timers like the Stanley Brothers and the Fairfield Four. The success of the soundtrack outstripped even that of the film, spawning a series of concert tours and taking home the Grammy for album of the year.

Encores

Listening to musical stars from one era soldiering on through another can be gruesome. Frank Sinatra's 1966 album *Strangers in the Night* returned Old Blue Eyes to the top of the pop charts, but peruse his version of Petula Clark's 1965 number-one smash "Downtown" on side two. The Chairman of the Board sounds like he's auditioning for an antacid commercial, repeatedly interjecting nauseous asides. There are plenty of blues purists who'd still rather go deaf than sit through Muddy Waters's psychedelic *Electric*

Mud (1968), or the 1969 debacle *This Is Howlin' Wolf's New Album.* The subtitle of the latter is *He Doesn't Like It,* and the great guitarist made no bones about telling the press that, either.

One of the most interesting aspects of the flourishing of Americana has been the second acts the genre has ushered in for older roots artists written off by the mainstream. For *O Brother, Where Art Thou?,* T Bone Burnett tapped bluegrass great Ralph Stanley, born in 1927, to sing the haunting Appalachian traditional "O Death." His eerie a cappella performance was recognized with a Grammy for best male vocal country performance, beating out Tim McGraw, Willie Nelson, and Johnny Cash. In 2006, Stanley was awarded a National Medal of Arts, presented to him by President George W. Bush.

Solomon Burke, the "King of Rock and Soul," was one of the cornerstone acts of Atlantic's seminal R&B roster in the 1960s, racking up hits like "Cry to Me," "He'll Have to Go," and "Got to Get You off My Mind." It wasn't until well after he'd vanished from the commercial landscape that he won his greatest accolade. In 2002, the small Fat Possum label teamed Burke with producer Joe Henry, to record new songs by Americana heavyweights like Nick Lowe, Tom Waits, Bob Dylan, and Elvis Costello. "I never thought that something called Fat Possum Records would do what all the record companies in my life had never accomplished: getting me a Grammy," admits Burke. That 2002 release, *Don't Give Up on Me,* won for best contemporary blues album.

The same producer, Joe Henry, and rowdy southern rockers Drive-By Truckers also helped soul singer Bettye LaVette reach beyond a handful of vintage R&B enthusiasts. LaVette's inimitable interpretive gifts, seasoned over decades of experience, brought added gravity to material by Lucinda Williams, Sinead O'Connor, and John Hiatt on her albums *I've Got My Own Hell to Raise* (2005) and *The Scene of the Crime* (2007). More than forty-five years elapsed between LaVette's 1963 Top 10 smash "My Man—He's a Loving Man" and her performance alongside Jon Bon Jovi at the Washington, D.C., inaugural celebration of President Barack Obama. "I am relieved that it doesn't look like I will die in obscurity," she confessed

in 2005. "I won't have to go door-to-door, saying, 'Hi, my name is Bettye LaVette,' and do a show on everyone's porch!"

The best example of this second-act scenario is *American Recordings* by Johnny Cash.* In the early 1990s, the Man in Black was a genuine folk hero. Yet he'd failed to have any significant commercial impact since 1976. Producer Rick Rubin, who'd built a formidable reputation working with acts as diverse as the Beastie Boys, Slayer, Red Hot Chili Peppers, and Run-D.M.C., reversed that by recording Cash in a bare-bones setting, and interspersing original compositions by the singer with sympathetic selections by Leonard Cohen, Nick Lowe, Tom Waits, and even Glenn Danzig (formerly of New Jersey punk combo the Misfits).

In Cash, Rubin had a sound that was authentic, trusted, time-tested, and wholly American. *American Recordings* didn't need to add unnecessary bells and whistles, just introduce its star to a younger audience and demonstrate that the same gifts that distinguished Cash in his initial heyday could be successful applied in modern times. Over the next decade, until his death in 2003,† Cash enjoyed a tremendous resurgence of popularity and influence. His interpretations of acts like Nine Inch Nails, Soundgarden, and Depeche Mode inevitably got the most attention, but Cash sounded even better on songs written by like-minded followers such as Will Oldham ("I See A Darkness") and Nick Cave ("The Mercy Seat"), who'd been steeped in similar roots music traditions.

Since then, plenty of younger artists have used their commercial clout and industry prestige to resuscitate the careers of veteran musicians. In

* The best, but not the first. In 1987, producer Hal Willner and a cast of players including Dr. John and members of the Band helped Marianne Faithfull kick-start her singing career again as an earthy interpreter of blues, jazz, and theater songs on *Strange Weather*. Likewise, songwriting, production, and guest performances by T Bone Burnett, Elvis Costello, Tom Petty, and U2 on Roy Orbison's 1989 full-length *Mystery Girl* ensured that the Rock and Roll Hall of Famer's final album was also among his finest.

† And even after—released posthumously, the final Rubin/Cash collaborations *A Hundred Highways* (2006) and *Ain't No Grave* (2010) entered the charts at number one and three, respectively.

addition to including covers of blues greats Robert Johnson, Son House, and Blind Willie McTell on early albums, Detroit alt-rock two-piece the White Stripes used versions of Loretta Lynn's "Rated X" and Dolly Parton's "Jolene" as single B-sides. In 2004, twenty-eight-year-old Jack White joined forces with sixty-nine-year-old Lynn to produce *Van Lear Rose*, and the outcome won a Grammy for best country album. Since that comeback, Lynn has gone on to collaborate with Elvis Costello (cowriting "I Felt the Chill" for his 2009 album *Secret, Profane & Sugarcane*), while White was recruited to make a record with the Queen of Rockabilly, Wanda Jackson.

A musician doesn't even have to have been famous to enjoy this type of resurgence. Gospel preacher Reverend Johnny L. "Hurricane" Jones has been the minister at the Second Mount Olive Baptist Church in Atlanta for more than fifty years. Singing and sermonizing with a full rock band behind him, Jones drew huge congregations at the height of his popularity in the 1970s. By the turn of the century, attendance had dropped off, and he was just accompanying himself on the organ. After a local PBS affiliate spotlighted Jones as part of a larger piece on archival label Dust-to-Digital, he found a new following, including members of notorious punk quartet Black Lips. Atlanta musicians offered their services, and Jones resumed performing with a full band . . . now made up of young, white players in their early twenties.

The Anthology of American Folk Music

> "If God were a DJ he'd be Harry Smith."
>
> *—Peter Stampfel*

It's every record geek's wildest dream: to make a mixtape with the cream of your handpicked collection and to have the recipients clutch and hold on to it as if it were as life-giving as oxygen or water. Which is exactly what happened to Smith's *Anthology of American Folk Music* (1952).

Smith (1923–91) was an experimental filmmaker, painter, folklore expert, and anthropologist who grew up in the Pacific Northwest. His mother was a schoolteacher on the Lummi Indian Reservation, just outside Belling-

ham, Washington, and Smith was fascinated by Native American culture. By the age of fifteen, he'd already recorded numerous Native American songs and rituals. Smith's parents were Theosophists, and he would grow up to embrace unorthodox spirituality, attempting to reconcile Eastern and Western philosophies in his life and work.

Harry was also an avid collector of 78s and came of age at an ideal time for such an esoteric pursuit: World War II had prompted warehouses to clear out unsold inventory, and the introduction of the LP format—which could showcase much more music—had hastened the 78s demise.* Starting with a disc by delta bluesman Tommy McClennan, purchased in South Bellingham, Smith amassed a vast personal library from junk stores and secondhand dealers. "It sounded strange so I looked for others," Smith recounted in 1968.

Prior to the *Anthology*, the man best known for preserving America's musical heritage was Alan Lomax. Lomax and his colleagues—who included his father (folklorist John A. Lomax), writer Zora Neale Hurston, and others—combed the prisons, honky-tonks, and back roads of the Deep South and other regions on behalf of the Library of Congress between 1933 and 1942, recording countless specimens of delta blues, Appalachian folk tunes, and field songs. Lomax made the earliest recordings of Woody Guthrie, Leadbelly, and Muddy Waters, resulting in essential commercial releases such as Guthrie's *Dust Bowl Ballads* (1940) and Leadbelly's *Negro Sinful Songs* (1939). Later Smith traveled to document musical traditions in Great Britain and Ireland, Haiti and the Caribbean, and Italy and Spain too.† He also hosted radio shows, presented concerts, and made films. "Lomax's

* Ten-inch 78-rpm records were made of shellac, which is brittle, and could only feature roughly three minutes' worth of music—usually a single song—on each side. Long-playing 33-rpm records ("LPs") are made of vinyl, which is more flexible, have less surface noise, and can accommodate twenty minutes or more of music per side.

† In 1997, Rounder Records began an extensive campaign, of more than one hundred compact discs, to issue Lomax's varied musical specimens. Today the Alan Lomax Collection is housed at the American Folklife Center of the Library of Congress (www.loc.gov/folklife/lomax/).

dissemination of traditional music was as important as his recording of it, and he did it in the spirit of 'cultural equity'—the right, as he saw it, of all cultures to have their expressive traditions equally represented in the public sphere," says Nathan Salsburg of the Alan Lomax Archive.

In 1940, working with Pete Seeger, Lomax assembled a research aid for the Library of Congress, an annotated "List of American Folk Songs on Commercial Records." Lomax said that he compiled it so that "the interested musician or student of American society may explore this unknown body of Americana with readiness."* Among the selections Lomax included were several that would appear on Smith's *Anthology*, including Bascom Lamar Lunsford's "I Wish I Was a Mole in the Ground," the Alabama Sacred Harp Singers' "Rocky Road," and Dock Boggs's "Country Blues." Smith was aware of Lomax's list and, in the words of blues scholar Marybeth Hamilton, regarded it as "a kind of collector's Bible."

Unlike most releases on Folkways Records, the independent label that issued the *Anthology* in 1952, Smith's influential compilation was not folk music as documented on field recordings, but early commercial releases. As radio, motion pictures, and records aiming at wider national audiences eroded the character of regional music scenes, Smith took records that had enjoyed some level of popularity, somewhere, between the dawn of electrical recording, circa 1927, and the Great Depression, and assembled them into a scrapbook of an America that was vanishing . . . if it had even existed at all.

"It just seemed like a history, discovered. Here are my relatives that everyone's kept me from," recalls Rennie Sparks of the Handsome Family, who found *American Folk Music* in a library in Ann Arbor, Michigan, in

* None of the selections on Lomax's list was culled from his own field recordings. It was limited exclusively to commercially recorded and released records by big labels of the prewar era (Brunswick, Vocalion, Decca, etc.).

the late 1980s. "Listening to the Harry Smith *Anthology*, it sounded like this raw, violent, chaotic America that I always felt like was around me and should've been in the past . . . but I'd been told the past was perfectly orderly." The *Anthology* gave scores of musicians a window onto what critic Greil Marcus has called "the Old, Weird America."

A great mixtape follows its own internal logic, and Smith followed his own idiosyncratic muse while sequencing the *Anthology*. Rather than divvying up the songs by marketing categories (for example, "race" or "hillbilly" records) or according to the geographic region of origin, Smith erased such demarcations by compiling his selections into three double-LP sets: Ballads, Social Music, and Songs. Artists like bluesman Blind Willie Johnson and the Carter Family nestled comfortably, side by side, separated only by the momentary band of silence between tracks.

How much or how little information is made available about an artist can have a profound effect on how we hear their music, and in a playful fashion Smith took advantage of that. His liner notes detailed the minutiae of catalog numbers, original labels, recording dates, and instrumentation with scientific scrutiny, but otherwise the individual citations were index-card-sized masterpieces of creative writing, typically kicked off by a humorous overview. "Got the Farm Land Blues" by the Carolina Tar Heels is summarized thusly: "DISCOURAGING ACTS OF GOD AND MAN CONVINCE FARMER OF POSITIVE BENEFITS IN URBAN LIFE."

Smith's unusual notes often emphasized information about the song rather than the performer, which left much to the listener's imagination, especially if the citation was unaccompanied by a photo—as in the case of one of the cornerstone blues artists who appears twice on the *Anthology*. "It took years before anybody discovered that Mississippi John Hurt wasn't a hillbilly," Smith claimed in a 1968 interview. Or take Sparks' experience with Bascom Lamar Lunsford ("the Minstrel of the Appalachians"), the singing banjo player of "I Wish I Was a Mole in the Ground."

"When I first heard that song, I imagined he was some crazy Grizzly Adams who hiked on up the mountains to hunt beavers and have spiritual

revelations." In truth, he was a lawyer from Asheville, North Carolina, who performed in evening dress. "That happens a lot," admits Sparks. "I wanted to imagine the Carter Family as these rugged, backwoods people, isolated from the modern world, carrying on these ancient secrets. But really, I know A. P. Carter wanted to be a successful businessman and musician."

Smith oversaw the design as well, and the packaging made his vision of bygone America seem that much weirder. The cover of each volume was alchemically assigned a different color—green, red, and blue—to correspond to the elements water, fire, and air.* Behind the titles of each was an etching of an ancient one-stringed instrument, the monochord, as a symbol that all music sprang from the same primal source. The accompanying booklet featured crude photographs, snatches of sheet music, and diagrams of instruments, juxtaposed with Smith's text to resemble collectively some kind of madcap mail-order catalog. Even the index had character, populated with citations like "POVERTY MENTIONED ON RECORD" before a list of corresponding selections.

Upon its original release, the *Anthology* attracted only modest attention, but in time its influence spread through devotees including Bob Dylan, Joan Baez, and John Fahey. It formed a canon of classics for the folk revival of the 1960s and led to the rediscovery of artists including Hurt, Johnson, Charlie Poole and the North Carolina Ramblers, and Dock Boggs. A new generation of musical archivists, including Ralph Rinzler (who would later bring the Folkways catalog to the Smithsonian) and Mike Seeger and John Cohen (both members of early string band revivalists the New Lost City Ramblers), extended Smith's legacy with their own work.

In 1991, just a few months before he died, Smith's landmark contribution was recognized by the National Academy of Recording Arts and Sciences with the presentation of a Chairman's Merit Award at the Grammys.

* Smith also compiled a fourth volume, meant to represent earth in his cosmology. Featuring more popular recordings made between 1928 to 1940, it was shelved due to a disagreement with Folkways over what tracks to include. This "lost" volume, featuring seminal songs like Joe Williams's "Baby Please Don't Go" and the Carter Family's "No Depression In Heaven," was finally issued in 2000 by Revenant Records.

"I'm glad to say my dreams came true," he remarked on the occasion. "I saw America changed through music."

The *Anthology* continues to mystify new generations, and ascended in prominence and influence yet again when it was issued as an elaborate CD box set in 1997. *The Harry Smith Connection*, a 1998 tribute album culled from highlights of two nights of concerts celebrating the *Anthology*, includes selections by Jeff Tweedy, Jay Bennett, the Byrds' Roger McGuinn, and John Sebastian of the Lovin' Spoonful. A decade later, producer Hal Willner threw the net even wider, inviting performers including Nick Cave, Elvis Costello, Marianne Faithfull, and Lou Reed to participate in the shows and recordings that culminated in *The Harry Smith Project: Anthology of American Folk Music Revisited*.

The Decemberists' front man, Colin Meloy, and his wife, illustrator Carson Ellis, purchased the *Anthology* CD reissue with a Christmas gift certificate. "At that time, we were living very hand-to-mouth," remembers the songwriter. Because he had rarely reached back further than 1976 during his most active years of music exploration (which were high school and college), the *Anthology* proved a revelation. "Discovering this untouched time capsule of a different era was really exciting to me. We then spent the next year just being fully obsessed."

Repackaging the Past

Released in 2003, and subsequently nominated for two Grammy Awards, *Goodbye, Babylon* featured 135 gospel songs dating from 1902 to 1960, spread across five compact discs, accompanied by a sixth of nothing but vintage sermons. As with Smith's *Anthology*, the music itself was enriched by its accompanying packaging. *Babylon* also included a two-hundred-page book of Bible verses, lyrics, commentary and rare photographs. It all came housed in an oblong cedar box, packed with raw cotton, each set assembled completely by hand.

It might sound like an esoteric project, to say the least, but *Goodbye, Babylon* found favor with superstars like Bob Dylan and Neil Young and

mainstream publications including *Entertainment Weekly.*[*] Lance Ledbetter (no relation to Leadbelly), the Atlanta DJ who conceived the project and released it on his Dust-to-Digital label, was really programming for his Inner Teenage Record Geek when he compiled it. He wanted to connect with adventurous listeners of any age seeking to recapture that feeling of when "they were fifteen years old, finding records that were just blowing your mind. That was who I was, and who I was hoping the *Goodbye, Babylon* set would reach." Five years on, *Goodbye, Babylon* continues to win raves, with more recent accolades coming in from Brian Eno and the Arcade Fire, who cited it as a big influence on their critically lauded 2007 album *The Neon Bible*.

Dust-to-Digital aspires to give fans a complete experience with each of its releases, which also include *Take Me to the Water*, an elaborate book of vintage immersion baptism photographs accompanied by a CD of appropriate archival songs ("Wade in the Water," "At the River"), and *Fonotone Records: Frederick, Maryland (1956–1969)*, five discs' worth of highlights from archivist Joe Bussard's small vanity label, packed in a cigar box. "Our mission is to produce high-quality cultural artifacts, which combine rare, essential recordings with historic images and detailed texts describing the artists and their works," says Ledbetter. The resulting combinations of images, sound, and information are an intoxicating marriage of showbiz and scholarship, a window on American society that often predates industrial times.

Adventurous listeners have fostered a whole new wave of labels reissuing vintage roots music. Tompkins Square Records proprietor Josh Rosenthal had an epiphany when he heard the raw, electrified gospel cuts compiled on Mississippi Records' *Life Is a Problem* LP. "I bought that in a record store, I put it on, and I lost my mind," he says. "It changed my entire direction towards gospel."[†]

While not all of these new labels are strictly devoted to reissues and

[*] At the Seattle record store where I worked at the time, we sold copies to Peter Buck of R.E.M. and two-time Pulitzer Prize winner August Wilson, hand-to-Bible honest.

[†] So much so that he recruited *Life Is a Problem* mastermind Mike McGonigal to assemble the more ambitious *Fire in My Bones* set for his own label.

archival projects, they share a rabid enthusiasm for preserving the past. The Numero Group in Chicago has issued a slew of compilations showcasing everything from kiddie R&B acts to flaxen-haired Joni Mitchell wannabes, forgotten and unheard gems originally issued on tiny, regional labels. Seattle imprint Light in the Attic uncovered the funky side of the birthplace of grunge in *Wheedle's Groove*, a set of 1960s and '70s soul sides from the Emerald City.

Looking for a nice mix of crackling tunes about the sinking of *Titanic* and forgotten crime sprees? Try Tompkins Square's *People Take Warning! Murder Ballads & Songs of Disaster 1913–1938*, which features a written introduction by Tom Waits.* All those folks snapping up turntables in recent years have made it almost impossible for independent record shops to meet demand for the limited-edition, esoteric offerings of Portland, Oregon, vinyl-only label Mississippi Records.

Whether packed in raw cotton, or available on iTunes, either way it seems odd to find an offering like Tompkins Square's triple-disc *Fire in My Bones: Raw + Rare + Other-Worldly African American Gospel* being feted by the same online outlets—Pitchfork, Other Music, Aquarius Records—that go bonkers for underground acts like Animal Collective and Grizzly Bear, or hard-to-find Norwegian death metal. These are music fans hungry for anything new and thrilling and unexpected, be it minimalist U.K. dub step or Peruvian flute music. The only twist is that, in this case, the "new" music generating buzz is actually very, very old. Sometimes the sound quality may have deteriorated over the decades, but the raw power of these recordings, however obscure, has not diminished.

Music with a Purpose

It may come as a bit of a surprise when Robin Pecknold, front man for acclaimed quintet Fleet Foxes, expresses admiration for Sacred Harp singing.

* And anthologizes its subject matter along classic literary lines: "Man vs. Machine," "Man vs. Nature," and "Man vs. Man (And Woman Too)."

⊰[THE CRANKY DJ]⊱

Like many young men and women living in a big metropolis, Michael W. Haar—our straight-razor shaving expert from chapter 4—is also a DJ. He spent two years in residence at the Box, one of New York's hottest clubs, and plays regularly at events featuring tony liquor sponsors and nattily dressed guests. Of course, he has a devoted Internet radio following too.

What makes Mike any better than every hipster with a secondhand Guns 'N' Roses T-shirt and no idea how to use a cross fader? Let's start with his position on the vinyl-versus-MP3 debate. Mike's preference? Neither. Shellac 78s and wax cylinders, please. Mike the Barber's tastes run toward the cakewalk and Irving Berlin, not dub step or German techno.

He doesn't even need electricity to get the crowd jumping. The antique players he lugs to gigs, such as his 1923 Brunswick phonograph and 1921 Victor Victrola, are hand-cranked. Hence his professional alias, "the Cranky DJ."

Only on his weekly East Village Radio show, *The Ragged Phonograph Program,* does he make concessions to modernity, using CD reissues from specialists like Champaign, Illinois, imprint Archeophone Records. "They have a great selection of all these vaudeville stars," he gushes, "not just the popular ones, but ones that you've never heard of, even if you thought you knew about this kind of music."

You know those audiophiles who moan about how digital technology ruined recorded music? Haar voices similar complaints about the introduction of electricity. He prefers recordings from the first quarter of the twentieth century, the premicrophone days, when "the performers literally shouted into the horns when they recorded" and the oomph came from low-end brass, not bass.

Acclimating modern ears to these textures takes a while, but the music still packs plenty of punch—certainly more than the soft-focus croon-

ing of the subsequent Swing Era. "Early ragtime is like early punk," the Cranky DJ insists. "The older generation was looking at it, saying 'That music's too fast, too loud. The way they're dancing is out of control . . . they're getting too close . . . I can't waltz to it!'" Who knew Scott Joplin and the Ramones had so much in common?

The twenty-four-year-old leader of one of the hottest indie acts around is espousing the merits of a little-known form of communal singing, dating back to colonial times and preserved in the crucible of the Deep South. When you listen to the opening lines of the band's popular "White Winter Hymnal," though, there it is: hints of a fugue in the repeated opening phrase, the wide vocal harmonies and full-voiced singing.

Pecknold is even more enthusiastic about the legacy of John Jacob Niles. A balladeer, composer (his best-known tunes include "Black Is the Color of My True Love's Hair") and song collector who built his own dulcimers and lutes, Niles was born in Louisville, Kentucky, in 1892 and was still performing when Bob Dylan was coming up in the folk revival. What Pecknold responds to in the music preserved on record by Niles—or Smith's *Anthology,* or the field recordings of Alan Lomax—is the same primal quality ("just a plain, honest recording") and a sense of purpose.

Fleet Foxes invited Frank Fairfield to open a North American tour in 2008. Fairfield, who is in his mid-twenties, plays fiddle, guitar, and banjo and is an avid collector of old 78s. Until recently, you were most likely to encounter him busking for spare change around Los Angeles. "I was just walking up and down the streets, and belching out murder ballads." His eponymous 2009 album, filled with thrilling renditions of standards including "Nine Pound Hammer" and "John Hardy," won plaudits from purists like critic Greil Marcus and Grammy Award–winning producer Chris King (who oversaw Tompkins Square's *People Take Warning* box).

As far as Fairfield is concerned, the music he makes isn't defined by any particular era. "It does bug me, all that talk of nostalgia and the twenties,"

he admits, apropos of how his work is sometimes perceived. "I don't consider myself to be playing 'old music.'" After all, some of these songs had been around for centuries before musical recording became widespread. "It was already old. It's just something people have always done."

On a Friday night in July 2009, I visited Floyd, Virginia. This mountain town is still a hotbed of bluegrass and old-time music, and I planned to take in some string band tunes. While there are chairs set up in the performance area of the Floyd Country Store, each with a different handmade cushion, this is not music to simply observe. The aisles and dance floor were crowded with folks, young and old, enthusiastically clog dancing, the taps on their shoes resonating in time.

Outside, pickup groups of players lined the sides of South Locust Street. College-age kids rambunctiously picked out tunes on instruments older than them, alongside seasoned vets triple their age. The songs that they share span a gamut of Americana classics: "I Saw the Light," "Will the Circle Be Unbroken," "This Train," "Scarlet Purple Robe." A summer Friday night in Floyd feels like a giant musical tailgate party, not the spectator sport of going to a concert, and soon I found myself lifting my own voice to join in on tunes I recognized, such as "Long Black Veil."

The Internet has done plenty to preserve and celebrate traditional American music—particularly Internet radio, which allows listeners all over the world to tune into specialty programs like *The Moonshine Show* and *Tennessee Border Radio* on WKCR 89.9 FM New York,* or "The Roadhouse" on KEXP 90.3 FM Seattle.† But nothing compares to enjoying this music live, and the fellowship it inspires. "I've learned far more from the people that I've had a conversation with than research that I've done on-

* www.studentaffairs.columbia.edu/wkcr/.
† http://kexp.org/. Full disclosure: I am also a DJ on KEXP.

line," confirms former *Moonshine Show* host Matt Winters. At big annual events like Telluride Bluegrass Festival and Merlefest, traditions are passed along and reinvigorated in parking lots and around campfires at informal jam sessions. Performers onstage pass along information too. Country and bluegrass great Ricky Skaggs has played and recorded alongside Phish, Bruce Hornsby, and the Raconteurs, yet he also makes a point of prefacing classics in his repertoire. "So much pedagogy occurs at a concert," adds Winters. "Seventy-five percent of the old-time music bands out there can give a decent introduction for every tune they're going to play, about where they learned it and who else has played it, maybe what makes it distinctive from another version of the same tune and who's recorded it."

These songs will continue to survive and evolve. Between 1882 and 1898, ten volumes featuring more than three hundred Scottish and English folks songs (and their American variants), collected by Francis James Child, were published as *The English and Scottish Popular Ballads*. Among "the Child Ballads" was "Fause Knight on the Road," later recorded (as "False Knight on the Road") in 1971 by English folk rock act Steeleye Span. Four decades later, Fleet Foxes released their own rendition, on the B-side of their single "Mykonos." Only the future will tell for certain, but I'd wager that nothing from the catalog of Lady Gaga or Lil' Wayne will stick with music lovers quite so long.

A Different Kind of House Music

Over the ages, common folk have proven extraordinarily resourceful at making music with everyday objects. While the fiddle, mandolin, and pedal steel guitar remain synonymous with country, and even the ukulele has enjoyed a surge of popularity in recent years, some very D.I.Y. instruments also continue to crop up in the realms of roots music and Americana.

CIGAR BOX GUITAR: Since Civil War days, folks have been making impromptu guitars (and other types of stringed instruments) by using wooden cigar boxes for the resonators, and fashioning necks from simple objects like broomsticks. Tom Waits, Billy Gibbons (ZZ Top), and PJ

Harvey have all played cigar box instruments. In recent years, thanks to proponents like Kurt Schoen and Shane Speal, and the 2008 documentary *Songs Inside the Box*, cigar box guitars have enjoyed renewed hoopla.

JUGS: Glass and stoneware jugs can be played by making the opening vibrate by blowing across the top of it. Skilled players change pitch by altering mouth shape and tension. Jug or "skiffle" bands, which also featured other impromptu instruments like spoons and washboard, rose to prominence at the turn of the twentieth century, in southern cities like Louisville, Kentucky (home of the National Jug Band Jubilee) and Birmingham, Alabama, and enjoyed a comeback during the 1960s folk revival.

SAW: Drawing a bow across the toothless edge of a metal saw creates an eerie, "singing" sound (reminiscent of the more modern theremin). The player holds the handle of the saw between crossed legs and alters the pitch by bending the blade up and down. Track down *Super Saw* by Jim Leonard or *The Singing Saw at Christmastime* by Julian Koster for audible examples of its haunting beauty.

SPOONS: A pair of wooden or metal spoons, gripped loosely between the thumb and a crooked forefinger, can be rapped against the legs, chest, and other body parts to create a lively percussive effect. It's trickier than it sounds. For a great tutorial, check out the David Holt DVD *Folk Rhythms* (available from Homespun Video).

WASHTUB BASS: Again, the resonator is a household object, typically a galvanized washtub, with a broomstick or other handle affixed, and a single string. To change pitch, the player alters the tension, or changes the length of the vibrating section by sliding their fingers up and down. Jeff Eaton, bassist for Wichita, Kansas, "speed bluegrass" band Split Lip Rayfield, plays a washtub-style one-string bass fashioned from the gas tank of an old truck.

·⋗[AND THEN THERE'S THE WASHBOARD . . .]⋐·

How to Play the Washboard

Playing the washboard is easy, but doing it well requires a little practice. In the wrong hands, the washboard makes an awful din. Imagine being trapped in a tin-roof shack during a hailstorm. The first time I unpacked my galvanized Sunnyland washboard at band practice and ran my digits over its metal ridges, our rhythm guitarist doubled over like a question mark. Even when my fellow musicians kept me as far away from the microphone as possible (which was hard, since I was also the singer) my enthusiastic efforts overpowered their sound.

The secret is to approach the washboard with a subtle touch. Yes, its original intended purpose evokes vigorous manual labor and/or angry outbursts on *Little House on the Prairie,* but if your desired outcome is pleasing percussion, rather than a spotless shirt, refrain from being too gung-ho.

1. Protect your fingertips with metal sewing thimbles or banjo finger picks. Don't armor up the entire mitt; the index and middle digits will suffice. Or go nuts and add the ring finger too.
2. No need to press down hard; you'll only make your fingers sore. Let the surface of the washboard do the work.
3. Refrain from keeping time by scraping up and down. No matter how fast or slow the tempo, uninterrupted scraping instantly becomes the most grating sound this side of a screaming infant on an airplane. Instead, simply tap your fingers against the metal surface.
4. Incorporate scraping as a rhythmic accent. Make the motions short. Run your fingers over just a few ripples of the washboard, rather than up or down its entire length.
5. If your washboard sounds especially "live" when played, damper excess vibration by putting tape on the reverse side.

6. Don't feel limited to playing just the metal surface of the washboard. Vary the timbre by tapping or drumming on the upper wooden face as well.

7. Want even more variety? Augment the arsenal. Many players trick out their washboard with additional bits of percussion affixed to the sides, legs, or upper body. Options include wooden blocks, cowbell, different sizes of tin cans or metal cups, and service bells.

8. Alternately, try playing it with a whisk broom, à la old-time jug bands, instead of the fingertips.

Vinyl Keeps on Spinning

Since the introduction of the phonograph in 1877, commercial sound recordings have evolved through multiple formats. In the early twentieth century, phonograph cylinders competed with shellac discs. Eventually the flat, spinning circles won. Vinyl would replace shellac after World War II, sizes and speeds came and went, and music lovers flirted with other media—cassettes in particular enjoyed a good run, thanks to the Walkman—but records would reign supreme until George H. W. Bush was elected president; in 1988 sales of compact discs surpassed records.

The vinyl record seemed destined to join outdated gizmos like the eight-track tape and the player piano roll on the scrap heap of history, especially after digital files began to make even compact discs obsolete. By 2006, less than a million units of new vinyl were being shipped annually in the United States, but then a funny thing happened. The following year, that number went up, to 1.3 million. According to Nielsen SoundScan, vinyl sales had the best year of the CD era in 2009, enjoying a 37 percent increase over 2008. In the late 1980s, Rainbo Records in Canoga Park, California, one of the last pressing plants in the nation, was producing fewer than 10,000 vinyl records a day, compared to six times that in 1977. Today they're back up to a daily average of 25,000 pieces of black wax. Even Best Buy, the number-three retailer of music in the United States (after Walmart and

Phonograph Cylinder

What Is It? The first medium of recorded sound widely available to the public. Cylinders went on the market circa 1888, and remained popular until World War I. The brainchild of Thomas Edison, who conveniently invented the phonograph too. Grooves were originally etched into tinfoil wrapped around a metal cylinder, but soon replaced by etched cylinders of hard wax and celluloid plastic.

Practicality: Cylinders reportedly boasted better fidelity than early disc-style recordings, which evolved simultaneously—kind of like VHS and Betamax.

Availability: The cylinder eventually lost the commercial battle to phonograph discs, and manufacture ceased in 1929. But you'll find a host of them, ITRW and online, at the Cylinder Preservation and Digitization Project of the University of California.

SUBLIME OR RIDICULOUS? *Today they make eight-track tapes look as sophisticated as iPods, but without the cylinder, we might all still be sitting around in silence.*

iTunes) has started stocking vinyl records. Meanwhile, sales for CDs continue to decline.

"Most of the people buying it are half my age," says Rob Miller, founder of Bloodshot Records. "They are maybe the first wave of the people who totally bypassed the CD generation." What's the appeal? For one thing, there's an audible world of difference between the compressed, tinny sound of an MP3 file and the warmth generated by a needle in the groove. "Quite frankly, anyone who can't tell the difference between an LP and an MP3 should have their ears removed."

Vinyl sales still only constitute a tiny fraction of the overall market, not nearly enough to offset the music industry's losses due to illegal downloads and plummeting CD sales, but at least vinyl buffs have a choice again. Sales are substantial enough that small labels that couldn't justify releasing albums on wax in the 1990s have resumed at least small runs of most titles. "There's enough people buying it now that we can press up one thousand of our releases, sell through most of them, and make our money back."

Vinyl records are larger, which allows more space for liner notes and cover art, and heavier. Something to hold on to. "People are attached to the experience of having a big record sleeve," says the Decemberists' Colin Meloy. "Just the act of putting on a record itself is comforting and interesting to people. It's this big hunk of plastic that you've got to flip over." That kind of hands-on experience is easier to share with friends too. "Having your record collection out gives people an opportunity to just come over and browse, in a way that you can't really do with your iTunes," he adds. "It's like bookcases."

Face it, people don't brag about their MP3 collections. "What kind of soul is there if you look at your hard drive and there's forty-five hundred songs on there?" asks Miller. "How do you craft an identity out of that? What does that say about you? Maybe having that totemic object, the LP, is the first step towards a reinvigoration of valuing 'the thing.'"

Serious music fans very much associate

their identity with their vinyl library. Any imbecile can show taste when blogs and search engines do all the heavy lifting and the cool song of the day is just a click away. Buying physical records, though, reveals a lot about an individual. Sure, sometimes what it says is embarrassing: "I have too much disposable income," for example. Or: "My mania for Neko Case may one day feature in a psychology textbook." The continued existence of vinyl hounds serves as a welcome riposte to music-biz doomsayers. These are men and women who go to concerts and buy the tour-only, limited-edition seven-inch to say, "I was here." Loitering over the used bins, they succumb to curiosity. Can "Ring of Fire" be improved upon by singing it *auf Deutsch*, or performing it on the Moog? There's only one way to find out . . .

Savvy bands and labels cater to those whims, with limited-edition product or by adding exclusive tracks to vinyl releases (a reversal of the early days of CD- and cassette-only bonus cuts), as well as by including a free download in the price of purchase. The double-LP edition of the Decemberists' 2005 breakthrough, *Picaresque*, featured five songs unavailable on its CD counterpart. Jack White's Third Man Records, located in Nashville, releases editions of his own output (White Stripes, Raconteurs, the Dead Weather) and other artists,* typically in small runs and on unusually colored vinyl.

Even manufacturing vinyl involves more craft and skill than cranking out CDs. According to Rainbo owner Steve Sheldon, he can train an employee to man a CD or DVD production line in a single week. Instructing someone in the fine points of turning a handful of PVC pellets into a shiny new record album, however, requires six months. Just like producers of old-school shoes and clothing, Rainbo relies on machinery that can't be easily replaced; pressing machines stopped being made back in 1986.

In a delicious twist, by promoting the compact disc over vinyl, the music industry actually nurtured a whole new generation of collectors. As casual consumers disposed of their old albums at Goodwill shops and mom-and-pop record stores and replaced them with CDs, used bins filled up with classic titles. More often than not, they're still priced to move. You can build

* Including famed astronomer Carl Sagan.

a quality, and quirky, collection of secondhand records at a fraction of the cost of CDs or downloads.

Loving vinyl shows a commitment to music that transcends consumerism. Some thrill seekers lurk in duck blinds, waiting years for a glimpse of Bigfoot. Groove hounds comb tiny shops from Indianapolis to Iceland, looking for records that may only exist in our imaginations. Both parties may appear foolish but do so *in the real world*, and gladly. IPods are anonymous; carrying a Led Zeppelin LP under your arm sends a unique, and highly visible, message to passersby.

THE
GREAT
INDOORS

8

Design
and
Décor

That Rustic Modern Look

When Taavo Somer arrived in the Big Apple from Minnesota in 2000, he was an architect whose heroes included minimalist sculptor Donald Judd, so he seemed a perfect fit for his new job with contemporary architect Steven Holl. Instead Somer lasted six months, having tired of what he later described as a "cultlike dedication to minimalism." Out with the antiseptic, in with warm and woodsy. Four years later, Somer and partner William Tiggert opened Freemans restaurant, tucked away at the end of Freeman Alley on the Lower East Side. Its look completely eschewed the space-age interiors and molded plastics popular at the turn of the century. In homage to the bohemian vibe at a favorite Minneapolis bar from his college days, Somer went for an eclectic, earthy look, and festooned the walls with taxidermy; during its first three years, Freemans rotated more than thirty different animals through its interior, including a ram's head and a wild boar.

That stark minimalism that prevailed in the 1980s and '90s—clean, white spaces appointed with chrome and slick surfaces—endures, but many have tired of its perfectionism and precision. "When I'm putting together a room, I'm thinking about what is going to make people feel good to be in that room," says Seattle restaurant and bar owner Linda Derschang. And what makes them feel good looks older and earthy.

At Vinegar Hill House, the Brooklyn restaurant opened in 2008 by Sam Buffa (of F.S.C. Barber) and his wife, former Freemans chef Jean Adamson, diners can tuck into their grass-fed, local meats in booths made

from salvaged bleachers or at the coppertop bar.* Even Philippe Starck, once renowned for his use of bright colors and clean lines,† has shifted tack. His designs for the Clift Hotel in San Francisco include mismatched furniture (chairs in the lobby are either huge or tiny, and often juxtaposed side by side) and reproductions of antique chandeliers.

In her book of the same name, writer Eva Hagberg dubbed this design trend Dark Nostalgia: surroundings that evoke a sense of history and familiarity, even if the space or its tenant is relatively new. Whether you find it at a high-end hotel, a trendy boutique, or a friend's downtown loft space, there are distinct hallmarks of this style that pop up time and again.

ARCHITECTURAL SALVAGE: Reusing building materials from a prior structure is a surefire shortcut to connecting with the past, and accompanying nail holes or gouges can add to that "lived-in" look. At her Oddfellows Café and Bar, Derschang saved a piece of regional antiquity when installing the booths. One of her employees at another restaurant mentioned that her grandmother was a parishioner at a nearby Catholic church that was replacing its pews. Derschang bought the old ones, repurposed them, and now they provide seating for diners instead of the devout. "There's a little bit of Seattle history," she says. "They've been recognized by a few people that have come in here, and said 'Are those from St. Joe's?'"

There's also the ecological angle to consider. According to some estimates, as much as 20 percent of the solid material dumped in America's landfills comes from building salvage, much of it wood that could be recycled.

EDITING: Use a critical eye when integrating older pieces (for example, furniture, lighting fixtures) with contemporary and industrial elements, especially if you don't want the final look to appear jumbled, or worse yet, like a museum installation. If your gut says that nineteenth-century armoire looks "too grandma" to effectively complement a space's overall aesthetic,

* A press release upon its opening touted the aesthetic as embodying "the soulful beauty of hodgepodge."

† A good example is Starck's designs for Ian Schrager's Royalton hotel in New York, featuring an entry that greeted guests with an extended, royal blue carpet and a lounge full of furniture featuring his trademark tapered steel legs.

listen to it. "There's a certain balance you're trying to achieve, and also a sense of tension," says hotelier Alex Calderwood. "Sometimes you put two things together and there's a friction that can be engaging."

That goes for individual pieces too. Robin Standefer of New York design firm Roman and Williams (who worked on several of the projects featured in Hagberg's book *Dark Nostalgia*) cites a desk she made for her office as an example of that ideal tension between old and new. "I happened to find these incredible vintage table legs, but I used a completely modern, clean walnut top for it—not old barn boards. It's about that voltage between the two."

THE PAST, DARKLY: Relaxation comes easier in a cozy interior where lights are low and golden, and the color scheme doesn't burn the retinas. Austere, brightly lit spaces put the focus on patrons. All well and good if you're part of the see-and-be-seen crowd, but in a world where social networking makes our lives übertransparent, most of us can appreciate a little anonymity. Wrought iron absorbs history, while chrome reflects it back. Being surrounded by darker shades can feel reassuring, invoking the solidity of wood and earth, and the natural world.

EVERYDAY OBJECTS ARE BEAUTIFUL: Form follows function in everyday office machinery and kitchen equipment. Once progress has rendered a particular item obsolete, the utilitarian beauty of a rotary phone or hand-operated coffee grinder radiates brighter than ever. Sixty years ago, secretaries and journalists might've been aghast to find manual typewriters displayed in a saloon; you step out for a tipple, and your cruel oppressor follows you. Today at Oddfellows, though, the antique Smith Coronas tucked in shelves and windowsills seem downright benevolent compared to all the hardworking laptop computers propped open everywhere.

A SENSE OF ADVENTURE: Vintage globes and maps evoke that bygone era when learning about far flung locales required more than just popping search

terms into Google Maps. They remind us that boundaries can change, empires rise and fall. Steamer trunks, commonplace throughout the nineteenth century, conjure up ocean cruises and exotic journeys, especially if featuring vintage hotel and railway labels. (Urban dwellers especially tight on closet space should keep an eye out for old wardrobe trunks, which stand on end and open to reveal one side that accommodates hanging garments and another containing a chest of drawers.)

BACK TO NATURE: With less and less of the great outdoors at man's disposal, no wonder decorators are opting to bring flora and fauna, and the tools our ancestors used to subjugate them, indoors. The leather that upholsters antique armchairs or binds the vintage tomes displayed just out of reach is just the beginning. At chic Lower East Side boutique Against Nature, a furry animal hide covers the hardwood floor of the dressing room, and vintage feathers are artfully arranged alongside accessories. The fixtures at Winn Perry in Portland include a harpoon that proprietor Jordan Sayler has had in his family for five generations. The lobby of New York's Hudson hotel (another Starck outpost) is overrun with ivy. Sometimes the natural influence is more conceptual. Roman and Williams took inspiration from a winding river for the floor plan of the eighteenth floor, the penthouse nightclub at the Standard hotel New York, while the sleek, wooden vortex rising from the center of its circular bar evokes the trunk and branches of a giant tree.

Be a Part of History

Alex Calderwood is one of the partners in both Ace Hotels (a small chain with locations in Seattle; Portland, Oregon; Palm Springs; and New York) and Rudy's Barber Shops (see chapter 4). As he and his collaborators decide on the specific look and feel for each of their ventures, Calderwood

likes to draw inspiration from resources that are highly valuable and distinctly unique: the history of the location and its surroundings, and the character of the regional community. "We're interested in narrative or backstory," says Calderwood. "There's that curiosity: 'What kind of context are we in?'" Instead of relying on a uniform look that could be plopped down anywhere, Calderwood and his colleagues emphasize design that complements the surrounding environment. "We're still creating an experience that feels new, but it's rooted in this sense of narrative, a sense of place. Whatever city you're in, you really have a sense of it, both historically and currently."

Robin Standefer of Roman and Williams, who collaborated on the design of the Ace Hotel New York, shares that enthusiasm for tapping into history. "We have the opportunity to take the bones and the spirit of a particular piece of architecture, and some of the references from the time it was built, and even how it's evolved over the years . . . and then invent new ideas."*

Before the Ace New York opened in 2009, the same space was home to the Hotel Breslin (established in 1904). The building is located on West Twenty-ninth Street and Broadway, just a few blocks south of the Garment District, and in a nod to the area, instead of closets the hotel rooms feature garment racks made from plumbing pipes and hanging steel boxes. Music is another influence on the Ace New York, which is just a stone's throw from historic Tin Pan Alley.† When Calderwood learned the Hotel Breslin had once been the home to musicologist and filmmaker Harry Smith, the man responsible for *The Anthology of American Folk Music* (see chapter 7), he set out to secure Smith's work a place too. Beginning in the fall of 2010, Smith's artwork and films will be on display in public spaces, and his

* Roman and Williams take the same approach with projects they start from scratch, too, such as 211 Elizabeth Street in historic Little Italy, for which they enlisted a family of Irish masons to hand-lay handmade bricks (instead of using brick panels) and execute their original designs for beveled corners, brick cornices, and other details.

† The strip of Twenty-eighth Street between Fifth and Sixth avenues where many famous songwriters (Irving Berlin, George and Ira Gershwin, Hoagy Carmichael) and music publishers worked in the late nineteenth and early twentieth centuries.

experimental movies and related documentaries featured on the on-demand video system. Even after the Smith installation in the lobby comes down, his legacy will live on in Room 1211, which is being outfitted as a permanent homage to the artist and archivist.

Calderwood also emphasizes the importance of working with artists and craftsmen specific to the region. While brainstorming unique ways to display room numbers for the Ace Hotel Portland, someone thought of the metal ID tags affixed to utility poles. Research led them to the Irwin-Hodson Company, a Portland visual communications specialist established in 1894. "On our first tour of their facility, the salesperson was trying to sell us on all their digital capabilities." But the Ace team wanted to do things old school, and use traditional stamping and die-cutting machines—which Irwin-Hodson could also still accommodate. On a similar tip, the uniform shirts for Ace New York are custom made by Mel Gambert, a long-running made-to-measure shirt company based in nearby New Jersey.

In Calderwood's estimation, working local does much more than just create organic, grassroots-level buzz. "It's important that you create as much emotional investment from the community into the project as possible. You're expanding the family around it and they have a vested interest in its success."

Taxidermy: Where the Wild Things Are

As the twenty-first century unfolded, woodland critters resumed adorning saloon walls throughout North America. Smith, a Seattle restaurant reviewed as "a hunting lodge for rich weirdoes," features elaborate shadow boxes, pheasants, and mounted elk and deer heads. The menagerie at Please Don't Tell in Manhattan includes a black bear head, as well as an otter, an owl, and even a cobra, while thirsty Toronto types nursed their tallboys surrounded by a zebra, a rooster, and an alligator at the Ossington.

Taxidermy—it isn't just for lodges and museums anymore. When the late Alexander McQueen hosted his spring-summer 2009 show in Paris, pieces of antique taxidermy collected from all over France were a featured

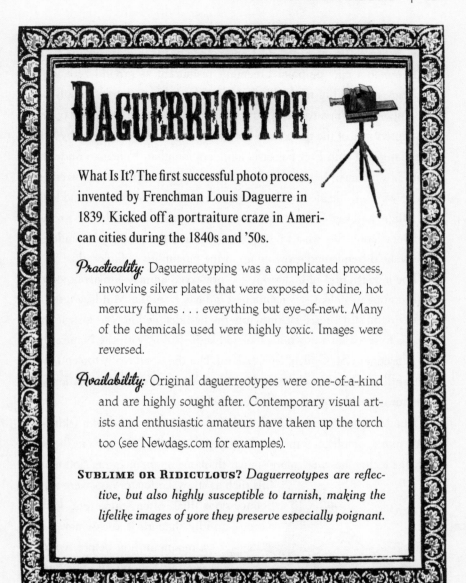

DAGUERREOTYPE

What Is It? The first successful photo process, invented by Frenchman Louis Daguerre in 1839. Kicked off a portraiture craze in American cities during the 1840s and '50s.

Practicality: Daguerreotyping was a complicated process, involving silver plates that were exposed to iodine, hot mercury fumes . . . everything but eye-of-newt. Many of the chemicals used were highly toxic. Images were reversed.

Availability: Original daguerreotypes were one-of-a-kind and are highly sought after. Contemporary visual artists and enthusiastic amateurs have taken up the torch too (see Newdags.com for examples).

SUBLIME OR RIDICULOUS? *Daguerreotypes are reflective, but also highly susceptible to tarnish, making the lifelike images of yore they preserve especially poignant.*

part of the backdrop, chosen to complement a collection inspired by Charles Darwin, the Industrial Revolution, and humanity's relationship with the natural world. In 2005, New York department store Bergdorf Goodman began selling pieces from Parisian taxidermist Deyrolle, including an ostrich

that went for just under twenty thousand dollars. Japanese conceptual artist Kohei Nawa covers mounted deer and coyote heads in glass beads.

The media may pinpoint Freemans restaurant as ground zero for the taxidermy revival, but in the Pacific Northwest, hipsters had already been drinking in the company of furry trophies a decade before Freemans opened. The centerpiece of the bar at Linda's Tavern, established in 1994 by Linda Derschang and Sub Pop Records founders Jonathan Poneman and Bruce Pavitt, is a mounted buffalo head. In a town known for political correctness, not everyone was thrilled by the big guy. "People would come in and look at the buffalo, and say, 'That's awful, why would you put that there?'" remembers Derschang. She wasn't trying to stir up trouble. It simply reminded her of bars she'd frequented growing up in the mountains of Colorado.

The modern idea of taxidermy—a preserved animal skin arranged on a mold to appear lifelike—is mentioned in texts from the Middle Ages, and in 1555 naturalist Pierre Belon wrote the first detailed how-to instructions.* Curious to see what a crocodile looked like in 1623? Visit the Natural History Museum in St. Gallen, Switzerland. But the trend really took off in the eighteenth and nineteenth centuries, when Western man's fascination with the natural world was running especially high.

Taxidermy—from the Greek *taxis* (arrangement) and *derma* (skin)—is a little more complicated than making a sock monkey, although in the early days, the techniques were more similar than one might imagine. Soft materi-

als such as straw, cotton, or rags were stuffed into skins that often came out looking oddly shaped. If you've never seen a mountain lion before, who's to say it isn't supposed to be lumpy? Regardless, taxidermy wasn't simply a way to show off hunting trophies. It served as a vital natural

* The first person to use the specific term *taxidermy*, however, was French naturalist Louis Dufresne, in the 1803 reference work *Nouveau dictionaire d'histoire naturelle*.

history tool, allowing the public to see exotic animals from other continents for the first time.

The craft took a turn for the better in the late nineteenth and early twentieth centuries, with the development of elaborate foundations known as mannequins, and the work of men like Carl Akeley, William T. Horneday (creator of the prize-winning "A Fight in the Tree Tops," which depicted a battle between two orangutans in a rain forest setting), Coleman Jonas, and Leon Pray. Using wood and wire to fashion a skeleton, the taxidermist would then build up that internal form with wood shavings and twine, to better replicate the animal's true shape. Only after the skinless wonder was complete would the tanned hide be sewn on, and meticulous details added. Today, ready-made polyurethane mannequins for almost any animal imaginable, from armadillos to wolverines, are available in many different sizes from taxidermy supply centers—although purists customize their own to capture the minute details of their specific subject.

Almost every state in the union has an annual taxidermy competition.* The first big one was hosted by the Society of American Taxidermists in 1880 in Rochester, New York, but it would be almost another century before the American renaissance of competitive taxidermy. In 1976, discouraged by the quality of work he'd seen at taxidermy conventions, Joe Kish launched the Taxidermy Review Show. The National Taxidermy Association competition soon followed, and 1983 saw the arrival of the biggest of all: the World Taxidermy Championships. At the 2009 championships, competitors from all fifty states and twenty-two countries vied for more than twenty-five thousand dollars in prizes in twelve categories.

Getting the animal's face right is especially important. Just popping in some glass eyes and fake teeth† doesn't cut it, particularly at the competition level. Showing off pieces at her Game Over Taxidermy studio, Jaime Dotson—who learned her craft in northwest Montana—points out all the

* The conventions tab at www.taxidermy.net leads to an extensive list of American events.
† Depending on the condition of the specimen's own choppers. Sometimes the originals can be used.

little nooks and crannies that must be tended to.* When a judge shines a flashlight into the nostrils or ears of a well-done piece, painted-on veins should appear to be visible, with cavities as deep as they would be in real life. Synthetic saliva is applied to make tongues seem moist. However, if you find yourself complaining to the bartender that the buck lording over your banquette doesn't have fake ear wax, don't be shocked when you get cut off before last call.

The Culture of Curiosities

The *New York Times* dubbed them "The New Antiquarians." Individuals like blogger Hollister Hovey and her younger sister, Porter; book designer Megan Wilson; and shopkeeper Ryan Matthew, who appoint their homes and stores with artifacts from bygone eras: taxidermy, apothecary cabinets, medical antiques, wax mannequins. However, the article overlooked this small community's very real historical precedent: the cabinet of curiosities, or *Wunderkammer*.

The original cabinets of curiosities emerged in the German-speaking nations of the sixteenth century, where wealthy monarchs assembled rooms,[†] and sometimes even entire wings, dedicated to unusual items collected at home and abroad. They were organized according to different primary categories: products of nature (antlers, feathers, claws and bones of unusual animals; rare geological and botanical specimens); scientific and medical instruments; religious artifacts, artworks, and other man-made treasures. The aim of a stellar cabinet of curiosities was to condense the whole universe—which had only grown larger and wilder with the discovery of the New

* Life-size male mammals are even expected to have testicles.

† In archaic parlance, "cabinet" referred to a small room or exhibition hall.

World—down to a small, manageable scale that encouraged study and enlightenment.

Most of the great cabinets, the precursors to our modern museums, were the province of well-to-do nobility; others were the pride of men of science, such as Dutch physician Ole Worm. Perhaps the finest was that of Emperor Rudolph II. Others of note included the Hapsburg Kunstkammer in Vienna (established in 1553 by Ferdinand I, king of Austria, Hungary, and Bohemia) and the cabinet of Albrecht V, Duke of Bavaria.* Some collectors even created worlds within worlds, and fashioned smaller *Kunstschränke* (conceived by merchant prince and diplomat Philip Hainhofer of Augsburg), individual cupboards† full of drawers and secret compartments to guard their tiny treasures.

Evan Michaelson of New York's Obscura Antiques has been dealing in taxidermy, medical apparatus, and other esoteric ephemera since the early 1990s. "The value is aesthetic, but the rarity is real," she says of her wares. "And they're actually authentic things that tell a story, as opposed to something that's disposable." She feels that modern collectors of such items are compelled by very similar impulses as those who assembled the original cabinets of curiosity. "It has to do with putting things in context. Nothing is in context anymore. When everything is a style or fashion, you lose the narrative. The culture of curiosity, which involves natural history specimens and such, is so huge. And that roots [collecting] in a tradition, which is comforting and instructive."

Ryan Matthew, one of the co-owners of the East Village bespoke suit shop Against Nature, and a patron of Obscura Antiques, shares Michaelson's point of view. "I've collected things in my travels. I've taken trinkets of life experiences. If you want to call that assembling it into my cabinet of curiosities, then yes, I do that." Matthew taught himself how to articulate skele-

* Czar Peter the Great, always eager to keep up with Western trends, got into the action late; his St. Petersburg cabinet dates to 1714, and was opened to the public five years after that.

† Cabinets in the more contemporary sense.

tons (the technical term for reassembling them for display), and has been doing it professionally for five or six years. More recently, he learned to create Beauchene "exploded skulls," disarticulating human and primate skulls by creating pressure inside them (by filling the specimens with beans or rice, and then submerging them in water until they expand) so the skull splits into its individual components, then rearticulating them and mounting them under Victorian glass domes.

Matthew doesn't view his work or collections as morbid or macabre. He presents them as if they were in a learning institution or museum. "That's why I started obtaining these things first and foremost, to learn about them and have them there to actually study." His pastimes are rooted in a lifelong fascination with natural beauty, not death and dying. "I like to think that if Martha Stewart were to walk into my house, she would be thoroughly impressed, and not disgusted."

Hatch Show Print

The Hatch Show aesthetic has been one of the most influential in American entertainment and media for more than a century, defining the look of American roots music since 1879. This small shop in Nashville, Tennessee, has created works for icons as hip as Dwight D. Eisenhower and as square as the Beastie Boys, and maintained its reputation largely by sticking to the same traditional methods around during its inception. Over its century and

a quarter in business, Hatch has created posters advertising everything from sausage to circuses, coffee and professional wrestling, but the shop is best known for its affiliation with popular music, and country in particular. The archives of Hatch include posters created for such Opry mainstays as Roy Acuff, Flatt & Scruggs, Hank Williams, Hank Snow, Minnie Pearl, and Eddy Arnold.

The company was founded in 1879 by mustached siblings Charles R. and Herbert H. Hatch. Their father had been a preacher and printer, too, and moved the family to Nashville when it was one of the great seats of publishing in the United States. From the start, Hatch relied on all the components that are still crucial to its look today: nineteenth-century typefaces, letterpress printing, metal type, and carved woodblocks. It also enjoyed close ties to show business from the beginning, printing promotional materials for the full spectrum of events, including evangelical preachers, touring theatrical productions, and minstrel shows.*

Charles's son Will T. Hatch took over the family business in 1921, and ushered in what many consider its first golden age. His posters featured vibrant, eye-popping colors—typically just two or three, since each additional color required another run through the press—such as the bright orange and green used on a 1941 poster for Grand Ole Opry tent shows. Equally important were his custom woodblocks. To create them, Hatch had to draw detailed pictures in reverse and then carve them into the wood by hand, thus creating a positive image when the inked block was applied to paper.

For much of its history, Hatch Show Print was located in downtown Nashville, on Fourth Avenue between Broadway and Commerce streets. Just a block away was the historic Ryman Auditorium, home for many years to the Grand Ole Opry. Then as now, most of the musicians on the show made the bulk of their income playing live dates, and Hatch Show Print

* Musical productions that lampooned African American life—usually in an unflattering manner—with a program of music, dance, skits, and variety arts, performed by white actors in blackface (and later, African American performers too), most popular between 1840 to 1910.

promotional materials were a surefire way to advertise. In the 1950s, the printer began using metal photoplates, rather than woodblocks, for images of the actual artists, but retained all its other distinctive hallmarks.

Despite lean times and passing through various hands in the 1960s and '70s, Hatch rallied in the 1980s under the new ownership of Bill Denny. Their classic red circle logo was revived, and manager and historian Jim Sherraden began reproducing classic Hatch Show images on postcards. Restrikes (reprints) of especially popular posters, such as one for Elvis Presley's August 1956 shows in Jacksonville, Florida, were another source of revenue and helped spread the Hatch Show look nationwide.

Owned and operated by the Country Music Hall of Fame and Museum since 1992, Hatch Show Print continues to shape American advertising. Graphic designers in search of communicating "authenticity," whether the product is whiskey or sportswear, have come to appreciate the one-of-a-kind look created by letterpress printing, vintage typefaces, and hand-carved woodblocks. Meanwhile, Hatch added a new layer to its look when Sherraden began making custom monoprints, original works of art that combine classic blocks and type faces in colorful new combinations.

Hatch is still in operation today. In addition to its famous posters, it prints birth announcements, calendars, and invitations, for clients ranging from kennel clubs to fraternal orders. In 1992, Hatch moved around the corner to 316 Broadway but otherwise looks virtually unchanged. Even the original neon sign still hangs out front. And inside, all work is done the old-fashioned way: printers are hand-cranked, rollers are hand-inked, edges are hand-trimmed. Although new woodblocks are continuously being created by staff, to add to the library, modern typefaces have not been introduced, the better to maintain the historic look.

Sherraden's motto is "preservation through production," and Hatch's staff of ten—augmented by interns who come from all over the world— churns out roughly six hundred jobs a year. It also entertains more than fifty thousand walk-in visitors annually, and since the fall of 2008 has been the subject of the Smithsonian traveling museum exhibit "American Letterpress: The Art of Hatch Show Print."

Corncob Pipe

What Is It? A rudimentary smoking pipe made by hollowing out the end of a dried corncob and inserting a stem. Beloved by Mark Twain, Huck Finn, et al.

Practicality: Insanely easy to make. All you need is a corncob, a pocketknife, a suitable stem—the base of a wheat or hay stalk works in a pinch—and a little know-how.

Availability: They probably existed for centuries before, but Missouri native Henry Tibbe patented the first corncob pipe design in 1878. His company, Missouri Meerschaum, still operates to this day. They even grow a special breed of corn for their cobs.

SUBLIME OR RIDICULOUS? *Looks best with a button nose and two eyes made out of coal.*

Jon Langford

When it comes to an individual artist who exerts comparable impact to Hatch Show Print on the Americana music community, these days Jon Langford is the man to beat. Whether the subject is a big star like Patsy

Cline or a cult figure like Patsy Montana, his brightly colored, stylized, and distressed portraits of country music icons are instantly recognizable. The backgrounds of Langford's paintings and etchings are often dotted with snakes, crosses, and skulls, as well as hearts, moons, and stars. Sort of like an overturned bowl of Goth Lucky Charms. Borders of flowers and leaves recall classic embroidery motifs.

Born in Wales, Langford set out to study fine art at Leeds University. Once there, he quickly fell in with the underground music scene that generated legendary postpunk bands Gang of Four, Delta 5, and the Au Pairs. He quit making art, and pursued a different path. In 1977, Langford helped form the Mekons, which began as a cacophonous punk act; their debut single, "Never Been in a Riot," was a poke at the Clash ("White Riot"). Later, though, they crafted the 1985 album *Fear and Whiskey*, which kick-started the alt-country movement. It was the ease with which the Mekons continued to work—despite label hassles and lineup changes—that helped Langford regain his desire to make visual art.

"It was only thinking about songwriting that allowed me to get back into painting," he says. Langford, who relocated to Chicago in the late 1980s, had become increasingly comfortable with "the process that went into making songs, and the ease with which we were writing albums, that I still really like now, in a couple of days." This ongoing accomplishment finally made painting, which had felt daunting to Langford after so long away from the canvas, feel possible again.

Langford still plays music (with the Mekons, the Waco Brothers, and other bands), but today his paintings can be found on countless album covers, for artists from Buddy Guy to Jim Lauderdale; at art galleries like Yard Dog in Austin, Texas; and compiled in his glossy 2006 retrospective *Nashville Radio: Art, Words, and Music.*

Yet there is a strong political edge to his art too. Sometimes it surfaces subtly, through the integration of lyrics, such as "Another class of people put us somewhere just below" hovering over the head of "Hungry Eyes" singer Merle Haggard. Other Langford works are more pointed: "Saint Hank" depicts an emaciated Hank Williams, his rail-thin body riddled with arrows

à la St. Sebastian. In 1998, Langford brought an exhibition titled "The Death of Country Music," which paired his paintings with carved granite tombstones, to Music City.

Although his painting came to prominence as a by-product of a culture that rejected slick, commercial country, Langford owes a significant debt to Nashville. In 1988, while promoting the multi-artist AIDS relief album *'Till Things Are Brighter* (which Langford produced), he made his first visit to Tootsie's Orchid Lounge. Located across the alley from the Ryman Auditorium, this watering hole had slaked the thirst of Grand Ole Opry stars for years (until the Opry pulled up stakes in 1973 and moved to Opryland). Fifteen years later, the walls of the saloon were still plastered with promotional photos of country artists: big stars, one-hit wonders, hopeful unknowns. These tattered images had been discolored by years of cigarette smoke and curious fingers. It was an "aha" moment for the painter, a turning point in his visual style. He began deliberately scuffing and scratching his works. The finished products appear to have seen lifetimes of hard-won experience, neatly mirroring the themes of perseverance and survival that have characterized country music from its inception, but also its devil-may-care love for a night out on the town.

9

ONE STITCH AT A TIME

Crafts and
the D.I.Y.
Handmade Movement

Nowadays, it seems like everywhere you look—at the coffee shop, on the bus, waiting in a line—someone is working on a craft project, but that wasn't the case at the end of the twentieth century. In a 2005 survey, the Craft Yarn Council of America (CYCA) found that 53 million U.S. women knew how to knit, a 51 percent increase from the decade before, and the fastest growing demographic was women under thirty-five. Just between 2002 and 2004, the CYCA found that participation in crafts such as crochet and knitting shot up 150 percent among women between twenty-five and thirty-four.

Crafting had never vanished completely. It just didn't seem terribly hip or timely, which actually provided many individuals with the impetus to take action. One such entrepreneur was environmentalist Nikola Davidson, founder of Sticky Wicket Crafts and author of the 2009 felting guide *Feltique*. As someone who aimed to learn a new craft skill every year, she appreciated that teach-yourself, all-in-one kits from hobby and fabric stores were an easy point of entry. They also seemed woefully cheesy. "The choices out there were so lame," says Davidson, who also cofounded Seattle craft fair Urban Craft Uprising. "It might be a cool skill to have, but then what they'd want you to make was really uninspiring."

Along came Martha Stewart, whose rise to fame in the 1980s and '90s put the domestic arts, including handcrafts, back in the spotlight. Stewart's workmanship and detailed instructions were a leap forward, and Davidson admired her skill, but felt Stewart's projects had "no edge, no hip, no funk."

To offer potential alternatives to other crafters, she married her passions and started her line of ecofriendly kits that teach a skill and also garner an amusing end result, for example, beeswax candles that looked like sushi.

Many pioneers of the crafts revival tell similar anecdotes. They loved working with their hands and the act of creating something, but loathed the outdated design aesthetic that pursuits like needlepoint seemed saddled with. The world had seen more than its fair share of smiling scarecrows and Raggedy Ann dolls. These individuals took it upon themselves to develop alternatives, then share what they'd learned with others,* often launching successful independent businesses in the process.

Embroidery company Sublime Stitching was started by Jenny Hart, a graphic designer who creates her own original designs, everything from rock bands to rocket ships. In addition to her own creations, she carries an Artist Series of transfer patterns, drawn by underground icons such as outsider musician Daniel Johnston and Etsy superstar the Black Apple (Emily Martin). Hart also created a customized embroidery kit for the Decemberists, which they sold alongside T-shirts and CDs on their 2006 tour.

Hart correctly guessed there was a market hungry for craft projects that weren't wincingly cute and cuddly, and her files are filled with thank-you notes from lifelong crafters to prove it. "Women would write me saying, 'I spent years doing needlework with patterns I hated. They weren't even designs I would hang up in my own home or show people. I just did them because I love doing the needlework, and had no other resource.'"

The modern-day craft world is very different from your mother's or grandmother's, though there are points of overlap too. Craft in the twenty-first century is an amalgamation of D.I.Y. punk rock bravura and Third Wave feminism. Most importantly, whether a project involves pompoms and white glue, glass blowing, or knitting "disposable" plastic bags into durable shopping totes, craft chips away at America's reputation as a nation of con-

* Naturally, over time, the indie craft world has lapsed into some clichés of its own: skulls and crossbones; devil horns and cat ears for knit caps; and classic tattoo iconography à la Ed Hardy, but better that than more ducks and bunnies.

sumers. Instead it celebrates productivity, individuality, and creativity—one stitch at a time.

The Emancipation of Crafts

According to a Chinese proverb, "Women hold up half the sky," but 50 percent of the heavens seems paltry compared to the modern craft scene, where women have been the primary driving force. Hip feminist publications such as *Venus* and *Bust* were early champions of the crafts revival; the latter magazine, edited by *Stitch 'N Bitch* author Debbie Stoller (who has a Ph.D. in the psychology of women), was featuring a column called "She's Crafty" by the mid-1990s. In 1996, Jean Railla—the doyenne of "hip home ec"—debuted the zine *Get Crafty;* an online version appeared two years later.

For many young women, crafts were unfamiliar territory. Their aunts and mothers had put aside embroidery hoops and quilting frames during the women's liberation movement. No matter how highly skilled some of these disciplines were—arguably more so than many office jobs—many women were reluctant to be stereotyped as "old-fashioned."*

Even today, there are others who don't understand why crafters would opt to avoid modern convenience. Nicky Gawne is one-half of Estrella Soap Company, which produces vegan, handmade, all-natural soap. When she first told friends she wanted to learn to sew, too, some of them greeted her with astonishment. "They were like, 'Why would you want to do that? What is this, *Little House on the Prairie?*'"

* As Stoller notes in *Stitch 'N Bitch*, these cycles are not uncommon. In the late nineteenth century and again in the Roaring Twenties, shortly after receiving the right to vote, young women spurned knitting. Then came the Great Depression, and being able to make your own socks didn't seem like such a curse.

Nevertheless, in the late twentieth century, young women found their way back into crafts. One point of entry was punk and indie rock, like the Riot Grrrl movement, which sprang from the Pacific Northwest in the early 1990s. In addition to spawning influential bands Bikini Kill and Sleater-Kinney, Riot Grrrl also emphasized the importance of women working together, activism, and a D.I.Y. ethos that extended well beyond playing music and publishing zines. One way to honor the generations of women who'd come before was to reclaim handcrafts and give them a contemporary spin.

"You have to build on those traditions and do something new with them," says Sublime Stitching's Jenny Hart. In order for young folks to regain interest, crafts needed to evolve. "Embroidery was like Latin. It had to change and grow, and you had to give it some breathing room, or it was going to die." The same chutzpah that inspired indie-punk kids with no musical experience to pick up guitars and form bands also gave neophytes who didn't know a knit from a purl the courage to delve into crafts.

One tool the new generation of crafters had that their predecessors lacked was the Internet. Faythe Levine recalls her epiphany when she began exploring the virtual craft community around 2001, a few years before she founded Milwaukee craft fair Art Vs. Craft. "I was like, 'Oh my God, this is it! This is my scene!' Because it was about living a D.I.Y. lifestyle—which is something that I'd been doing—and making art, and, from what I could see online, for the most part it was all women." It still is—in a 2008 survey of thirty thousand users, online handmade vendor Etsy found that 96 percent of its users—buyers and sellers alike—were women.

There's no giant "Boys Stay Out!" sign hanging over the door of the crafts scene. "There was never an anti-male sentiment," says Levine. "There were just more women than men." In part that came down to women revisiting traditional handcrafts that they associated with their mothers and grandmothers, and adding new twists.* As woodworking, screen printing,

* To this day, every time I see a story in the mainstream media about Men Who Knit, I have to catch myself and think of all the pioneering female musicians who were shoehorned into Women Who Rock articles for decades.

and other disciplines play a bigger role at craft fairs, more men are showing up at booths.

Levine spent three years shooting her 2009 documentary, *Handmade Nation*, about the scene. She visited fifteen cities and interviewed more than eighty individuals; 95 percent of the participants were women. She has no complaints about the gradual influx of guys, though. "It's nice to have a balanced energy." There's room for everyone. But she still gets the biggest charge from being part of a community driven by women working together—and dispelling outdated myths. "There are all these stereotypes that women are catty with each other, and competitive, and you just don't see that. It makes me wonder where that stereotype even comes from, because I haven't really experienced any nastiness."

Cooperation is a cornerstone of the D.I.Y. handmade movement. Take the Austin Craft Mafia, brainchild of nine Texas women with backgrounds in art, fashion, and craft, all aspiring to be their own bosses. In 2001 they banded together, and built their ventures (including the independent fashion designs of Tina Sparkles and the handmade jewelry of Jennifer Perkins's Naughty Secretary Club) concurrently. Since then, they've shared that knowledge over the Web, encouraging other cities to take advantage of that strength in numbers. Dozens of Craft Mafias have followed, from Indianapolis to Atlanta, and even overseas.

⇥ "WHAT ARE YOU DOING?" ⇤

Knitting: No wonder Boy Scouts were recruited to knit socks and blankets for U.S. soldiers during both world wars: knitting is just tying knots with pointy sticks. Or, to put it more elegantly, using two or more knitting needles to fashion yarn or other fibrous material into rows of interlocking looped stitches of knits and purls.

Crochet: Fibrous material? Check. Interlocking loops? Check. So how is crochet different from knitting? The primary tool is a single needle end-

ing in a hook, not a point. Depending on the specific project, crochet is often a faster way to whip up a bigger piece (that's why it's great for afghans) but can lack the stretch of knitting.

Sewing: In the words of *The Sound of Music,* "a needle pulling thread." It's that simple: binding together pieces of fabric (or other material) with stitching, either by hand or machinery. The complicated part? All the other elements that make *Project Runway* thrilling: cutting cloth, making seams line up, not stabbing your fingers.

Quilting: Sewing together two or more layers of cloth, including an inner lining of "batting" (that's what makes it puffy), usually to make a coverlet. "Patchwork" or "piecing" is fashioning smaller scraps of fabric into larger blocks and decorative patterns, often for the top layer of a quilt. Enlist the nimble fingers of friends and neighbors to expedite these processes and you're hosting a "quilting bee."

Embroidery: The umbrella term for all the decorative needlecrafts. And there are many; for an ever-growing list, check out the Glossary page of the Sublime Stitching Web site. Essentially, using a needle and thread (typically embroidery floss) and different stitches to ornament a piece of fabric or other material. It can be something as simple as a border on a cuff or collar, or as complicated as a museum-quality portrait.

Needlepoint: Sort of like paint-by-numbers embroidery. The tools: a blunt needle, yarn or floss, and a wide-weave canvas. The image is already painted or printed on the canvas, and the embroiderer simply fills in the appropriate matching colors in repeated rows of diagonal "tent" stitching. Yields a nifty, pixilated look.

Cross-Stitch: The medium of all those cutesy kitchen wall hangings. (Want hip alternatives? Investigate Julie Jackson's world of Subversive Cross Stitch.)* Rows of X-shaped stitches, typically done on Aida, a fabric

* www.subversivecrossstitch.com/.

perforated into a grid that facilitates even placement. In counted cross-stitch, the artist works from a pattern on a graph. Can be taxing for those with a touch of ADD.

Felting: Using a combination of heat, friction, and moisture to bind wool fibers into a matted fabric. Wet felting (rubbing moistened natural fibers together until they bind) is the oldest known technique. In recent years, knitting an item and then felting it, by either hand or machine washing and drying, has become quite popular. Needle felting, which doesn't require water, involves poking the wool (once it's been shorn, please) with triangular, barbed needles, allowing the crafter to fashion precise shapes, as in soft sculpture.

Screen Printing: Creating an image on fabric, paper, glass, or some other surface by forcing ink through screens with porous and nonporous areas (the ink passes through tiny holes in the part of the image being stenciled, but is blocked everywhere else), building up layers of color and negative space. A different screen is used for each layer of color. Especially popular for T-shirts and posters.

Bookmaking: The art of using paper, needle and thread, glue, and other materials to construct books. For an entertaining overview of one particular style (there are many), check out the riotous If'n Books demonstration video on YouTube.

Letterpress: This is printing the way Gutenberg intended. Movable, reversed blocks of raised text and images are set in a frame, inked, and impressed upon paper. Great for small runs of artisanal books, posters, or gift cards. The stock-in-trade of our friends at Nashville's Hatch Show Print (see chapter 7).

A Better Way to Shop

Craft fairs have come a long way from the Kozy Kraft Korner tucked away at church bazaars and county fairs of yore. In Boston in 2001, Greg Der

Ananian founded the Bazaar Bizarre. Today Bazaar Bizarre hosts events in other cities, including Cleveland and San Francisco. Renegade Craft Fair, which started in Chicago in 2003, has spread to Brooklyn, San Francisco, and Los Angeles. Poke around the right Web sites and message boards and you can easily find an independent craft fair anywhere from Anchorage to Miami. The like-minded spirit of the indie rock and crafts communities have meant that many smaller, monthly events, such as Seattle's I Heart Rummage and Portland's Crafty Wonderland, started in nightclubs.

Large or small, monthly or annual, what craft fairs offer is another platform for makers to share ideas, information, and fellowship and, hopefully, to make some money too. Also, unlike most other shopping experiences, they permit the customer to interact directly with the manufacturer.

Once at a craft fair a gentleman told Jesse Gawne that his product, Estrella soap, was quite simply the best soap he'd ever used in his life. Being on the end of such genuine praise felt almost embarrassing. At the end of their chat, the customer shook Jesse's hand and thanked him for making such a fine product. The soap maker's tear ducts started to well up. "Things like that are priceless."

That enthusiasm travels both directions too. Something like the size of an eyeball on a plush toy may seem trivial from a distance, but hearing the person who made that doll recounting excitedly how they deliberated over that design choice is a persuasive sales tool. It's a reassurance that it was

made with an emphasis on quality and, yes, love. At craft fairs, like farmers' markets, vendors stand behind their wares in more ways than one.

For makers, crafts and entrepreneurship often go back to an early age. Some remember having ad hoc art shows in their bedrooms, charging parents fifty cents (or even a whole dollar) for select paintings. At summer camp between fifth and sixth grades, Kristen Rask and some friends started making friendship bracelets and selling them to their fellow campers. "By the end of camp, we'd each made thirteen dollars," she remembers. They were ecstatic. Unsurprisingly, today Rask operates Schmancy, a successful toy shop in Seattle that specializes in handmade plush items, from limited-edition, cuddly stalks of broccoli by Heidi Kenney (My Paper Frame) to squeezable ninjas from Shawnimals.

Boutiques like Rask's are a boon for shoppers who want to buy D.I.Y. yet crave real world interaction, too, and don't want to wait for the next big local craft fair. In San Francisco's Mission District, Needles and Pens carries an array of zines, original works by artists like Niki McClure, and other D.I.Y. goods. Art Star Gallery & Boutique in Philadelphia teems with handmade ceramics, stationery, and more; jewelry and prints featuring designs by Portland, Oregon, artist Kurt Halsey, a fervent vegan who draws cuddly, big-headed animals, are a popular staple.

Whether a craft or handmade item is found through an artist's Web site, a small gallery or boutique, or at a fair, there is a level of direct connection absent from most of modern commerce, which more and more people place a premium on. Many makers bristle at the very word *consumer* since buying handmade is about interacting with an artist and their art, and showing support for creativity and the D.I.Y. ethos, rather than simply consuming a product.

The handmade nation won't become a stand-alone economy. But as it becomes increasingly accessible, and concerns like labor practices and ecology move to the forefront of consumers' minds, it provides an attractive marketplace alternative. Diehards who only shop handmade are commendable, but there are also growing numbers of individuals moving between both worlds, for whom shopping at a craft fair or indie boutique is a small epiphany: they don't have to go to the mall.

Etsy

The Internet has long played a pivotal role in the modern craft scene. Get-crafty[*] was one of the earliest Web sites that offered not just projects and tutorials, but also hosted lively discussion boards. Others like SuperNaturale[†] and Craftster[‡] followed. Using knit and crochet community Ravelry,[§] members can find and share patterns, track progress on projects, investigate new yarns or techniques, show off their creations . . . it's a nonstop cyberspace "stitch and bitch." All these sites allow users to put their own stamp on projects—change a fabric, add a pattern—and share their stories of success or failure.

Consequently, one of the handmade movement's biggest success stories isn't an individual artist but a single Web site that acts as a clubhouse for thousands of makers: Etsy. As of late 2009, it had more than 3.3 million members, including more than 250,000 different sellers, and seventy full-time employees.

"The online marketplace for buying and selling all things handmade," Etsy was conceived by painter, photographer, carpenter, and tech guy Rob Kalin, and executed with two colleagues in 2005, after they had helped Jean Railla redesign Getcrafty. According to the company mission statement: "We created Etsy to reconnect producer and consumer, and swing the pendulum back to a time when we bought our bread from the baker, food from the farmer, and shoes from the cobbler."

Pretty much anything handmade you could imagine—and a lot of things you might not—are lurking on Etsy's pages, from the practical to the ridiculous.[¶] Drinking glasses made from recycled beer bottles. All-natural

[*] www.getcrafty.com.

[†] www.supernaturale.com.

[‡] www.craftster.org.

[§] www.ravelry.com.

[¶] Etsy's greatest misses gain notoriety on Regretsy ("Handmade? It looks like you made it with your feet"), a satirical Web site that cherry-picks the worst and weirdest Etsy offerings. "Don't get us wrong," reads their disclaimer. "We like crafts. We just don't like *these* crafts." Like the man says, art is subjective.

soaps shaped like old-fashioned cassette tapes. Doll-house-sized crates of itty bitty toy cucumbers. Too busy to paint that acrylic portrait of operatic German New Wave singer Klaus Nomi? You can order one on Etsy. Members can search the site by variables including color and locality, as well as price or when an item became available.

The beauty of Etsy is that it also encourages extensive community activity and creativity even without making a purchase. The weekly Craft Night opens up the Etsy Labs in the company's Brooklyn office to the flesh-and-blood public, but members can also participate in events online. In addition to Craft Night, the schedule of virtual happenings includes critiques, business and creative workshops, scheduled chats for newcomers, and more. Their blog the Storque* is a wonder in itself, including its own Craftivism section connecting members to causes including Quilting for Peace, breast cancer awareness, and combating malaria.

Even seasoned crafts vets who don't use Etsy regularly can appreciate its wide appeal because it encourages the public to make things, or at least buy from individuals who do—either way, being on Etsy is supporting somebody's craft habit.

"For the majority of our sellers, I don't think Etsy is their primary source of income," says Etsy spokesman Adam Brown. If they can be, that's awesome, and Etsy offers plenty of tools, such as tips on how to set prices and promote, but success can be measured in many ways. Page views and positive comments boost an artist's pride too. Etsy wants to help members earn a living making things, but that's only one facet of the experience. "We're saying, 'Here's a marketplace, and you can come be a part of it.' And we promote the marketplace. And you get out of it what you put into it."

Practicing "Craftivism"

As romantic as the image of Betsy Ross stitching together the first American flag may be, it might seem odd to think of crafts as political. For many members of the D.I.Y. handmade community they are just that, because making

* www.etsy.com/storque/.

their own clothing, soap, or furniture means they don't have to hand over their money to big corporations like Walmart. To paraphrase Betsy Greer, the Carrboro, North Carolina, crafter who runs the Web site Craftivism ("craft + activism = craftivism"), it is a way to break the chains of consumerism.

When the makers of Estrella soap rolled out handmade lip balm, their friends acted as if they'd cracked a secret code. Doesn't ChapStick have that locked down? Urban Craft Uprising founder Nikola Davidson had a similar epiphany, although it was with a sandwich spread, not a craft project. "When I found out, as a young adult, that you could actually make mayonnaise? That it wasn't something that had to be manufactured in a factory? I was like, 'Oh my God, I could go home and make mayonnaise. I have that technology available!'"

Another political component of the craft scene is eco-consciousness. Resourceful artists have figured out numerous ways to thumb their nose at "throwaway society." Covers from discarded hardback books are reborn as one-of-a-kind blank journals. Pieces of vintage wallpaper enliven note cards. Starting with remnant fabrics or old leather jackets, rather than new textiles, also ensures final products that are unique and strictly limited-edition. Savvy crafters make a point of spotlighting reclaimed and upcycled source materials, as well as green components like soy inks and mineral pigments.

All that talk about supporting small business and items Made in America? The handmade movement dovetails perfectly with these concerns, just like shopping local and organic, and thinking green. "People might not be buying as much, or as frivolously, but they are willing to spend extra if they know where something is coming from," says Faythe Levine. Folks are not only voting with their pocketbooks, but voting *for* them too—as long as they're made from salvaged leather jackets or old shopping bags, rather than being mass-produced with sweatshop labor.

Art vs. Crafts

Throw out the word *graffiti* and most people think of shadowy figures in hooded sweatshirts, bombing brick walls with spray paint, or whipping off

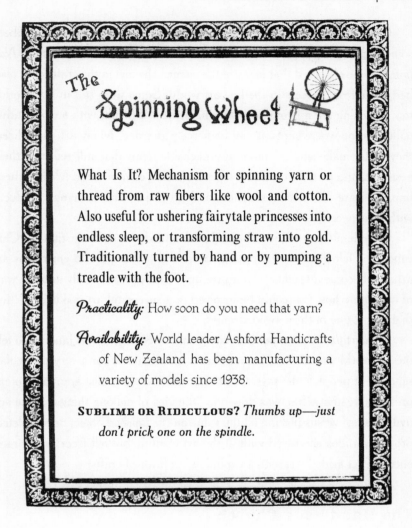

The Spinning Wheel

What Is It? Mechanism for spinning yarn or thread from raw fibers like wool and cotton. Also useful for ushering fairytale princesses into endless sleep, or transforming straw into gold. Traditionally turned by hand or by pumping a treadle with the foot.

Practicality: How soon do you need that yarn?

Availability: World leader Ashford Handicrafts of New Zealand has been manufacturing a variety of models since 1938.

SUBLIME OR RIDICULOUS? *Thumbs up—just don't prick one on the spindle.*

elaborate tags with Krink markers, one eye always open for the cops. In Houston, a different type of crew uses their visual flair to enliven the urban landscape. Underground craft group Knitta swathes street signs, bridges, and bike racks with fuzzy, knitted "tags" secured in place with zip ties. (Imagine a lamppost wearing an elongated, striped leg warmer.) The collision of practices from opposite ends of the arts spectrum—one clearly illegal, the other sometimes derided as quaint—calls into question how both graffiti and knitting function in society.

Crafts have also freed many young or struggling artists from the cumbersome trappings of the art world. While researching her film *Handmade Nation*, Levine observed that many of the women she met in the craft scene also had come from careers in the fine art world. Some were still in that world, too, but eking out a living as a working artist is difficult, with a competitive gallery scene where contacts can be fiercely guarded. Many artists realized they could make smaller, more approachable items that still reflected their aesthetic, and turn a profit, in a more nurturing environment. Most crafters happily share sources, information, and processes, and exchange products with their peers.

Church of Craft founder Callie Janoff attended the Art Institute of Chicago. She felt like the only options presented to her were to emerge as an art star, become a teacher . . . or give up. "There wasn't really another way of imagining how you could be involved in a successful art-making practice that wasn't one of those two extremes."

It wasn't just the competitive nature that discouraged her; Janoff also felt the art world was elitist, "because art is usually made for a very particular segment of people," she says. Craft offered a more populist approach to expressing creativity. She was drawn to "the idea of making things for the activity's sake," versus placing all the value on the finished object or completed project, an idea she toyed with at the art institute but felt freer to embrace once she set aside "Art with a capital A" in favor of crafts.

The Handmade Church

Lifetime practitioners, lapsed faithful, and newcomers alike acknowledge the transformative powers of craft. Jenny Hart of Sublime Stitching took up embroidery during an especially dark period, while several of her family members were hospitalized. "When I started doing it, it was better than drugs, alcohol, therapy—anything I had ever tried. Embroidery dealt with my anxiety better than anything else." Doing crafts can soothe the soul.

The Church of Craft is neither an organized religion nor some oddball cult. Suppliants do not bow down before a King Kong–sized canister of

rubber cement, nor sit in a congregation thirty pews deep, crocheting in perfect synchronicity, under the watchful gaze of a pastor in felted robes. You know the old expression "idle hands are the devil's tool"? The Church of Craft is a take on the equal and opposite reaction: through the act of creation, we attain enlightenment.

Part of the initial impetus behind the Church of Craft came when co-founder Janoff was asked to officiate a friend's wedding, and found herself thinking of their nuptials as an art piece in itself. Since then, she's gone on to perform between fifty and sixty weddings and delivered eulogies too. Now she's attending seminary (even though she remains "a pretty committed agnostic"). "This is not where I would've imagined this path would have taken me," she admits, "but I'm also really excited that it has."

The Church of Craft is not knitting meditation. Instead its philosophy centers on the many choices we make every day, even something as simple as selecting 2 percent milk versus skim, or picking out what T-shirt to wear with your jeans. "Those are creative decisions," says Janoff. "To be able to see them as such, and see the process as a moment of inspiration or creativity, is empowering. That's the kind of empowerment that I want to encourage through Church of Craft." Instead of singing hymns or chanting prayers, these churchgoers express their spirituality through making handmade items, and sharing community while making choices about fabric color or which beads to use.

The "church" was founded in 2000. Now there are chapters in more than a dozen cities, from Manchester, England, to Boise, Idaho. Some meet more regularly than others, or focus on social justice and community building. Thus far there haven't been any denominational schisms. "We don't have enough dogma for something like that," Janoff chuckles. "If there's no rules, there's not a lot to split up over." In the New Testament, Matthew 18:20 states "Where two or three come together in my name, there am I with them." Janoff doesn't even require that big a turnout to consider a Church of Craft fellowship successful. "There are days when it only takes one. Sometimes the goal is just to be, to make that space in the universe and see what happens, and not how many people came."

Bubbling Up

You know crafts are back on the mainstream's radar when Paris Hilton gets involved, lending her name to a line of scrapbook supplies in 2009. But nobody mistook her Creativity Collection for an underground product, either. Nevertheless, some savvy companies have done a great job of introducing elements of the handmade aesthetic into mass-produced items. Is that adorable ceramic, screen-printed teapot from Etsy . . . or Urban Outfitters? My favorite nap blanket is edged with big, brightly colored stitching that could've easily been done by hand; it was only after I'd grown attached to its fleecy charms that I noticed the JCPenney Home Collection label.* "If the whole indie crafts movement is a revolution, and it's saying 'No, this is how we're different, we're rejecting you' then when it's co-opted, is that victory or defeat? Or both?" wonders Urban Craft Uprising founder Nikola Davidson.

In late April 2009, Sublime Stitching locked horns with a one-woman venture positioning itself as a hip, indie newcomer to the hand embroidery scene—while covertly operating under the auspices of a much larger, professional craft vendor. And replicating elements of everything from Jenny Hart's business model to specific designs and projects. After she went public in an e-mail circulated among other indie craft colleagues, blogs and forums blazed briefly over the "indiewashing" scandal, and Hart filed a legal complaint—which she ultimately had to withdraw a few months later. Financially, a lawsuit would have put her entire Sublime Stitching operation in jeopardy.

But the part that really cheesed her? In one blog post, the competition implied that the Sublime Stitching founder had been naïve to assume that anyone could have established a flourishing hand embroidery business single-handedly. How could such a superwoman exist? "Guess what? Meet Superwoman!" says Hart, who started Sublime Stitching with a thousand-dollar loan from her late father. Her voice is tinged with exuberance and

* I know, I know. I'm sorry. It was a gift.

rage. "That is exactly what every one of us who works every day to build their dream, that is what we do." Those are the people driving the D.I.Y. independent craft community, she reiterates.

When Levine started filming her *Handmade Nation* documentary in 2006, she felt indie craft was approaching a tipping point. "All these magazines were popping up,* and it was the beginning of the handmade aesthetic being this marketing tool," she remembers. She'd seen the same thing happen in punk rock. "And I was worried that someone was going to come in and make this exposé film about 'cute girls making cute stuff!'" *Handmade Nation* was her way to ensure the political, social, and economic impact of the movement was preserved on film too.

"If you're an artist or a crafter, you're always going to be one step ahead anyway," concludes Nicky Gawne from Estrella Soap. "In general, independent artists think of stuff first, and then the mainstream adopts it." The most determined makers don't find that fact terribly discouraging. "It's not like you're going to run out of ideas."

* O'Reilly Media launched *Craft*, a quarterly digest devoted to "transforming traditional crafts," in 2006.

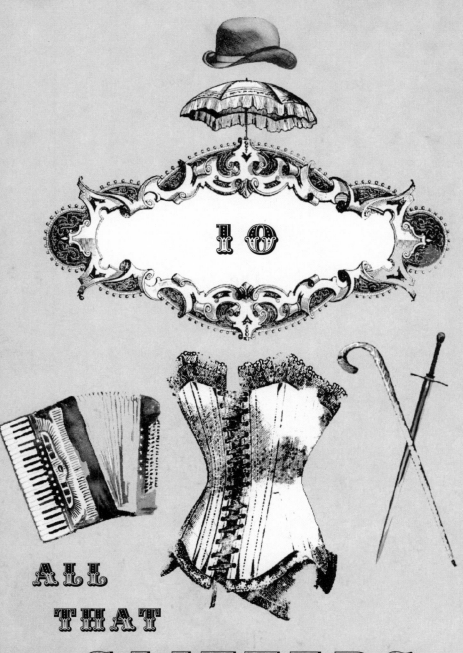

10

ALL THAT GLITTERS

The
Lively Arts

In any decent-sized American city, any week of the year, there is a bur-lesque show going on. Thank goodness. In the last fifteen years, the options for adults looking for a night out on the town have diversified signifi-cantly. There are still rock bands and jazz combos aplenty who can lure the public out of the La-Z-Boy, and touring productions of Broadway shows to tempt theater fans. For thrill seekers who want to color outside the lines, however, the options continue to diversify: burlesque, circus, vaudeville, and other old-school showbiz forms are alive and well.

Modern entertainers and promoters put a lot of thought and energy into keeping these arts vital. Nobody wants to come off like a clutch of sad-eyed saloon girls in ruffled bloomers, doing a can-can in some Podunk theme park. Burlesque has provided a new creative outlet for performers ranging from pole dancers to Shakespearean actors, and the circus isn't the only place you're likely to see a trapeze today.* Using familiar terms like *circus* and *burlesque* makes life easier for the events calendar editor of your regional alt-weekly or arts blog, but don't show up expecting a historical reenactment. A mash-up of elements from the past, present, and future is more likely what's in store.

* Many burlesque artists, such as Poppy Daze and Tamara the Trapeze Lady, are also aerialists.

What Is Burlesque?

Burlesque is not just striptease, even though striptease is the heart beating beneath all those ostrich feathers and rhinestones.

"If you go into a strip joint, there's striptease, but that's kind of the only layer," explains Jo Boobs (aka Jo Weldon), who worked as a feature dancer in strip clubs before the current wave of burlesque took off. A burlesque routine may involve peeling off stockings or opera gloves, but it accessorizes with other accoutrements: social commentary, politics, humor. In the heyday of burlesque, strippers shared the bill with comics and variety acts; today the peelers do a little bit of it all. "We take striptease, and layer it with extreme glamour, or circus skills, or theatrics," Weldon says. "But understanding the art of the striptease, and making clothing removal interesting, is the basic layer." Modern mass media bombard our eyes with explicit images. Burlesque deliberately engages the imagination.

To appreciate the versatility of burlesque as an art form, consider the root of the term: the Italian word *burlare*, to make fun of. Burlesque doesn't just celebrate exaggerated ideas of femininity, glamour, and sexuality; an inventive routine can also satirize just about anything else, from politics to pop music, simultaneously.

As far as Miss Indigo Blue (aka Amelia Ross-Gilson) is concerned, burlesque is feminist. "In a culture where women tend to be undervalued or sexualized, burlesque elevates them *while* sexualizing them." That charged status calls into question patriarchal society, and capitalism, and the other buttresses of the status quo. Old-school feminists might raise objections that modern burlesque plays into stereotypes, but artists like Indigo Blue, who like to toy with ideas of perceived femininity and womanhood in their routines, argue that they're actually subverting them.

To appreciate the distinction, you need to see burlesque performed in the flesh. Looking at a picture of a scantily clad performer only shows one facet of the art. "Watching a live theatrical performance of burlesque, not only do you see the objectification—which I say with tongue *firmly* planted in cheek—but you see the wits, the humor, the preposterousness of the whole thing," says Indigo.

Gender stereotypes are a prime target in modern burlesque. Drag king Ernie Von Schmaltz is a potbellied, mustache-stroking ladies' man who makes Tom Jones look like a pantywaist. The World Famous *BOB* is billed as a female female-impersonator; a biological female who identifies as a drag queen.* You don't even have to be a woman to perform burlesque. "In the sense that burlesque is about bodies and people and sex, and relationship and politics and community, and ideas, it's humanist," adds Indigo Blue. There are male burlesque acts, too, men like Tigger! (actor James Ferguson) and Waxie Moon (dancer Marc Kenison) who specialize in "boylesque" routines in such unlikely costumes as a bridal gown, or done up like a six-armed Hindu goddess.

"Burlesque is a sensibility," says Scotty the Blue Bunny (aka Scott Grabell), a popular burlesque emcee and variety act. "People think that this idea of the pinup girl is burlesque. But it's not. Yes, there has to be pasties and a thong in there somewhere, but anybody can do anything that appeals to an adult, sexual, raucous, raunchy sensibility."

Bicoastal burlesque producer and performer the Swedish Housewife mixes Valkyries, Vikings, and voluptuous maidens with a live rock band for her annual "House of Thee Unholy" burlesque celebration of Led Zeppelin. In four years, "Land of the Sweets: The Burlesque Nutcracker" has become a bona fide holiday tradition in Seattle, running for twenty performances in 2009. Meanwhile, Jo Boobs has been pushing the boundaries by integrating Lindy Hop (a dance style from the 1920s and '30s that evolved from the Charleston), wrestling, burlesque, and heavy metal, all into one routine.

Modern burlesque can be confrontational, too, titillating the audience while making them squirm. In his routine "Buttons," Waxie Moon portrays an elegant dandy who submits to being whipped by a domineering leather daddy. Los Angeles performer Jewel of Denial even went so far as to build a routine around being a sexy fly emerging from a pile of dog poop.

"The best thing about burlesque is it's incredibly ingenious," says Baltimore-based performer Trixie Little. "It can work so many different ways,

* Also known as a "bio-queen," for those keeping score in the gender wars.

through theatrical effects, or costume rigging, or the layering of ideas and references."

One thing burlesque doesn't necessarily require is an extensive background in dance. Choreography, yes, but a choreography of specific movements and pantomimed gestures, gradually accumulating—not a cavalcade of fancy footwork. In classic, old-school burlesque, mischief and timing are key. In theatrical burlesque, the narrative arc must remain clear. Movement ability is a plus, but it's hardly mandatory. Timing is everything.

A Brief History of Scant Clothing

"People keep calling burlesque a trend," says Jo Boobs, "but I actually consider it a development in the performing arts, the way punk was a development in rock-and-roll music. And I'm interested in what the next step is." Don't be deceived by the lascivious stage name, her wasp waist, and generous bosom—Jo Boobs is a very smart cookie. She holds a business degree and did graduate work in journalism, with a concentration on media ethics. She's also been entertaining audiences by disrobing since a *Rocky Horror* preshow in her teens. When the ecdysiast,* author of *The Burlesque Handbook*, and headmistress of the New York School of Burlesque says her art form is no mere fad, it's hard to quarrel.

The roots of burlesque in America stretch back to 1868, when English actress Lydia Thompson and her troupe of British Blondes took New York audiences by storm with their ribald performances, witty repartee, and scanty costumes. Skirts above the knees! Pink tights! Women dressed as men! Thompson and her ensemble toured the States, inspiring other theater folk to get in on the profitable act.

Another important date to memorize for that Burlesque 101 pop quiz: 1893. That was the year of the World's Columbian Exposition in Chicago, when displays of the *danse du ventre* kept the midway bustling. Belly dancing. Muscle dance. Oriental dance. Hootchy-kootchy. Whatever it

* A fancy word for a striptease artist, from *ecdysis*, to molt or shed an outer layer.

was called, undulating ladies—especially the legendary Little Egypt—were good for Expo business.

As the twentieth century unfolded, creative disrobing became an integral part of the choreography in such shows. As the novelty of exposed flesh (or the illusion of same) became commonplace, producers and performers ratcheted up the production values and staging. A pretty girl is like a melody—but integrate elaborate costumes and props, and clever, well-executed numbers, and that lovely lady becomes a symphony. Between the 1930s and '50s, American burlesque enjoyed a golden age. Gypsy Rose Lee, Sally Rand, Blaze Starr, Lili St. Cyr, and Tempest Storm were all household names.

By the time it petered out, burlesque had become synonymous with striptease. However, there are big distinctions between what went on at Minsky's burlesque houses in the 1930s, and the floor show of today's gentleman's club. For starters, the art of classic striptease stressed the second syllable: tease. In stark contrast with today's culture of instant gratification, the great stars of burlesque often took as long as a quarter of an hour, stretched across several songs, to complete one number.

Nor were they the only performers appearing nightly. "Peelers" shared the bill with comics and variety acts. Emcees kept the show running and stoked audience excitement, and those audiences weren't just men. Ladies enjoyed burlesque too: the glamorous costumes, knowing asides . . . and seeing a sister with a crowd eating from the palm of her hand. It may not have been family entertainment—far from it, burlesque was squarely aimed at adults—but it catered to both sexes.

By the 1960s and '70s, burlesque was in decline. Venues trotted out more dancers but fewer numbers, more strip and less tease. Live bands were replaced with canned music. One by one, the great burlesque theaters

closed, and burlesque moved into nightclubs. Feature strippers might still eke out a living on the road, but where their predecessors had worked with variety acts, now they shared the bill with adult movies. Skin flicks were cheaper—and more explicit; the latter-day queens of true burlesque couldn't compete.

One veteran who soldiered on was Marinka, "Queen of the Amazons." She remembers arriving for a run of dates in Philadelphia, only to find her name on the marquee alongside the 1972 hard-core adult flick *Behind the Green Door.* "Every time I went out as people were coming in, they'd ask, 'Are you Marilyn Chambers?'" She sighs and smiles sadly. "'No, dear, I'm not the porno star. I'm the striptease *artist.*'" Marinka managed to keep working into the late '90s, but only by taking her shows to Europe, where audiences remained receptive.

Nevertheless, burlesque didn't completely vanish from the American landscape. In the 1970s and '80s, you could find traces of it in Las Vegas extravaganzas, the arty downtown New York club scene, and even the music hall format of *The Muppet Show* and Bob Mackie's eye-popping costumes for Cher. Ann Corio, a contemporary of the great Gypsy Rose Lee, kept the flame aloft with long-running stage shows like *This Was Burlesque* (which premiered on Broadway in 1962), and *Here It Is, Burlesque.* The latter toured until 1991 and was filmed by HBO.

By then a new generation of women and men, inspired by everything from the swing music revival to their dissatisfaction with the same adult entertainment industry that had undermined burlesque, were ready to break out the tassels and give them a twirl. The Blue Angel Cabaret in New York, the Velvet Hammer in Los Angeles, and Fallen Women Follies in Seattle all showcased acts that would now easily be classified as burlesque, but the regional scenes hadn't quite coalesced into a national community. As early pioneer Tigger! admits, "We had thought we were inventing this new spin in NYC in the mid-nineties until we heard about the burlesque zeitgeist."

One big tipping point was the first Tease-O-Rama, held in New Orleans in 2001. "That was our first chance to see how all these other cities did it," says Tigger! "Since then it's ballooned so much, and we all travel

and cross-pollinate aplenty." Or as Miss Indigo Blue puts it, reflecting upon meeting Dirty Martini, World Famous *BOB*, Miss Astrid, and Julie Atlas Muz for the first time that weekend, "I just went, 'OMFG, *these* are my people!'"

Honor Thy Mothers

Preserving the "lost" art of burlesque isn't a new concept. Back when the glitter began to fade, dancer Jennie Lee—who'd already established the Exotic Dancers League, a labor union for strippers, in 1954—bought a plot of land in Helendale, California. Her plan was to turn this abandoned goat farm located between Los Angeles and Las Vegas into a combination retirement community for burlesque beauties and museum preserving their glorious past: Exotic World.

Lee's dream didn't reach full fruition. She accumulated plenty of mementos, but few curiosity seekers were willing to make the trek through the desert to view them. Jennie died of breast cancer in 1990, but her pal, Dixie Evans, who'd enjoyed a lucrative career as the "Marilyn Monroe of Burlesque," wasn't going to let Lee's vision dissipate like a highway mirage.

Evans launched the annual Miss Exotic World competition, a celebration of burlesque that brought out dancers old and new, raised money, and encouraged a level of competition for the title of Miss Exotic World that keeps increasing. Costumes get fancier, and rehearsals more intense. Two thousand ten marks the twentieth anniversary of the Exotic World Weekend. The nonprofit enterprise was renamed the Burlesque Hall of Fame, and relocated from Helendale to Las Vegas in 2006, but it remains a bastion of the community, albeit a somewhat old-fashioned one.

Jo "Boobs" Weldon just shrugs it off when people lament that Exotic World skews too retro, that the competition has not embraced "boylesque" and edgier routines. "It's a museum," she emphasizes. "Everywhere else we go, we get to do whatever crazy shit we want. If you can't come and spend one weekend a year being classic, I don't know what to tell you."

The two generations, the newer entertainers and surviving golden age

stars—the so-called "Living Legends"—such as Tempest Storm enshrined in Exotic World, have more in common than they sometimes realize, says Trixie Little. "The legends can be really funny" when they reminisce about the good old days. "If they really thought about it, we're doing a very good job at all the things they talk about: Being titillating, and tongue-in-cheek . . . and only going so far."

The current generation of burlesque luminaries acknowledge the work done by the women before them, even if history has forgotten their names, or their original shrine was a dilapidated trailer in the desert. When Indigo Blue first visited Exotic World in 2001, she felt a powerful connection to the Living Legends, and that made her more determined to understand and interpolate burlesque history, even as she and her peers advanced it. "It can't just be, 'Oh, I have this new, contemporary idea.' It has to be, 'How do I ground and root that in history?'" For newcomers to learn from the legends is crucial.

Indigo Blue is also excited to see what the next generation has in store. As the field gets more crowded, new acts have to innovate to distinguish themselves.

"The thing that resonates the most for me about burlesque being a uniquely American art form is that any generation of burlesque performers will look back at ten, or maybe twenty, years before and say, 'That wasn't burlesque.'"

Even in this scintillating art form, irking your elders is a sign you might be on to breaking new ground, and that thrills her. "Every time somebody does something where people say, 'That's not burlesque,' I think, 'Awesome!'"

Adult Education and Matriculation

Ladies (or gentlemen) curious to learn more about the art of burlesque needn't necessarily plan a pilgrimage to Sin City. There are plenty of other resources to study it first hand. Jo Boobs's New York School of Burlesque connects students with first-rate performers like the World Famous *BOB*, Tigger!, and Dirty Martini. Chicago has Studio L'Amour, operating under the tutelage of Miss Exotic World 2005, Michelle L'Amour. Seattle hosts

the annual BurlyCon convention, which includes four days of workshops and lectures hosted by veterans old and new, and the popular Burlesque 101 course at Miss Indigo Blue's Academy of Burlesque, where neophytes spend six weeks developing an original routine. (This class also inspired *A Wink and a Smile*, a 2009 documentary that beautifully showcases burlesque's reentry into mainstream culture.)

"I tell these people, 'You are very lucky that you have this BurlyCon, where you learn about routines, costumes, makeup, and so on,'" says veteran performer Marinka, a guest presenter in 2008 and 2009. "Because in my time? There was nothing."

Of course, not everyone who enrolls at one of these modern institutions plans to be the next Gypsy Rose Lee. Many are just looking for a new avenue of expression. While studying at the New England Center for Circus Arts in Brattleboro, Vermont, Trixie Little took time out to run a Burlesque Boot Camp. One of her students was a large woman in her fifties. "And she did this act where she was a milkmaid. She came out, and chopped wood on stage . . . and ripped her clothes off. You just couldn't believe it."

Miss Indigo Blue says the leading reason students enroll at the Academy of Burlesque is simply to get a taste of what they've already witnessed her peers projecting onstage: confidence and sex appeal. "What I try to imbue to the students is that what is sexy is confidence." You don't need to have a tiny waist or bodacious boobs, or stand six feet tall. "Your appearance is less relevant than confidence." Confidence creates charisma, which translates into appeal, culminating in sexiness.

What modern burlesque hasn't achieved yet is the star-making power the art form enjoyed in its twentieth-century heyday. Gypsy Rose Lee appeared in more than a dozen films, wrote three books, and was held in high regard for her wit as well as beauty and style. At one point, long before her life's story was turned into the award-winning musical *Gypsy*, she lived in the same artists collective as writers Carson McCullers, W. H. Auden, and Paul Bowles, and composer Benjamin Britten.

At the moment, there's only one bona fide burlesque superstar: Dita Von Teese. Born Heather Renée Sweet, this middle daughter of three chil-

dren has come a long way from her roots in a small Michigan town. Starting out in strip clubs and the fetish scene in the early 1990s, she has become a legitimate fashion icon. Dita has designed a line of retro-glamour undergarments for Wonderbra. Her sponsorship deals include MAC cosmetics and Cointreau liqueur, the latter inspired by one of her signature routines, performed in a giant cocktail glass. While her marriage to rock star Marilyn Manson barely lasted a year, the impact of its media coverage (her wedding dress was designed by Jean Paul Gaultier) didn't vanish after the divorce papers were signed.

"I think Dita is like Janet Jackson and Madonna, in that she is a self-made artist who is also fiercely controlling of her vision, and fiercely controlling of herself as a commodity," observes Miss Indigo Blue. Maintaining tight control over the interviews and photo shoots she grants, Von Teese enhances her carefully constructed persona as the epitome of glamour and opulence, while underscoring her mysterious iciness. For another burlesque artist to reach her heights will require phenomenal ambition, presence, and persistence. "It takes a lot of personal commitment for someone to become what Dita has become."

Others may eventually follow. The tap-dancing World Famous Pontani Sisters, featuring Angie Pontani, have gotten their names out in public through national Christmas tours with surf rockers Los Straitjackets, a DVD of go-go-robics, and repeat appearances on the now-defunct *Late Night with Conan O'Brien*. At the end of 2009, their popular revue, *This Is Burlesque*, moved uptown to Times Square.

Both Jo Boobs and Indigo Blue point toward a vein of "visceral, salty ambition" evident in newcomers that the previous wave didn't display. Younger entrants into the field seem more likely to view burlesque as a fast track to fame. "Folks who are like, 'There is potential for me to be a star here, and I'm going to make this my vehicle,'" summarizes Indigo. And if it doesn't buy a mansion in Beverly Hills . . . well, it beats flipping burgers. "I've made a career—if you want to call it that—off of burlesque," shrugs emcee Scotty the Blue Bunny. "I don't have health insurance, but I've definitely been busy."

Circuses

At first, the show radiated all sweetness and light. That's not entirely accurate, but it felt good natured. The feats on display in the single ring of Seattle's Circus Contraption on this warm June night in 2009 evoked smiles and laughter. Eyes widened in amazement. Pinky D'Ambrosia turned acrobatics astride her trusty steed, Moonbeam. Decked out in a crash helmet and patriotic jumpsuit, daredevil Bunny LaMonte smashed wooden boards with his bare hands. For her "Mermaid" number, aerialist Poppy Daze defied gravity even while creating the illusion of frolicking fathoms below the waves.

Just as ringmaster Armitage Shanks promised, tonight's show was truly "a bracing curative for the afflictions of our times." Especially when paired with the curious cocktails sold at the Contraption bar, featuring ingredients like fig-infused Tennessee whiskey, candied ginger, and sparkling organic limeade. And then it all went to hell.

As act 2 unfolded, the Contraption family descended into chaos. Ringmaster Shanks swelled to grotesque proportions, flecks of half-chewed popcorn flying from his mouth as he berated his charges. Poppy's second act showstopper was an eye-popping aerial pole dance. LaMonte's jet-powered "Flight of the Bunny" climaxed in a brutal crash landing. Shots were fired. In the end, all that remained was a chorus line of dancing cockroaches* and bleachers full of dropped jaws. Thanks for coming, folks. Don't forget to pick up some balloons in the crush for the exits!

The posters promised "The Show to End All Shows," and they meant it. After thirteen years, Circus Contraption was pulling up stakes and shut-

* Well, actors in oversize cockroach costumes.

What Is It? Early ancestor (circa 1870) of the modern bicycle. Also known as high wheel, penny-farthing, boneshaker. Pedal drive attached to front wheel, hence the ridiculous proportions; the larger the front tire, the farther one could travel on one revolution of the pedals.

Practicality: Precarious height makes it easier for automobile drivers to see cyclist. Prone to embarrassing ass-over-teakettle spills.

Availability: Reproductions average around a thousand dollars. Vintage models can fetch ten times that on eBay.

SUBLIME OR RIDICULOUS?
Depends on how high a premium you place on amusing the townsfolk.

ting down. The core performers wanted to pursue new, separate pursuits. "As with too many things, I didn't know how much I loved Circus Contraption until I realized it was going away," laments theater critic Brendan Kiley in local alt-weekly the *Stranger*.

The American circus as an art form, however, is far from dead. It may be facing some hurdles as it marches into the twenty-first century, but the circus—from newcomers like Cirque Berzerk and Circus Bella, to established veterans including New York-based Bindlestiff Family Variety Arts—continues to display a tenacity that would make Contraption's cockroach kick line proud. Just don't show up to today's circus expecting the cotton candy and sparkling tutus of yesteryear.

That Was Then . . .

Feats like juggling, fire-eating, and balancing on ropes could be found in ancient China, Egypt, and Rome. The latter also featured the notorious Circus Maximus, where three hundred thousand spectators could be treated to thrilling or gruesome spectacles: chariot races, gladiator fights, and wild animal hunts. However, circus as we know it is only a few hundred years old. In the late eighteenth century, British riding master Sergeant Major Philip Astley staged equestrian displays in a forty-two-foot diameter ring, Astley's Amphitheatre of Equestrian Arts, and rounded out the bill with jugglers, fireworks, dancing bears, tumblers, and rope walkers. In 1793, John Bill Ricketts, following a model similar to Astley's, opened Ricketts' Circus in Philadelphia, the first of its kind on U.S. soil.

The golden age of the American circus spanned from 1870 to 1915, but tented traveling shows continued going strong through the first half of the twentieth century. In the 1940s, Ringling Brothers and Barnum & Bailey Circus relied on 109 railway carriages to transport its crew of fourteen hundred, plus an exotic menagerie to rival any well-stocked zoo, and a four-ring big top with a seating capacity of ten thousand. In the wake of World War II, the big tented circus began to go the way of vaudeville. On the evening of July 16, 1956, Ringling Brothers held its last performance under the big top.

Newer entertainment forms like television and movies, and, later, video games, made the sort of thrills delivered by the circus seem corny, outdated. The biggest shows had also inadvertently sabotaged themselves with su-persizing. The larger the audience, the less intimate the performance, and the higher the production costs. In the 1960s and '70s, big touring circuses increasingly played in stadiums and indoor arenas, and by the early '80s, the large-scale tented circus was kaput.

How could an art form that celebrated man's ability to transcend the limitations of humanity—to defy gravity, tame wild animals, consume flames—be brought low by something as mundane as dollars and cents? It couldn't, but the next wave of circus, as embodied by '70s start-ups like San Francisco's Pickle Family Circus and the Big Apple Circus of New York City, were leaner, closer in spirit to street performance and traditional European one-ring productions.

In the latter half of the '80s, Montreal's Cirque du Soleil hit the States. Their 1989 HBO special, *Cirque du Soleil: The Magic Circus*, introduced them to even more spectators, and won an Emmy Award. It has since be-come as synonymous with circus as Ringling Brothers and P. T. Barnum in the mind of the general public. But with its sophisticated theatricality, surrealism, French dialogue, and all that fog, Soleil can seem awfully hoity-toity too.

> Marge: *Finally, a circus full of whimsy and wonder.*
> Homer: *Oh, yeah, that's way better than fun and excitement.*
> —from *The Simpsons* (season 12, "Skinner's Sense of Snow")

This Is Now . . .

Underground America had different ideas about the circus. Seedier ones. Troupes like Bindlestiff and Circus Contraption began emerging from the fringes.

Either way, the mere term *circus* carries connotations that are often hard to shake: pretty ladies in pink tutus, and elephants doing headstands. No

wonder some groups adopted alternate spellings: Bindlestiff Family Cirkus and Know Nothing Zirkus. "For some people, especially if they're not hip to the modern circus, that word immediately meant happy clowns with balloons and twisty animals," says David Crellin, cofounder of Circus Contraption. They come expecting trapeze and hand balancing, maybe a little fire play, but not nudity.

Meanwhile, the Jim Rose Circus, a troupe out of Seattle, had smacked alt-rockers around the country upside the head as a second stage attraction on Lollapalooza 1992. Rose and his cohorts treated audiences who'd turned out to see Red Hot Chili Peppers, Soundgarden, and Pearl Jam to entertainment very different from the dressed-down angst of grunge: classic carnival sideshow feats like eating glass, sword swallowing, or walking up a ladder of swords, as well as modern variations including lifting cinder blocks from nipple piercings. The group would go on to tour with Nine Inch Nails, Marilyn Manson, and Korn, and appear on TV shows including *The X-Files* and *The Simpsons*. Kids in the provinces went nuts. Alternative circus was clearly accessible, and cheaper than other options for a night on the town. "It wasn't forty dollars to go to a show," adds Crellin. "People were seeing a hell of a lot of entertainment for ten bucks."

That lower price point wasn't the only thing it shared with the underground music and club scenes. The D.I.Y., no-rules spirit, and the dissolution of barriers between performer and audience, ran strong in these troupes. "Our earliest days were antimicrophone and very low-tech," recalls Keith Nelson, who started Bindlestiff Family Cirkus in 1995 with partner Stephanie Monseu. They taught themselves how to book shows, do advance publicity, and take circus into places it rarely visited. "When you're playing a dank little punk rock dive that comfortably holds sixty, and you have two hundred people packed in, that forces that intimacy."

Contemporary circus may overlap with theater, especially since most productions rely on a narrative to provide a through line, but as in burlesque, there is no fourth wall. The performers are very much in-your-face. These are not productions where the audience is expected to simply clap politely. "We're all going to be part of this experience together," says Crellin with a mischievous leer.

·≡[HOW TO JOIN THE CIRCUS]≡·

Back in 1881, James Otis Kaler published *Toby Tyler: Or, Ten Weeks with a Circus*, the story of an orphan who runs off with a traveling show. The popular children's book was a work of fiction, but more than a century later, similar adventures still unfold for real-life boys and girls.

Long before *Ripley's Believe It or Not* crowned him "The Most Flexible Man Alive!," Daniel Browning Smith, better known as Rubberboy, was just a very limber kid who'd momentarily climbed onstage with the Bindlestiff crew at a Pensacola, Florida, punk club. After they left town, Smith followed the Cirkus all the way to New Orleans, where he convinced them to take him on as a contortionist. In 1998, Jason Williams and Evelyn Bittner, two stage hands at the Seattle Fringe Festival, were so smitten by Circus Contraption that they took lessons in acrobatics, then successfully auditioned for the company. Their disturbing alter egos, the gothic tumbling act Dr. Calamari and Acrophelia, became two of Contraption's best-loved members.

Some of their mentors and colleagues had to be more resourceful. Keith Nelson of Bindlestiff Family Cirkus first learned juggling while studying at Hampshire College. At the same time, he harbored an interest in fire pageantry, perversely nurtured by that most wholesome of organizations, the Boy Scouts of America's honor society, Order of the Arrow. "A few times a year I had to put together these big productions with flaming arrows being shot across lakes, and torches, and bonfires." He traded a bottle of whiskey to some jugglers for his first lesson in a skill the Scouts didn't teach: fire-eating.*

* At least Nelson had the luxury of human instruction. "I learned fire from a book . . . and then asking other people," says Crellin. Nor did he wait 'till he met some experts to start practicing. "I went from this book that said, 'Stick this in your face like so . . .' to going 'Note to self: Trim facial hair.'"

Like so many skills and trades, circus arts and sideshow feats were in danger of dying out at the end of the twentieth century. Even Ringling Brothers and Barnum & Bailey Clown College, which turned out fourteen hundred funnymen across three decades, closed shop in 1997.

"There was an in-between period where there weren't that many old-timers to pass the knowledge on," recalls Nelson. And curious youth were sometimes deterred by the amount of commitment required to get an in. "Real circus, real sideshow, you're doing anywhere from three to thirty shows a day, putting up tents, taking them down, moving. The old-timers aren't going to show you anything until you help put up the tent first."

To become aerialist Poppy Daze, Lara Paxton traveled to the Ecole Nationale du Cirque in Montreal. Flying rigs and circus school in North America were relatively rare at the time. When she returned to Seattle, she and Crellin knocked a hole in the ceiling of their home and suspended a practice trapeze.

There are other, more landlord-friendly options. The San Francisco School of Circus Arts offers a veritable UN of courses, including Chinese Acrobatics, Mongolian Contortion, and private instruction on the German Wheel. Coney Island Sideshow School will happily teach you how to pound a twenty-penny nail into your noggin. Identical twins Elsie and Serenity Smith, veterans of Cirque du Soleil's Saltimbanco, pass along their acrobatic skills at the New England Center for Circus Arts. Just don't assume clown college comes cheaper than any other learning institution. Five sessions of Sideshow Skills 102 from Coney Island will set you back $750. Pay the rent or walk on glass. Which sounds more exotic to you?

"I paid lots of money to learn my craft," says Cirque Berzerk's Suzanne Bernel. She studied three days a week at a Los Angeles circus school and took private sessions on the side. Be prepared: If you run away with the circus, you may never go home again. "From the minute I took my first class I couldn't do anything else."

Visceral Thrills and Insurance Bills

Circus is a real-time antidote to first-person shooter video games and Hollywood CGI blockbusters. Circus performers sweat and pant. They exude body odor. "The rest of our life in the twenty-first century is pure escapism," says Bindlestiff's Keith Nelson. Circus brings people back to reality, vividly. "Somebody could actually be maimed, hurt, die. That's intimate beauty, and intimate amazement, that you're taking part in. Every other experience we have has a screen between you and the subject matter."

"Everything these days is so fake, so virtual," adds aerialist Bernel, cofounder of Cirque Berzerk. "We don't even play tennis anymore. We have Wii. Seeing the physical human body do something death-defying is thrilling."

Danger definitely adds to the allure of modern circus. To promote its 2009 season, Cirque Berzerk shot two humorous "accident" commercials.

In one, an innocent belch causes a fire breather's head to explode, and the other has a trampoline artist wedged in ceiling rafters. Both concluded with the opening date, and the assurance "We'll be ready by then."

At the same time the risk is very real. Performers at Berzerk don't use nets or safety lines. Consequently, one of their biggest expenses isn't sawdust, sequins, or greasepaint, but insurance. "It's not cheap to insure a circus," confirms Bernel. While you'd think the cost would taper off over the course of a run, as the acts get more experience under their leotards, the opposite is true. Insurance companies view each show as a fresh throw of the dice. "The more times you roll, the greater the chances of a particular outcome."

There are other hidden costs, particularly for touring ensembles. Gasoline, food, and shelter for performers adds up quickly. Bindlestiff Family Cirkus would much rather tour in a full-sized bus, but can't afford the

expense. "At near forty, I'm not up for doing vans anymore," admits Nelson. Nor are the performers all fearless young punks. "I physically can't ask a wire walker or a contortionist to travel like that for eight or nine hours, and then get up and do their thing."

The rigor of the road was one of the reasons Bindlestiff alum David Hunt and partner Abigail Munn launched San Francisco's one-ring, open air Circus Bella in spring 2008. They'd both just completed a tour with Zoppé, an Italian family circus founded in 1842, and wanted to continue the thrills of that jaunt, but without having to always travel.

Eddy Joe Cotton, founder and self-appointed "straw boss"* of Yard Dogs Road Show, is no stranger to the hardships of travel. Before he founded the group, which was born from a shared love of music, burlesque, poetry, and sideshow in 1999, Cotton spent many years riding the rails.[†] The Yard Dogs show occupies a curious zone somewhere between rock band, burlesque troupe, and family circus, and they try to make the most of the endless treks their enterprise can entail. "We swim in rivers and camp out a lot," says Cotton. "There's a good amount of nature between all the towns we play. All that space feels good, but the travel breaks you down too. If you don't truly believe in what you're doing you won't last long."

The mythological status of circus folks as outsiders adds to their allure. The charm of the Yard Dogs show owes much to their gypsy lifestyle, which stands in stark contrast to the safe, regimented lives of many workaholic Americans. "[This show] came together out of a love for art and travel," says Cotton. "There was no blueprint. When there's no plan you're forced to invent in the moment."

Unlike larger operations such as the long-running Cole Bros. Circus, underground circuses rarely employ animals. Who needs the hassle from PETA (People for the Ethical Treatment of Animals), which targets big circuses for inhumane treatment of elephants and other nonhuman

* Hobo slang for the person in charge.

† A lively, detailed account of Cotton's early travels can be found in his 2002 book, *Hobo: A Young Man's Thoughts on Trains and Tramping in America*.

234 | UNITED STATES OF AMERICANA

performers?* "I'm not a huge fan of animals in circus," says Kevin Bourque, ringmaster and cofounder of Cirque Berzerk. "I've worked in Africa, and after seeing animals in their native habitat, I just think it's really sad. That's not a direction I would ever want to go in."

Modern circuses don't tend to be kid-friendly, either (although most troupes will adapt their performances for all-ages audiences). Today, Bindlestiff productions are more traditional, reflecting Nelson and Monseu's love of classic circus arts, but in the early days, Monseu's Ringmistress Philomena did a plate-spinning act that might have been right at home in a Bangkok sex club. On the other side, when a clown with skin that makes a zombie look tan saunters out wielding a pickax, as in Cirque Berzerk's *Underworld* show, one is more inclined to think of John Wayne Gacy than Emmet Kelly.

"People ask me, 'Is your show okay for families?'" says Circus Contraption's David Crellin. He shrugs. It depends on your definition of *family*. The ringmaster's own son started attending Contraption productions around third grade. He says adults are much more likely to flip out than youngsters. Somewhere in his files, Crellin still has the letter banning Circus Contraption from Lynwood, Washington, where some parents thought his Armitage Shanks character was the devil incarnate, even though the circus had watered down the show's content. At least, that's what the note from the mayor's office said. "We thought that was the best review we ever got."

Other troupes aren't so extreme. Circus Bella bills itself as a classic circus for contemporary times. "We're not trying to look old-timey," says cofounder David Hunt. "Not turn-of-the-century, not 1920s, not 1950s, not steampunk." While their visual aesthetic is modern, the program emphasizes classic skills, albeit with new variations (one of their most popular performers is a juggler who doubles as a human beat-box) and a traditional circus formula.

* Toward this end, the Oklahoma-based traveling Kelly Miller Circus goes so far as to spotlight "Animal Care" on its Web site, detailing the lives of its nonhuman stars.

The Future . . .

Even as the worlds of burlesque and underground circus continue to evolve, their influence is disseminated. Starting in Seattle, and then expanding to San Francisco, Teatro ZinZanni has enjoyed great popularity mixing circus arts and cabaret with upscale dinner theater. Pop stars Britney Spears and Pink both mounted circus-themed world tours in 2009. While Britney's show leaned heavily on talent recruited from Big Apple Circus, Pink got in on the act and took to the trapeze and bungee herself, winning admiration from international critics.* In 2009 alone, contortionists and aerialists popped up in TV commercials shilling everything from Marriott hotels and the Burlington Coat Factory to feminine protection and Vaseline skin care lotion. Pop stars Christina Aguilera and the Pussycat Dolls have used elements of burlesque to their advantage, and comedian and actress Margaret Cho embraced burlesque wholeheartedly in her 2007 live variety show *The Sensuous Woman*, which counted Dirty Martini among the cast members.

As an art form, circus has always had to adapt to survive, notes Circus Bella's David Hunt. "It's just exciting that it's becoming popular entertainment again. I think about the people who are creating this movement, and how when we're in our sixties, the next generation—our children and our friends' children—will once again be familiar with circus."

Bindlestiff's Keith Nelson, however, expresses mixed feelings about mainstream appropriation of circus arts. "I'm very happy that four of my friends will probably be able to buy a house when Britney finishes her tour," he concedes. When he sees a fire-eater or stilt walker in a video or commercial, odds are good he knows them. On the other hand, he laments that reality TV shows like *America's Got Talent* cheapen the variety arts through overexposure, getting performers to display their skills before huge audiences in exchange for little or no compensation.†

* "Headfirst she gets lifted towards the ceiling, flies over the audience, and . . . sings with a quality that some of her colleagues wouldn't be able to hold, even when they were just standing," noted Germany's *Rheinische Post*.

† At the behest of scouts, Trixie Little and the Evil Hate Monkey auditioned for *America's*

The circus may sparkle and gleam, but there will always be bumps in the road. "No matter how many silk flowers you stick on your hat or vintage vests you own, if you're not comfortable with hardship, you won't survive," concludes Yard Dogs' Eddy Joe Cotton. "If someone sees an abundance of status or romance in this lifestyle, then they don't know the whole story."

When it all clicks, though, the thrills are still transcendental for performers and audience alike. "Our first shows consisted of one song that was thirty minutes long, interspersed with bits of incoherent garble and, on a good night, one or two pretty girls prancing around in fishnet stockings," remembers Cotton. "If the stars aligned for one of those thirty minutes, it was a good night. That one minute felt more magical than all the Cirque du Soleils and Barnum and Baileys in the world, and we did it ourselves, with broken guitars and a three-legged dog."

Got Talent. After trimming a seven-minute paired acrobatic act down to ninety seconds, in order to be more TV-friendly, they incurred antagonism from audience and judges alike when they refused to drop their stage personae. In the words of Evil Hate Monkey, "They're not helping educate America about what is really culturally new and innovative."

EPILOGUE

"Nothing is new, except that which was already forgotten."

When I was in grade school, my mother was forever running errands to see "the little man." There was a "little man" who fixed her sewing machine, another who made tortillas, a third who resoled Dad's dress shoes. Her affectionate diminutive confused me. Who were these "little men" and what imbued them with these unique powers? Were they elves? (I knew from fairy tales that elves were good with shoes.)

Over time, I grew to understand that Mom's "little men" were skilled craftspeople, both male and female, who were integral to the life of our small Virginia town. While they didn't have pointy ears and wear curly-toed slippers, I considered many of their skills akin to magic. The jobs they did seemed beyond my capabilities as a mere mortal.

My favorite moments researching and writing this book were the many episodes when I got to do something with my hands and interact with people who had knowledge they were eager to share. Visiting the farmers' market and asking which cucumbers were best for pickling, inspecting the stitching on boots at the Wesco factory, and working as a pickup artist (that's the individual who retrieves discarded clothes and props) in a burlesque revue all made me realize that I could be a "little man," too.

In one of our many e-mail exchanges over the last year, Chris Bray of Billykirk recounted a conversation he'd had with a gentleman at the 2009 Pop-Up Flea Market, concerning the amount of goods the United States

imports from abroad. "It seems not only did this kill off jobs and make upper management and CEOs rich but it has killed off the 'How To' in this country. It's no surprise that when one starts to make it financially they get other people to make and do things for them. Has our greed tied our hands behind our backs? Is it out of the realm of possibility that we will be so reliant on other countries to make and do things for us that we will be a nation of needers and not doers?"

I don't want to think so, and if you took the time to read this book, I suspect that you don't, either. You're already doing something about it by participating in one or more of the many activities discussed in these pages, or simply trying to learn more about them. Either way, it is my fondest hope that *United States of Americana* will inspire people to go out and do something new with their hands (even if that "new" thing is centuries old). Because when we all aspire to be "little men," we become greater as individuals and as a society.

Resources

RECOMMENDED WEB SITES

A Continuous Lean: http://www.acontinuouslean.com/

Aquarium Drunkard: http://www.aquariumdrunkard.com/

Archival Clothing: http://www.archivalclothing.com/

Art of Drink: http://www.artofdrink.com/

Canning Across America: http://www.canningacrossamerica.com/

Cold Splinters: http://www.coldsplinters.com/

Craftster: http://www.craftster.org/

DrinkBoy: Adventures in Cocktails http://www.drinkboy.com/

Get Crafty: http://www.getcrafty.com/

Hollister Hovey: http://hollisterhovey.blogspot.com/

No Depression: http://www.nodepression.com/

SuperNaturale: http://www.supernaturale.com/

SELECTED BIBLIOGRAPHY

Albo, Mike. "The Year in Style: The Turn of the Century Called . . ." *GQ*, December, 2009.

Albrecht, Ernest. *The New American Circus*. Gainesville: University of Florida Press, 1995.

Baldwin, Michelle. *Burlesque and the New Bump-n-Grind*. Golden, Colo.: Speck, 2004.

Barlow, Ronald S. *The Vanishing American Barbershop: An Illustrated History of Tonsorial Art, 1860–1960*. St. Paul, Minn.: William Marvy, 1996.

Blewett, Mary H. *Men, Women, and Work: Class, Gender, and Protest in the New England Shoe Industry, 1780–1910*. Champaign: University of Illinois Press, 1988.

Carlin, Richard. *Worlds of Sound: The Story of Smithsonian Folkways*. New York: Smithsonian Books, 2008.

Chensvold, Christian. "Hipster Patriotism Fuels the Market." *Apparel*, posted September 10, 2009, http://apparelmag.com.

Colman, David. "The All-American Back From Japan." *New York Times*, June 17, 2009.

Craddock, Harry. *The Savoy Cocktail Book*. London: Pavillion, 2007.

Goldwyn, Liz. *Pretty Things: The Last Generation of American Burlesque Queens*. New York: ReganBooks, 2006.

Green, Penelope. "The New Antiquarians." *New York Times*, July 30, 2009.

Grimes, William. *Straight Up or On the Rocks: The Story of the American Cocktail*. Revised edition. New York: North Point, 2001.

Grimes, William. "Bar? What Bar?" *New York Times*, June 2, 2009.

Hill, J. Dee. *Freaks & Fire: The Underground Reinvention of Circus*. Brooklyn, N.Y.: Soft Skull, 2004.

Impey, Oliver, and Arthur MacGregor, eds. *The Origins of Museums: The Cabinets of Curiosities in Sixteenth- and Seventeenth-Century Europe*. 2nd edition. London: House of Stratus, 2001.

Langford, Jon. *Nashville Radio: Art, Words, and Music*. Portland, Oregon: Verse Chorus, 2006.

Levine, Faythe, and Cortney Heimerl. *Handmade Nation: The Rise of DIY, Art, Craft, and Design*. New York: Princeton Architectural Press, 2009.

Martin, Timothy W. "Choice Advice from Meat Cutters." *Wall Street Journal*, August 12, 2009.

Milgrom, Melissa. *Still Life: Adventures in Taxidermy*. Boston: Houghton Mifflin Harcourt, 2010.

Schwaner-Albright, Oliver. "Brooklyn's New Culinary Movement." *New York Times*, February 24, 2009.

Severson, Kim. "Young Idols with Cleavers Rule the Stage." *New York Times*, July 7, 2009.

Sherraden, Jim, et al. *Hatch Show Print: The History of a Great American Poster Shop*. San Francisco: Chronicle, 2001.

Stoller, Debbie. *Stitch 'n Bitch: The Knitter's Handbook*. New York: Workman, 2003.

Sullivan, James. *Jeans: A Cultural History of an American Icon*. New York: Gotham, 2006.

Topp, Ellie, and Margaret Howard. *The Complete Book of Small-Batch Preserving.* Buffalo, N.Y.: Firefly, 2007.

Trebay, Guy. "The Fashion Report of 1920." *New York Times*, October 22, 2008.

Wigginton, Eliot, ed. *The Foxfire Book.* Garden City, N.Y.: Anchor, 1972.

———. *Foxfire 2.* Garden City, N.Y.: Anchor, 1973.

Wondrich, David. *Imbibe!: From Absinthe Cocktail to Whiskey Smash, a Salute in Stories and Drinks to "Professor" Jerry Thomas, Pioneer of the American Bar.* New York: Penguin, 2007.

Acknowledgments

More than one hundred fifty individuals helped research this book by sharing contacts, resources, information, ideas, and firsthand experience. A few others simply kept me sane. I am indebted to each and every one, including: Mike Albo, Eli Anderson, John Andreliunus, Keith Bacon, Suzanne Bernel, Tim Betterley, Alexis Biondi, Brooke Black, Lindy Bleau, Paul A. Bloch, Miss Indigo Blue, Kevin Bourque, Lora Brand, Mat Brooke, Adam Brown, Sam Buffa, Paul Burch, Solomon Burke, Alex Calderwood, Freddie Campion, Laura Cantrell, Robert Caplan, Robert Clark, Clean Cut Barbershop, Bethany Clement, Mike Compton, Michael Connolly, Eddy Joe Cotton, Andy Coulter, Wes Coulter, David Crellin, Nikola Davidson, Jason DeBari, Eric Demby, Betsy Devine, Jaime Dotson, Marah Eakin, Peter D. Engel, Scott Ewalt, Kyla Fairchild, Frank Fairfield, Ryan Farr, Jesse and Nicky Gawne, Steve Gdula, Brandon Gilmartin, Scott Grabell, Steven Grasse, Ryan Gray, Jason Gregory, Naomi Gross, Michael W. Haar, Simon Hammerstein, Kerri Harrop, Andrew Hart, Jenny Hart, Adam Hasson, Lynn Hasty, Ambrosia Healy, Robert Hess, Richard Hobbs, Robert Huard, Paul Hughes, David Hunt, Kate Jackson, Callie Janoff, Jim's Barber Shop, Laurie Kearney, Marc Kenison, Orion Keith, Brendan Kiley, Charles Kirkpatrick, PolyCotN and the Knotorious N.I.T. from Knitta, Marty Krogh, Bill Kulczycki, Jon Langford, Lesli Larson, Bettye LaVette, Lance Ledbetter, Tyler Jackson Lehman, Faythe Levine, Jill Lightner, Jessica Linker, Gabriel Liston, Trixie Little and Evil Hate Monkey, the Low Anthem,

Rob Ludlow, Marinka ("Queen of the Amazons"), Davida Marion, Alice Marwick, Michael and Rick Mast, Ryan Matthews, Bob McClure, Mike McGonigal, Judy McGuire, Sam McNulty, Shelby Meade, Daniel Motta Mello, Colin Meloy, Evan Michelson, Rob Miller, Stephanie Monseu, Tom Mylan, David Nelson, Jake Nelson, Keith Nelson, Christie Nye, Kim O'Donnel, Phil Olsen, Misty Otto, Owen Pallett, Tamara Palmer, Michael Paradise, Linda Parker, Lara Paxton, Aja Pecknold, Robin Pecknold, Amy Pennington, Aaron Perlut, Sasha Petraske, Cybele Phillips, Mark Pickerel, Brad Popick, Laura Price, Kristen Rask, A. J. Rathbun, Tresa Redburn, Bob Redmond, Kim Ricketts, the bartenders at Rob Roy, John Roderick, Bruce Roe, Janelle Rogers, Tricia Romano, Don Rongione, Josh Rosenthal, Nathan Salsburg, Eli Sanders, Maggie Savarino, Jordan Sayler, Brenda Schmidt, Seyta Selter, Stephanie Shih, Roberta Shoemaker, Kevin Shorey, John Simone, Paula Sjunneson, Laura Smith, Rennie Sparks, Robin Stedefer, Melanie Stepanik, Daiki Suzuki, Amy Terai, Miles Thomas, Tigger!, Tad Uchtman, Angelo F. Urrutia, Jay Della Valle, Jason Verlinde, Christina Vernon, Marcus Wainwright, Wade Weigel, Jo Weldon, Michael Williams, and Matthew Winters. (Mea culpa for any sins of omission.)

Extra special thanks to Chris Bray at Billykirk, who always went above and beyond and served as my "spirit guide." Linda Derschang, Ron Wilkowski, and Charmaine Slaven were all very helpful during the initial brainstorming process. Dan Savage forwarded the e-mail that started this whole damn thing.

A few portions of this book began life in various periodicals. My editors Grant Alden and Peter Blackstock at *No Depression*, Jennifer Maerz and Jen Graves at the *Stranger*, and Jason Killingsworth at *Paste* all deserve a big hand for making me work harder.

Kudos to my agent, David Dunton at Harvey Klinger Agency, for lending a sympathetic ear and professional expertise throughout this journey. My editor at HarperCollins, Rob Crawford, did a fantastic job of keeping me on track, curtailing my excesses, and refining the rough spots.

Illustrator Aaron Bagley and his wife, Jessixa, were inspiring me long

before we began exploring the *United States of Americana* together, and I have no doubt they will continue to do so for many years to come.

Lastly, my deepest love and thanks to my whole family—particularly Mom and Dad—and my partner, Mark. I couldn't have done this without you.